"WILL FOREVER CH[...]
WAY YOU LOOK A[...]
—ELIZABETH KOLBERT, author [...]

FROSTBITE

How Refrigeration Changed
Our Food, Our Planet, and Ourselves

NICOLA TWILLEY

An eye-opening look at refrigeration
from award-winning writer and
Gastropod host Nicola Twilley

"A perfectly executed cold fusion of science,
history, and literary verve."
—MARY ROACH, author of *Fuzz* and *Stiff*

GRANTA

12 Addison Avenue, London W11 4QR | email: editorial@granta.com
To subscribe visit subscribe.granta.com, or call +44 (0)1371 851873

ISSUE 168: SUMMER 2024

p.11 'The Museum Guard' copyright © 2024 by J.M. Coetzee. The story was composed due to the Prado Museum program *Writing the Prado. International Writer's Fellowship*, sponsored by Fundación Loewe and in collaboration with *Granta* en español; p.113 *A Woman I Once Knew* (2024) by Rosalind Fox Solomon published by MACK; p.241 'The Pneuma Illusion' by Mary Gaitskill quotes an excerpt of 'Something to Remember Me By', copyright © 1990 by Saul Bellow; from SOMETHING TO REMEMBER ME BY by Saul Bellow. Used by permission of Viking Books, an imprint of Penguin Publishing Group, a division of Penguin Random House LLC. All rights reserved. 'Something to Remember Me By' by Saul Bellow. Copyright © 1991, Saul Bellow, also used by permission of The Wylie Agency (UK) Limited; p.281 'Armance' by Fleur Jaeggy is taken from *Il dito in bocca*, Adelphi Edizioni, Milan 1968

This selection copyright © 2024 Granta Trust.

Granta (ISSN 173231 USPS 508) is published four times a year by Granta Trust, 12 Addison Avenue, London W11 4QR, United Kingdom.

Airfreight and mailing in the USA by agent named World Container Inc., 150–15, 183rd Street, Jamaica, NY 11413, USA.

Periodicals postage paid at Brooklyn, NY 11256.

Postmaster: Send address changes to *Granta*, ESco, Trinity House, Sculpins Lane, Wethersfield, Braintree, CM7 4AY, UK.

Subscription records are maintained at *Granta*, c/o ESco Business Services Ltd, Wethersfield, Essex, CM7 4AY.

Air Business Ltd is acting as our mailing agent.

Granta is printed and bound in Italy by Legoprint. This magazine is printed on paper that fulfils the criteria for 'Paper for permanent document' according to ISO 9706 and the American Library Standard ANSI/NIZO Z39.48-1992 and has been certified by the Forest Stewardship Council® (FSC®). *Granta* is indexed in the American Humanities Index.

ISBN 978-1-909-889-66-8

MIX
Paper | Supporting responsible forestry
FSC® C023419

CONTENTS

¡Ay, amor! Lleno de insultos,
centro de angustias mortales,
donde los bienes son males
y los placeres tumultos.

– Mariano Melgar (1790–1815)

Introduction

Y ou see someone at the edge of a gathering. The desire is simple and immediate. Your glance feels returned. *Have I seen this person before?* An unfathomable series of impressions – yours and those of others you have absorbed – have led here. But the pressure feels specific. Where did this need come from that moves through you? A question perhaps best left unanswered; there may be no surer way of losing desire than trying to understand it. The figure approaches. You exchange pleasantries. Beyond the facts, you offer each other impressions. Nothing but impressions all the way down.

Years pass. Together you allow the idea that each of you may know things about the other that they themselves do not. Occasionally, during an argument, you wonder if you project onto the other thoughts and feelings you want to be rid of. In gentler moments something else happens: you offer fragments of introspection for the other to make something of, which, once reinterpreted, are returned to you. Your relationship takes its cues from the script you make together. Whether the story will last depends on the quality of the telling.

'Significant other' calls up the invitation from a host who wishes to strip away presumption. But we insist it is a fertile concept. It was propagated in the post-war decades by the American psychoanalyst Harry Stack Sullivan. In his early work, Sullivan found that schizophrenic patients managed their lives better when they could count on regular contact with the same people. He was convinced that we cannot develop our sense of self in isolation, and that from the earliest stages the approval and disapproval of others pushes the self in radical directions. He grew up as a lonely gay boy in upstate New York at the turn of the last century, the sole Irish Catholic in his school. Certain kinds of alienation, he believed, could be manically productive, but without a sympathetic significant other, life was liable to be ruinous.

There can be any number of significant others in a life. Some we know for a long time; others are meteoric: we may see them only once.

On the fleeting end of the scale, J.M. Coetzee's story 'The Museum Guard' begins with a man named Pepe who lives a content life as a museum guard at the Prado. His life takes a bad turn after an encounter with an older woman visiting the museum. (Coetzee readers have spent rather more time with this woman than we have with Pepe.) As they contemplate *The Drowning Dog* by Goya, Pepe tells her that the painting may have been part of a larger work. There was another panel, so the story goes, which would change how they see the dog's distress. The museum conversation lingers with Pepe in such a way that he attributes a later road accident to their meeting. The sense of having been meddled with comes to a fine point when he thinks he discovers himself in one of the books she has published. Don Quixote-like, he and his girlfriend tear up her fiction and reclaim their independence.

The failure of fusion with a significant other is at the heart of Sophie Collins's story 'Private View', an excerpt from a novel-in-progress. At the outset, Collins's narrator finds herself in thrall to an artist ten years older. As she learns to navigate the higher rungs of culture – how to feel and talk about art – their mutually sustaining fiction starts to founder. What once came across as confidence she recognizes as woundedness. The narrator develops the kind of autonomy she once prized in her lover, while still in rebellion against this 'need for individuation'.

Kevin Brazil's 'Embrace' bursts open with a send-up of self-care, only to ease into a microscopic monitoring of a character who may be unable to fuse with others, but who, with barreling hubris, believes he carries – and may well carry – great reservoirs of love inside him.

Alexandra Tanner's 'Bitter North' is a story of a superficial young North American couple of almost uncanny wholesomeness, whose care for one another is marked by an intelligence about the gaps in their pasts, though their relationship threatens to sputter out in bouts of mutual infantilization.

There may be no greater contemporary artist of the tenuousness of human connection than Mary Gaitskill. For decades, she has written some of the most exacting portraits of broken unions, of scripts misaligning, of fantasies misapprehended, whether in the form of friends or lovers. In 'The Pneuma Illusion', Gaitskill takes up an episode from her life where all appeared to be going well, except for a growing undercurrent of distrust of her new stability. She seeks out respite in a form of physical therapy whose practitioners are able to access and assuage deep knots in Gaitskill's past. The piece is a sustained reflection on the double-edged procedure of submitting to people whose methods are highly questionable, whose speech even bleeds into malevolence, but who deliver undeniable results.

In *Granta*'s ongoing history series, Susan Pedersen hits upon an extraordinary set of documents in an archive. Behind the scenes of power in Arthur Balfour's England, his brother Gerald and other members of the Society for Psychical Research discovered they could communicate with the dead through female mediums. Pedersen examines this post-Victorian period of 'gender codes under pressure' when Messiahs were thick on the ground, and when women struggled through increasingly established pathways to become more public figures. The emotional predicaments of Pedersen's principals are as familiar as their methods of handling them are alien. The result is an exercise in humility: the romantic rituals of our own age will no doubt be subjected to similar scrutiny.

It has been a long time since *Granta* last published literary criticism. In this issue, Christian Lorentzen confronts a specious new form of pseudo-materialist critique – colophonoscopy, in a word – that would have taken György Lukács to task for bothering to read Balzac when he should have been modeling the outputs of Moscow's State Publishing House. The point is not that sociological readings of literature have no merit, but that, by abandoning the notion of literary value as anything other than elite consumerism, they are misguided, even on their own narrowly sociological grounds. In the Marxist tradition from Trotsky to Jameson, the phenomenon of individual genius – an idea currently under suspicion – is not just aesthetically

but sociologically richer than more ordinary production: *Daniel Deronda* or *A House for Mr Biswas* tells us more, both symptomatically and in their own words, about their societies than most bestsellers of the time. But then who reads fiction for information?

In our reportage, James Pogue follows his report from Central African Republic, from where he was deported in the last issue, to Mauritania, where a gold rush of great proportions trains the upheaval of the region into a single field of vision. In Uttar Pradesh, Snigdha Poonam follows a pilgrimmage – both real and virtual – to Ayodhya, where Hindu nationalists have built their dream temple of Ram on the ruins of a mosque.

We are pleased to publish a sketch (accompanied by a pencil drawing by the author) from Fleur Jaeggy's first novel, *Il dito in bocca*, published in 1968. The tumult of friendship and the conniving of love would become one of Jaeggy's great subjects. Here we catch a glimpse of her stepping into her style, in a novel that she has otherwise not allowed to be translated or reprinted.

A great light went out in 2018 when the Brazilian author Victor Heringer died at the age of twenty-nine. *Granta* admired Heringer's novel *The Love of Singular Men* for its kiln-hot vision of first love, and old age looking back. 'The first love can only be the first love because there's a second, obviously,' as the narrator Camilo says. In Heringer's story 'Lígia', an unusual affection grows between two figures who misperceive one another just enough to sustain each other's satisfactions as they live out their days in an apartment complex in Copacabana.

We wish you a significant summer. ⁂

TM

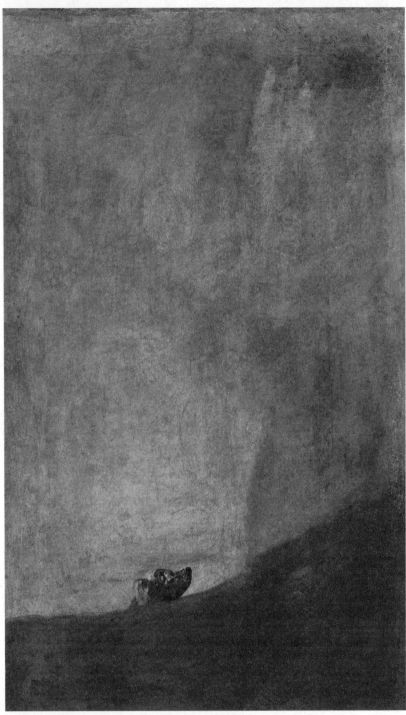

FRANCISCO DE GOYA
The Drowning Dog, 1820–23

THE MUSEUM GUARD

J.M. Coetzee

I

His name is José Eduardo but his friends know him as Pepe. He lives with his mother in a comfortable old apartment in Madrid's Barrio de Salamanca. He has had women friends over the years but has never married. Now, turning forty-five, he has begun to ask himself whether that was a mistake.

As a schoolboy he was studious but never brilliant. An only child, it was intended that he should follow in his father's footsteps (his father, a successful lawyer, passed away when he was twelve). When the time came he dutifully enrolled in the Faculty of Law, but by the second year had found his studies so boring that he persuaded his mother to let him abandon them. Since then he has followed a haphazard path: as a steward on a cruise ship, as the driver of a school bus, as a language tutor, and intermittently as a jobbing gardener.

During a course in life drawing (for which he has a mild talent) at the Art Institute, he makes the acquaintance of a man who works as a guard at the Prado. There are vacancies on the staff, the man says. Since he likes art maybe he should apply. The job is not demanding, and there are always pretty girls passing through.

He applies, passes the test with ease, and accepts a position as *vigilante de sala*, his duties to commence on 1 July. He finds the

work congenial, likes his colleagues and is liked by them. For him, winter afternoons are the best, when the sun goes down early and the galleries are almost empty of life, save for the paintings.

He has found his niche in life, he reflects, the niche prepared for each of us by a benevolent Providence, if we can but find our way to it.

In June of 2019, on duty in the Goya rooms, he observes a woman in black seated before the painting by Goya known as *The Third of May 1808*, depicting citizens of Madrid being executed by a French firing squad. All afternoon she sits there; when the bell rings for closing time she stands up and, moving swiftly for someone of her age – she is in her late sixties, he estimates, perhaps even older – disappears into the crowd.

The next afternoon she is there again, seated this time not before *The Third of May 1808* but before the drowning dog. From a distance he studies her. She sits with her back straight as a ramrod, her eyes fixed on the canvas, like an antique photographic apparatus.

It is a hot day. He takes a seat beside her and, without a word, holds out a bottle of water. Without a word she takes the bottle, unscrews the cap, has a long drink, and returns it.

'You are well?' he says in English.

'Yes, I am well,' she replies in English. 'Thank you.'

The museum has no particular policy on fraternization between its staff and members of the public. There is no reason why he should not offer a drink to a visitor from abroad, no reason why he should not show concern on a blindingly hot summer's day. So they sit companionably side by side until it is time for him to recommence his perambulations.

On the third day she is again there. He offers his identity card for her inspection. 'That is who I am,' he says. 'I am a guard in the museum but I am also a human being.'

There is a studied silence between them.

'I too am a human being,' says the woman. 'Well met.'

Well met. His English is good, but whatever nuances *Well met* carries are not familiar to him.

'Goya has a meaning for you?' he says.

'A meaning? Yes, he does have a meaning. In a complicated way.' Her voice is firm, her entire bearing firm, considering her age. So if she chooses to spend her time sitting in the Goya rooms, it must be for reasons of her own. There is no need to be concerned for her further.

'Do you want me to tell you about it – about that meaning?' she says, and gives him a smile, not what he would call a friendly smile, but a smile nevertheless. She does not wear glasses. Why did he not notice that before? Her eyes, the pinholes through which she draws in the world, are naked, unprotected. As for him, he has worn glasses for as long as he can remember.

'The meaning these paintings have for me – do you want to hear about it?' she repeats. 'Since you asked.'

He rises, bows formally. 'Madam,' he says, 'I regret, I have duties.' And retires.

Are such men as José Eduardo (Pepe) still to be found in the Madrid of today? Yes, apparently so.

II

He sees her one last time. He is about to leave at the end of his shift when he spots her sitting alone in the museum café. She sees him too, nods in his direction. He makes his way to her table, greets her. 'This has been a good day for you? You are a regular visitor to the museum, almost a citizen. We must give you a passport like mine.'

'Have a seat,' she says. 'I know you are curious. Do you want to hear the full story? Why I am here, why I am almost a citizen of your museum?'

He nods cautiously.

'I first visited the Prado in 2008. I came with my husband. He and I were not on particularly good terms, but we were on vacation, stuck with each other, so we made the best of it. Portrait of a marriage. Are you married?'

'I? No.'

'Ever been married?'

'No.'

'Interesting. My husband wanted to see the Goya paintings. I left him to Goya while I went exploring. When I returned he was in a black mood, not wanting to talk. We spent the rest of the day in silence. The next day, following our schedule, we drove south to Carboneras, where we had reservations at a hotel. My husband announced that he was going for a swim; I stayed behind, resting. One of the beaches near Carboneras is called *playa de los muertos* – you probably know it. Despite the name, it is a perfectly safe beach. My husband swam out to sea and, according to the police record, drowned. In English we say drowned but we also say drowned himself – the meanings are different. I don't know how it is in Spanish. The fact is, he swam out to sea and drowned himself. He was not a strong swimmer. He would not have ventured so deep if he had meant to come back.'

The café is emptying as the last of the day's visitors leave.

'I am still trying to understand what was going through his mind,' she says. 'To drown oneself in order to escape a wife one has ceased to love – that seems an excessive act. I am not an easy person to live with but I am not intolerable, I do not poison existence.'

Poison. *Veneno.* The erect posture, the even tone, the hands flat on the table before her (no ring, no adornment): he gazes at her intently, trying to imagine what it would have been like to be married to her, or a younger version of her. In himself, in his physical being, he can detect no tug of interest. She is not his type, it is as simple as that (though where on earth is his type to be found?).

'I fail to see,' he says . . . 'I fail to see several things. First, I fail to see why you are telling me this story when I am no one to you. And then I fail to see what your husband's death has to do with the Prado. But it is closing time, time to leave.'

'Allow me to finish,' she says, and offers him a second smile, and lays a hand on the sleeve of his jacket. 'All will become clear. I promise.'

They sit side by side on the warm steps outside the museum entrance.

'You are the man who watches over the Goyas, the *vigilante* of the Goyas,' she says. 'All day you are with them. They must surely have seeped into you, into your blood.'

Have the Goyas seeped into him? He does not know. He does not think so. It is purely by chance that he was assigned to the Goya rooms for the month when this woman – whose name he still does not know – chose to make her visit.

She leans closer, speaks in a low voice. 'I am haunted by the vision,' she says. 'The years pass but the vision will not fade. The sunny beach, the placid water, the man wading out . . . What was going on in his mind? Was it an act of revenge, a plan to leave me with a burden of guilt and remorse? Do you understand? Or did he die because of something he saw in Goya? Are there people on whom Goya has that effect? What do you think?'

Are there people on whom Goya has the effect of making them drown themselves? Is he, the makeshift Goya expert, expected to give a pronouncement?

'Did your husband never speak to you about Goya?'

'We were not speaking, he and I, by the time we arrived in Madrid. That is to say, we were on polite terms but we had ceased to speak about anything of importance. It happens in some marriages. The shutters are closed and never open again. You are not married therefore you will not know.'

He ignores the provocation. 'You know the painting of the dog in the sea?'

'Yes.'

'You know the history of the painting?'

'I know that Goya painted it in his later years. I know that he gave it no title, so we don't know what dog it was or why he chose to paint it. I know that he painted it directly onto a wall in the house he occupied. What else should I know?'

'We look at this painting and we think the dog is going to drown.'

But according to one story, the painting we see is incomplete. Part of it was never transferred from the wall of the house because it was too fragile. And now that part is gone. Vanished.'

'Yes?'

'According to that story, the vanished part showed a bird in a tree. The dog was looking up at the bird. That is all. That is the story.'

'So you say the dog was not in the vastness of the ocean, drowning. If Goya had painted a second panel, it would have shown the dog emerging from the water, shaking himself dry, and barking at the bird in the tree.'

'Maybe. It is only a story. We do not have to believe it.'

'But the fact is, we do not have the second panel, the panel of the bird on the branch and the barking dog, the panel of salvation. We have only the dog amid the waves. We have only what we have. We do not have what we do not have.'

Silence falls between them. The warmth of the sun, stored up in the marble, steals into his buttocks and thighs. A true pleasure, even if the price to pay is to share it with an afflicted stranger and wonder how to bring their conversation to an end.

'That is all I can offer,' he says: 'the story of the bird. As for the dog, I see him every day, in my work. Is the dog drowning? Is it not? I do not know. But believing the dog is drowning would not make me go into the sea and drown myself. Certainly not. Of course I am not your husband. We are all different.'

'What – may I ask? – would be enough to make you go into the sea and drown yourself?'

Suicide: it seems a very intimate matter to be discussed between strangers on a summer afternoon. He has never contemplated killing himself, never given it a moment's thought. He loves life. He would like to live forever, if that were possible.

He thinks of the lost husband, the man on whom this woman had closed the shutters, thinks of him stepping out into the sea, ducking his head under the first wave, drawing the first breath of seawater into his lungs. *Playa de los muertos*. So simple. So easy to do. Yet few of us

do it. Why not? Because we love life. Because we want to live. To live! Like the dog in the painting, swimming, not drowning. Swimming for its life. Like the bird in the tree, singing.

'You are new in the museum, are you not?' she says. 'I can see that. It is not your life's work, protecting paintings from vandals. Or from people like me. Let me tell you, we are many – not the vandals but the crazy people. You will have to get used to us.' She pats the sleeve of his jacket. 'You won't see me again, you will be relieved to hear. Tomorrow morning I catch a train and then a bus to Carboneras and the fatal beach.'

'You miss your husband. You must have loved him, despite all.'

'Loved him? I don't know. Perhaps. Perhaps not. What counts in the end is not what you feel in the depths of your heart but what you are prepared to give. If I had given my husband more, would he have walked into the sea? I doubt it. But just as you are not an expert on Goya, I am not an expert on love. He found me oppressive. An oppressive presence.'

If she expects more from him, if she wants to hear him say that he cannot imagine how any man could find her oppressive, she will be disappointed. It is time to free himself. Enough of exposing himself to the intimacies of a stranger's heart – a rather cold heart, so it seems to him. Something distasteful in the whole business of confidences, of telling your secrets to strangers. He rises. 'I have a bus to catch,' he says, 'I am sorry, but I cannot help you further.'

III

At the pedestrian crossing on Calle de Serrano he halts, waiting for the light to change. A shiver passes through him. *Like those witches in Goya*, he thinks. *Or like the other three witches . . . What is their name . . . The ones who cut the thread of life.* The light changes to green. He steps off the sidewalk, straight into the path of a scooter ridden by a young woman. The scooter strikes him at hip height, veers off into the traffic. He stumbles and falls, striking his head on the tarmac.

His glasses shatter. *Clotho?* he thinks. *Atropos?* Then everything goes black.

The crowd is, for the moment, less concerned for him than for the young woman on the scooter – in fact not a young woman but a girl of sixteen – who by some miracle stands unharmed in the center of the wide avenue, white-faced, cars whizzing past her on either side. As for the scooter, no one cares, it can be junked. The girl is saved, that is what matters. She will be reunited with her parents, what could have been a tragedy has turned out well.

There is a long wait before an ambulance arrives to convey the man lying on the sidewalk to the hospital La Princesa, to *Urgencias*. By the time he gets there he has recovered consciousness and is speaking rationally. His injuries seem to be minor: facial bruising, a gash where the plastic frame of his glasses embedded itself in his cheek, a wrenched knee. He is kept overnight for observation, then at his own insistence allowed to take a taxi home.

Forty-eight hours later he is back, hobbling on a cane, accompanied by his mother's cook-servant (his mother is away in the East): he is complaining of headaches, says the cook, also behaving out of character, shouting at her for no reason, refusing to let her touch him, refusing to eat.

He is readmitted to the hospital, where further tests show that his injuries are more serious than they had at first seemed. Specifically, he has suffered a degree of trauma to the brain, to the prefrontal cortex, which will in all likelihood involve him in lengthy – perhaps lifelong – rehabilitation.

His mother cuts short her travels to visit him at La Princesa, then has a private consultation with the resident neuropsychologist. The upshot: her son is released into her care and moves back into the apartment in Salamanca, pending news that a place should open at the nursing home in Hortaleza recommended by the medical team.

Back in Salamanca, she finds her formerly easygoing son a changed person – moody, irritable, stubborn in his demands on her and on the household, difficult to live with.

'Surely he is well enough to go back to the museum,' she remarks to the therapist who visits him twice a week. 'It is not demanding work, it will do him good to be among people again.'

The therapist shakes her head. 'Too soon for that,' she says.

At last there is a call from Hortaleza, from the nursing home: there is a vacancy for her son, but she must make up her mind at once, there is a waiting list. 'I accept,' she says. 'We will be there first thing in the morning.'

Thus José (or Pepe) moves from the comfortable old apartment in Salamanca to the much less comfortable facility north of the city in Barrio Palomas, where the gray wall of his compact little second-floor suite (bedroom, bathroom, storage recess) is relieved only by a framed picture of two kittens playing with a ball of wool. He spends his first days sitting motionless in his room staring out of the window, which looks onto a wooded park, his heart full of resentment against his mother for what she has done to him. When she comes on her first visit he refuses to see her. At meals he holds himself apart from the other patients.

The only person he gets along with is the physiotherapist. He tells her long-winded stories about his prior life, in particular about his career as a *vigilante* at the big museum; he shows her the pass (which he has retained) that allows him access to all the museum facilities. Of the accident with the scooter on Serrano he has no memory at all, but he vividly recalls the old woman in black who sat in the Goya rooms like a spider waiting for her prey, who captured his mind (his good mind, as he calls it) and consigned him to this purgatory.

IV

M onths pass, his condition improves steadily if slowly. He forms a bond with one of his fellow patients, a woman younger than himself. Is it love, a love-bond? he asks himself. He is not sure. But when he and she (her name is Rita) sit together on a bench in the park (they have a favorite bench), holding hands, enjoying the cool of the

breeze, the smell of cut grass, they might as well be lovers.

Rita too has to hear from his lips the story of the woman in black from the Goya rooms: Clotilde is the name he attaches to her, an ugly name. Together they take the Metro to the Prado – his pass is still valid, he and his guest are waved through – where he points out to her the very seat where the woman in black sat waiting for him to arrive and fall under her spell.

Rita is not a child – she is in her thirties – but she wears simple, childish outfits – white blouses, gray skirts, sensible black shoes – that do not flatter her figure and mark her as strange. As for him, he has new glasses that make his eyes look like pebbles at the bottom of a pond. Do they strike people as a strange couple? He does not know, does not care. Madrid is a big city. There are thousands of people in Madrid stranger than him, stranger than Rita, stranger than the two of them together.

He used to read a lot in the old days, but he no longer reads: there is always something flickering in his mind, he cannot concentrate, cannot recall what happened two pages ago. Nonetheless he takes Rita on a visit to the stalls on Cuesta de Moyano where the book vendors unpack their wares. At the very first stall his gaze is arrested by an image on the cover of a book: the woman in black, the very same, gazing coolly into the camera lens.

Cuentos escogidos, the book is called, selected stories, and the woman's name: Elizabeth Costello. 'That is who it was!' he hisses to Rita, drumming with his knuckles on the book. Fury overtakes him, coming out of nowhere, like a summer storm.

'Hush,' says Rita. 'Hush, hush, hush.'

He buys the book; as he hands over the money he notices that his hand is trembling.

On the train back to Hortaleza, Rita pages through the book. 'Look,' she says: '*El vigilante de sala*. Maybe it is about you.'

He tries to read the opening paragraph of the story, but the motion of the train and his declining eyesight make reading impossible. They have to wait until they are back at the home. There, sitting side by

side with him on the bed in her room (where the framed picture on the wall is not of kittens but of Muscovy ducks flying in formation), she reads aloud to him the story the woman has written about the *vigilante de salas*.

V

S he (*ella*, her proper name is never divulged) is standing before a painting in the Prado, sunk in a familiar, pleasurable state of contemplation that may ultimately be the reason why she visits exhibitions. Searching in her mind for something to which to compare that state, she fixes on a memory of herself as a child of six in one of those Greek milk bars that have now vanished off the face of the earth, solemnly absorbed in a chocolate sundae, rapt, immersed in the flavors and textures, wishing for it never to end, this private experience, while her mother in memory smiles benign approval. So she stands, lost in the past, when a voice speaks close behind her, in a rasping English: 'Horrible, no? Such a pig-man!'

For a moment she cannot believe she is the one being addressed. Frowning, she turns and finds herself face to face with a dapper little man in the uniform of a museum guard.

'*Perdone?*' she says as frostily as she can.

'It is an early painting,' says the man, not at all diminished. 'From when he was a fashionable artist. Francisco Goya. When he painted country scenes for his patrons.'

What puzzles her is that the man speaks as if there were some kind of accord between them, as if she had hired him to provide a commentary on the paintings, a task he is now cheerfully performing. Is it possible that he is not a real guard, despite the uniform and the badge, but some impudent scamp scouring the museum, touting for custom?

'Always he is on the side of the woman,' the man pursues, and this time his words reach her with a gust of fishy breath; he must have had *bacalao* for lunch, washed down with a glass of wine, that would

explain his conduct, *forward* conduct as people used to say. 'Goya,' he repeats, as if she is thick-headed, as if everything has to be explained to her twice. 'Always on the side of the woman.'

Goya on the side of the woman? She knows the late paintings better than these early country scenes, but she can think of many women, countesses among them, on whom Goya turned the cruellest of eyes. She would not have liked to sit for Goya. Would never have consented, in fact. Would have had to be dragged into position, as if to the executioner's block. An age of executions, Goya's age. For the masses, a new-found pastime. Starting in France. Carts full of aristocrats in their beshat finery rumbling toward the fatal site, unable to believe what is happening to them. *Pray for us now and at the hour of our death.* France and then Spain. Lining people up – *Stop moving. Stand still. Face forward. Bang.* Shoot them in the breast, in the groin, in the face, wherever it pleases you. A shooting gallery. Disasters of the war.

She turns away from the cheeky fellow with the fishy breath. When she looks again he is, thank God, gone.

Was he trying to pick her up? What nonsense! Seen from the outside (she has never had difficulty in seeing herself from the outside, seeing things from the outside is her business in life, as it was Goya's) she is about as unappealing as a woman, a member of the fairer sex, can be. Too old, too weather-beaten, too grim. So what did he think he was up to? Was he trying to offend her? To insult her? Does he roam around the museum in a half-drunken state, insulting visitors at random? Why do the guards permit it, the real guards?

Or perhaps he is a madman, straight out of the world of Goya, someone who gets up in the morning and dons his museum-guard uniform and sets off for the Prado to make a pest of himself. Or an actor – an actor paid to drum up custom for the museum by acting like a Goya madman. But does such a venerable museum really need to hire actors to advertise its wares? Are the fine arts really descending to that level?

She is in the café on the ground floor, an hour or two later, when he makes a second appearance. Without a word of invitation he sits

down at her table. '*The Wedding*,' he says. 'We were discussing the unequal marriage we see in *The Wedding*. By Goya.'

'Leave me alone,' she says, quietly, levelly. 'I don't want a scene, but if you do not leave me alone I will call the authorities. *Llamaré a las autoridades.*'

'The man in the picture, he is a pig-man, but he does not see it,' the guard, true or false, presses on, ignoring her words. She is beginning to get a feel for the variety of madness confronting her: not only does the man have no conception of who she is, he also does not care who she is, she can be anyone at all, picked out at random, anyone at whom he can direct this flow of words. 'He does not see what we see. What do we see? We see he resembles a pig, repulsive. Goya is not a subtle painter, no? So this young woman in the painting, she is marrying a pig.' And then, without transition, in the same insistent drone: 'I know who you are, madam. You are a famous writer visiting the Prado to see the paintings. You come for the paintings and you get me. So tell me' – he pushes his face forward for her inspection, rotating his cleanshaven chin from side to side – 'am I a pig? A pig-man? No, I am not.'

There are, of all things, tears welling up behind the thick lenses of his spectacles. How is one to understand what is going on in his afflicted mind? He is not the pig-man, he says. It makes him cry when people call him the pig-man, he who does not resemble a pig, or only a little.

'Is this true?' says Rita, setting aside the book. 'Is this man you?'

'No, no, no!' says he, Pepe, retired *vigilante*. 'It is a story! She is making up a story!' He clenches and unclenches his fists.

Rita turns back to the book of stories.

She (*ella* again) lays a soothing hand on the man's arm. 'You are not a pig-man. No one would say you are a pig-man. Will you tell me what this is all about? What has happened?'

From an inner pocket the man produces a clean white handkerchief and blows his nose theatrically. 'So I must tell you the story of my life, that is what you demand. Like Sherlock Holmes. You

sit in a train and a stranger, a man you have never seen before, tells you his deepest secrets. He is a murderer, he tells you. Or he is a bank robber. Then the train arrives at its destination and the murderer, the bank robber, the man without a name vanishes into the smoke and you never see him again. But you are Sherlock, you have his story, that is all you need. You rush home and take pen and paper and write the story about how you sat in the train and a stranger came up to you and told you his secrets and then vanished. Yes? You have the story, but now you see it lacks an ending. Where are you going to find an ending, if you are Sherlock? Where? You tell me.'

He sits back, folds his arms, regards her. No trace of tears. Tears all gone.

'First,' she says, 'Sherlock – the famous Sherlock – was not a writer. He was a detective. And not a real detective but a made-up one, a character in a book. So let us get Sherlock out of the way. Sherlock is not relevant.

'Second, the man in the train confesses his secret. He tells Sherlock he is a murderer, then disappears into the fog, as you say. He has achieved his purpose. What was his purpose? His purpose was confession. Having confessed, he is liberated, he is a free man, he has rid himself of an overwhelming burden – so he believes. But you, *señor vigilante*, you are not confessing. You are not revealing any secrets. I do not correspond to the Sherlock of your story. I am just a woman you accosted here in the museum.'

'You think I have no secrets?'

'Of course you have secrets. We all have secrets. But you do not have a big secret. You are not a murderer. I can see that. You are not a bank robber.'

'I am the pig-man. In the painting, I am the pig-man.'

'I don't understand this pig-man thing. What exactly do you mean by a pig-man?'

'He marries the girl. That is what the painting shows, how the pig-man marries the girl.'

'And?'

'He marries her but she does not want him. She is young and beautiful but he is a pig.'

'So?'

He does not answer. Rocking lightly back and forward in his chair, his arms still folded tight across his chest, he confronts her with his face, his unexceptional human face.

She stands up, slings her bag over her arm. 'I don't want to hear the rest of your story,' she says. 'I don't want to hear your secrets. I don't have the time. Find someone else to tell them to.' And she leaves.

VI

R ita closes the book. 'That is how it ends?' says he, Pepe. She nods.

'It is a lie from beginning to end. Nothing in it is true. Do you believe me?'

She nods again. 'Of course. It is just a stupid story.' She reaches out and lays a cool hand on his brow. 'Do you want to keep the book or shall we throw it away?'

He takes the book from her and, with a single great effort, tears it in two lengthwise, cover and all.

She takes the halves from him and tosses them into the basket. 'There. It is gone. We are free again.' ∎

ACKNOWLEDGMENTS:

My thanks to Valerie Miles, Sheila Loewe, Francisco Tardío and Alejandro Vergara Sharp for advice and information.

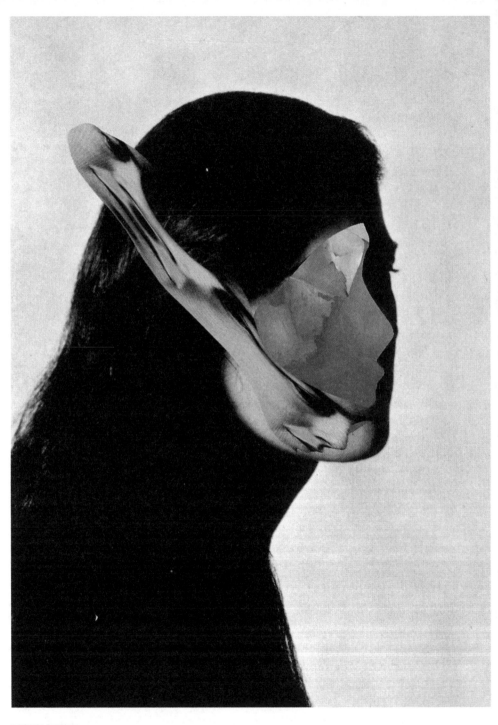

ERNESTO ARTILLO
Susan Sontag, 2016

PRIVATE VIEW

Sophie Collins

John and I met at the opening of a group show in Whitechapel. He was both an artist and a curator. He had recently been interviewed by a high-profile critic for the *Financial Times* and was becoming a recognised figure in the art scene. He'd been organising packed events since his first year at university, pulling together work by a number of fêted young artists in exhibitions staged in post-industrial spaces, in anti-squat buildings and shuttered, dilapidated shopping centres.

I wasn't aware of any of this at our moment of meeting, which took place in front of a portrait of John. The artist – like several of the others in the show – was a school friend of his. The painting, in which John occupied a dark, high-back armchair, had the swollen dimensions of Parmigianino's *Self-Portrait in a Convex Mirror*. The style reminded me a little of the American painter Alice Neel, but I didn't say that. Instead, I said that his – John's – thumb, indecently plain and out of proportion in the painting's foreground, resembled a flaccid penis. John smiled then, asked who I was with.

I looked him up on the internet when I got home, coming across the piece in the *FT* first. Heading the short text was a landscape photograph of John's face and shoulders, which were partly in shadow, his coarse hair flat against his scalp, the bow in his narrow lips cast into dramatic relief by the lighting. I found a longer profile

of him in an exclusively online journal. Poorly written, it spoke of the way in which John's work brought together 'architectural concerns and virtual reality as a means of merging the real and the imagined'. 'The relative emphasis assigned to the relationships between each of these elements,' it continued, 'depends on the viewer as well as on his or her presence.' I couldn't parse it. The other significant artefact was a quick-fire question and answer session on YouTube. Throughout the video, filmed outside Stockholm's Moderna Museet, John, dressed in a button-down and chinos, was pulling, between responses, on a slim roll-up. A woman – French or Spanish or Italian, I couldn't tell – was conducting the interview, laughing forcefully at most of his answers, apart from those whose tone requested a different sort of reaction. '*Wow*,' she said at such moments, the way you might to a child showing you a new toy. He would furrow his brow then, glance down, ash his cigarette. I watched the video a few times, wondering what he was thinking.

I was relieved whenever I reached the end of the clip and found that it had done nothing to shatter my image of John, now part constructed in retrospect.

Our first date was at the Coach & Horses in Soho. John listened closely as I spoke about the writing I was working on, and, without taking his eyes off the table in front of him, said that it made him think of Susan Sontag's *Death Kit* – 'Her second novel, I think.'

I told him I wasn't overly familiar with her work, that I'd only read one or two of the essays for my undergraduate seminars. I had recently realised, after years of pretending to have read or seen things I had not, that being as specific as possible about any gaps in one's knowledge had the counter-effect of making you appear sufficiently informed. It was a trick I had noticed men deploying not only in private conversations, such as the one I was having with John, but in their writing as well – and not only in relation to their cultural consumption. The cleverest ones were attuned to, were endlessly articulate on, the subject of their own interpersonal shortcomings.

I did not yet know that John's tactic – the hasty provision of references, of names and titles in lieu of personal, subjective responses – was yet another method of obfuscation.

The synopses of Sontag's novels and short stories I later uncovered online made them sound dire. As uncertain as I was of my judgements back then, it appeared clear to me that they employed experimental narrative techniques as a means of plastering over Sontag's lack of feeling for fiction – revolving, as they did, around so-called unreliable narrators and otherwise flat characters defensively styled as archetypes.

So, John had been correct; in this respect alone, Sontag's fiction sounded a lot like mine – or what it might have become, if I'd pursued it then. The comparison with Sontag is interesting also in that it now furnishes me with some key information regarding John's first impression of me: superficially over-serious but fundamentally childlike. An open wound, in other words.

What was my fantasy of John? Meeting him, pursuing our relationship – it all seemed preordained. I loved John and, most of the time, early on, felt that he loved me too. But the beginning of our relationship also felt like a negotiation, like a setting-out of terms, which, being young and in awe, I had eagerly agreed to. I did not yet know that their flouting was something that I could – and would – be pulled up on.

'I never want to be one of those couples,' he had said, 'arguing on the corner.' Meaning: *Never dispute me in public.*

'I need my space, a lot of alone time.' *My needs will supersede yours.*

I met his friends. I met Jude, his older sister. We went to dinner, to events: gallery openings, screenings, book launches. The adult life I had envisioned began to take shape, all at once. Being recognised as part of a couple thrilled me; I felt legitimised. John had a life, a full life. He had immediate and extended family, people he had known since childhood, school, university. I was surprised to discover that he found it all quite stifling. My own upbringing had been rootless,

what with our various moves and my mother's long and definitive estrangement from her relatives. I suppose you could say that I was unencumbered – I think that might have been John's word.

One friend of John's had dubbed me 'icy'. John told me so with relish, pronouncing the word in a way that made it sound more 'enigmatic' than 'frigid', more of a positive than a negative. He sounded impressed, and I understood something then about the kind of partner John wanted to be seen with: someone cutting, that was, someone a bit unusual. And yet, someone malleable. Someone whose eccentricities would generate interest that would ultimately divert back to him. ('Where is she from?' 'Where did he find her?' 'Young, isn't she?') I began to believe that this was what I wanted too.

I had been consumed by other men before, but never in combination with an equity of interest. While we were dating, John would never drop out of contact as those other men had, would never return to my inbox to creepingly ask whether our arrangement could be made, or might remain, 'casual', 'low-key'.

He had just been through a break-up when we first met. We ran into his ex early one morning near his flat in Brixton as he delivered me to the Tube. Isobel was John's age – older than me by almost ten years – and well put together. I eyed her coat and haircut as she and John exchanged a few words. On his failing to make introductions, she shot a curt hello at me, which felt less like a greeting and more like a swipe at John, before flicking her eyes back to him and arranging her face into an expression that I now know to have been incredulity.

'I knew that would happen,' John had said, wincing, as we'd moved off.

I looked Isobel up on Facebook and spent too long assessing what I could about her and John's relationship by tracing the nature and frequency of their public interactions.

John and I had already started to argue by this point, though always in private, our whispered, tearful reunions only consolidating our bond.

'I've never met anyone like you,' he said once, after a particularly wrenching falling-out.

Two months later, we were married.

The wedding took place in London. Not long after, we moved to Cork; later, to Edinburgh. The moves to Ireland and Scotland were made to follow John's work. I'd recently begun a PhD based in England, in Sussex, but I could be more or less anywhere for the duration. The only thing I would miss out on was the teaching experience typically offered to doctoral students entering their second year of research.

John had studied at Central Saint Martins and the Slade. There, he'd worked on large-scale installations, which had evolved into virtual-reality experiences, subtle engagements with new technologies that soon gave way to more sensational outputs. In one of these, a piece titled *Hold Your Applause*, viewers were invited to watch from all angles as structural fires erupted at some of the world's best-loved monuments and museums, and they burned to the ground in real time – the Sagrada Família, the Anne Frank House, the Met, Notre-Dame . . . *Applause* was described in commentaries as an act of desecration akin to Ai Weiwei's *Dropping a Han Dynasty Urn*, an artwork said to be geared towards challenging the audience's cultural values. Following criticism from political leaders, however, as well as an incident in which a gallery visitor stamped on one of the VR headsets, destroying it, the piece was retired.

After we were married, John put his own art practice on hold to focus on curating. With his connections to other young artists and his specialism in VR, he'd hit a rich seam in the eyes of the gallery directors. He wanted to reclaim the gallery space, he said in interviews, to progressively 'withdraw' it from the 'clutches of good taste and self-censorship, political correctness and virtue-signalling'. But having initially enjoyed the notoriety his public image had elicited – furthered by articles with titles such as 'John Munro: Is Edgelord an Insult?' and 'John Munro Does Not Like People' – he was soon keen

to shake off the iconoclasm that had earned him the attention of the major gallerists. In truth, he'd been spooked by the controversy his work had generated. I knew it, though he'd never put it into so many words. *Applause* had been borne of a love for architecture, he'd insist in interviews, the piece's title wholly ironic. He'd worked through endless technical drawings to produce it, to calculate exactly when Gaudí's towers would drop, at what point Lassus's rose windows might burst. Eventually, the line took, and things quietened down, the write-ups now stating that, although no less impish, John's outlook should not be dismissed as mere trolling. This was evident in his present interests, which were 'much closer to home'; he was studying the Classical Revival, and the influence of the British eighteenth-century architects James Gibbs and Robert Adam on contemporary life. 'Such an incredible draughtsman,' he would repeat, whenever he showed me images of Adam's work. I liked the images, though they didn't move me as they did John. We both enjoyed the work of Alexander 'Greek' Thompson, however, a pioneer of sustainable architecture in Glasgow. John had grown up in Scotland and had always wanted to 'get back up there'. When he was offered a job at a gallery in Edinburgh, he was happier than I'd ever seen him, and I felt hopeful.

I felt hopeful for myself too: I had just published my first academic article and soon after received an invitation to speak to students at Oxford. The soliciting lecturer had made much of placing me in New College's old quarters as opposed to a hotel. It had been blazing hot throughout my stay. I'd felt out of place in the college gardens, among the younger students, and so I'd walked further into town, towards the shops and the Ashmolean Museum.

Inside, the lofty, air-conditioned space had been a respite from the day's sun. I'd found the Italian Renaissance gallery and stationed myself in front of an early landscape, enjoying the feel of the smooth wooden bench on the backs of my legs. After a while, I'd drifted down to the gift shop, lingering by a display wall of postcards, listening in to the conversations taking place around me. Shortly, I was approached by a man. He was younger than John, nearer my own age. He had

noticed me upstairs, he said. Could he ask me about the painting I'd been looking at? Unsure of how to put him off, I allowed him to buy me a coffee and to talk for a while before excusing myself. 'I've got to meet my parents,' I told him, smiling, moving to leave, my limbs suddenly weak and heavy. 'It was nice speaking to you.'

Late the following day, after my talk, I took a coach and then a small plane back to Cork. I remember watching the toy-like propellers starting up through the window, the stewards turning the lights down for take-off, and then the feeling of hurtling through the dark, of being delivered back.

Life in Cork lasted three years. Once we were installed, John alternated between phases of self-isolation and something more obdurate, an anger that became the weather in which I lived. We rented a terraced house in Montenotte, a district sensationally named after a Napoleonic battle that took place in the Apennine Mountains. Located on a hill overlooking the River Lee, the area to the north of the city was sharply elevated and populated by lush trees. It had the feeling of being its own village, with its pub, post office and coffee shop, with its lone bus stop from which a trail of residents – all waiting to be ferried into town – would slowly build and diminish at intervals.

John returned to England every two months or so, sojourns in which he would attend openings and hold meetings with artists. These departures were marked by a sudden upswing in mood that was at once relieving and disconcerting. After he had packed, John would seem both impatient to leave and strangely tender, his attitude towards me softened. 'I'll miss you,' he would say, as he waited in the hallway for a taxi to the airport. 'I love you.' 'Me too,' I would reply. 'Me too.' I rarely heard from him while he was away.

Aside from my research, there was little for me to do, and so during the daytime I would either take up in the kitchen or work on my thesis from a small desk I'd tucked into a corner of the bedroom. From there, I could see clearly the sage-green house on the corner opposite, the stuffed tiger in its ground-floor window whose presence

I had chosen to take as a good omen when we'd first come to the street for a viewing.

Every now and then I would head out to the Triskel Arts Centre for a film, for a coffee on the Grand Parade. I would walk, making my way via Shandon, pausing there to look at the finer homes on Aubrey Place and the view they shared out over Bell's Field, a stench of malt emitting from the industrial brewery across the motorway.

I endeavoured to make friends, but none stuck. I felt alien. When he wasn't away, John stayed in most nights, drinking a bottle of red, sometimes two, by himself. Inevitably, this would lead to his rounding on me. 'What do you think you're doing?' he would ask me, his face flushed, contorted, his eyes unseeing. 'What are you doing here?'

When he was forced out for work – for a private view or some other event at the gallery – he was so affable with his colleagues and acquaintances, with the strangers we were introduced to, that I felt mad, senseless, obliged to play along. I realised then that I was the outlet (the only one), that it was through me alone that John could siphon off his resentments, his frustrations. That, in this sense, I was a vital part of his life.

I began waking in the middle of the night, usually at around two or three o'clock. At that hour, I would move slowly downstairs and occupy the sofa that divided the open-plan living room and kitchen. I would snack on things that could be prepared quickly and quietly. I would read or watch the films I thought John would otherwise prohibit. I had lately become taken with notions of purity and its soiling, a preoccupation whose focal point was, for some weeks, Pauline Réage's *The Story of O*. I came across the book in a charity shop in Cork city centre, a cracked black paperback decorated with a spare, italicised font dubbing the novel 'The Erotic Classic'. I was immediately struck by its use of the present tense, by its swiftness and inscrutability. Within the first three sentences, O, the title character, is ushered into what looks like a Paris taxi, though René, her lover, doesn't say a word to the driver. 'Here we are,' he

announces, simply, after a short journey in which O has obediently removed her stockings and underwear on René's instruction. They are outside a château. O is led inside and heavily made up by two other women ('her mouth very red, the point and halo of her nipples rouged'), after which she submits herself to the sexual predilections of a secret society. She is flayed. She is manhandled and chained to the château's walls for hours at a time. She is penetrated by one man after another in regular orgiastic sessions. René looks on. During one such session, an associate has difficulty entering O and demands that she have her anus stretched, which she does (after René approves the modification), in increments.

O's story fascinated me. In her ostensible debasement was an obscure victory that filled me with competing desires. I was turned on, I was repulsed, I was fascinated, I was exasperated. I was judgemental. I was many other things besides. I couldn't have named all of the feelings I experienced in response to these narratives. To name them would be to flatten and domesticate them. To attempt to situate them within a system to which they never belonged. What I remember most clearly, in any case, is my coming to when I would stop reading, when the room would brighten in time with the sky outside, and I would readjust to my surroundings, albeit with the feeling of having participated in a long and drawn-out purgation.

It was during these wakes that I became aware of John's emails to a photographer he'd met at a party in London. Joanna Kolasinski. I liked her work. Most of the images on her website were self-portraits, underdeveloped film photographs in which she struck enigmatic poses, gesturing stiffly with her hands and body while her face maintained a seductive, stoic expression. Her most recent series featured the artist posing as a dressage horse in various set-ups: in a cluttered artist's studio; on an upturned skip in a parking garage; on an MDF plinth, in a field, her long hair pulled into a tight, knotted braid; between the swings in a children's playground.

Her tone with John was light, friendly, to begin with: *this you?* read the subject line of her first dispatch. Mainly, the two of them

discussed art and films and music, much of which I had never heard John mention before. But Joanna soon became more sincere, her abstractions more directed. *I enjoy our conversations* . . . she'd added dreamily, just before signing off, at the end of her third or fourth email.

It was something John had said to me that had planted the seed, sent me looking. We'd been watching a film, which he had chosen and which he had liked, because the plot confirmed a theory of his regarding accusations as self-fulfilling prophecies. If you accuse someone of cheating, John had contended, by way of an example, they would most likely cheat. Why? Because they felt they were already paying for the crime; they might as well commit it. I checked John's inbox every morning after that. Once the initial horror had subsided, I experienced a new affect, a merging of relief and disappointment, when there was nothing new to read. By true morning, the correspondence felt like something I'd made up.

The exchange had ended abruptly when Joanna mentioned that she might be in Ireland for some location shooting in a few months' time. Should they try and meet for a drink, she wondered. *It's my wife's birthday around then,* John had replied, introducing – too suddenly – a newly formal register. *It's likely we'll be away.* Joanna never responded to that non sequitur, and I allowed myself to forget, for things to still.

I was sure there'd been others. I knew there had been, in fact. Another woman, back in London, before John's first proper job and the move to Cork. I had chosen to forget her too. She was a friend of his, and had been staying with us, having briefly returned from a new life in France to collect some documents from storage and catch up with friends. Weeks before I understood what had taken place (a realisation that dawned long after her departure), she came into my office and asked whether I could help her with something. Of course I could. She'd wanted to put an old nose piercing back in. I had offered her a seat at my desk chair, and she'd handed me the small silver stud. I'd tucked her hair into the scarf she wore around her head in the mornings and found the tiny indent, trying the stud gently at first. The hole had closed over. I'd said as much.

'Just push it,' she'd said. 'Don't worry about hurting me.'

I'd done as she'd asked, and she'd looked up at me then, her eyes red and watery, her expression one of tempered exhilaration.

When I confronted John, on a sudden notion weeks later, he was stunned into silence. Finally, he conceded that she'd made a pass at him while she was staying, and that, yes, he'd given in, for a moment, having had a drink, but that he had quickly gathered himself and rebuffed her. I pressed, but I was never able to get any more out of him than that. He told me, further, in tones of reassurance, that she was 'damaged', a word that recurred with notable frequency in his accounts of younger women.

I think I agree with John's speculations on infidelity as a self-fulfilling prophecy, incidentally – only, it seemed to me that John had always been the one to accuse himself. He behaved as someone pinioned from the outset. He had the posture, from the moment I met him, of a man who viewed himself as terminally hard done by. Once his worries about the judgements of his ex Isobel had worn off, I'd inherited the position of arbiter as his self-generated need for condemnation tracked over to me. There was little I could have done to dodge it, to shirk the role I'd been attributed against my will. This desire for castigation was something John experienced both in his personal relationships and in the professional realm. 'Of course, no one wants to hear what *I* think,' he would often say, all evidence to the contrary, when we were discussing a catalogue introduction he'd just finished, an interview he'd given – 'I' was not a pronoun here but a name, and the name was his. This was, further, a clipped phrase that signalled the end of an exchange, and as such doubled as a notice that I had said the wrong thing, something to displease him. It might be more generous to say that I'd inadvertently grazed an insecurity, that John was, at the heart of it all, a deeply insecure person.

*

Initially, the move to Edinburgh felt like a turn in the road. We adopted a cat, Mingus, from a friend of a friend, his beauty and benign presence elevating the mood in the new flat for several weeks. We doted on him. Drawn into a tenuous camaraderie by our mutual admiration, John and I began to do other things together: to go walking along the stream near the foot of Blackford Hill; to frequent Summerhall, an old veterinary school turned arts complex.

I handed in my thesis that first winter and immediately began applying for lecturing jobs. The institutions to which I submitted myself tended to be run, at the level of middle management, by other white women in their thirties and forties. It was a fact John never failed to remark on, conflating the women for effect – 'Bryonies or Kates or Helens . . .' Initially, the tone of these asides implied that I was in on the joke, but this changed as I became inducted into academia, though he knew full well I didn't share these women's background, or what I – we – assumed was their background (middle class, Oxbridge-educated). I'm sure people made the same assumptions of me. I suppose that was the point.

When, after a second interview, I was offered the job I'd hoped for at the University of Glasgow, receiving a phone call on the train home, I rang John. He was mute. I had to beg him to meet me at the pub at the other end. My friends Jay and Aimee bought me a mini bottle of Prosecco, toasted me with their pints. John remained quiet, concave. 'Of course – though I'm not surprised,' were his words, when Aimee (via a semi-ironic 'Aren't you *proud* of your wife?') finally forced a response.

As I reached the age John had been when we'd first met, I began to undergo an internal shift that was slow-moving and profound. This was the age at which the shape of one's own face, as regarded from unfamiliar angles in candid photographs, is no longer disturbing, no longer a psychic rupture. This was the age of thirty, or thereabouts.

I wouldn't have been able to identify the shift, at the time. Not in such words. Its main symptom – or perhaps its effect – was a need to

reach outward, to speak to other people and to reverse the walling-in I had undergone throughout my twenties. I made friends through my new job, people my own age, including Rowan, who as well as being a junior lecturer at Glasgow was one of the trade-union organisers. They had all liked John to begin with, but he had soon started drinking again – to excess. On such occasions, he would embark on rants, talking himself into a stupor, cutting down anyone who dared contradict his line of thinking. I was embarrassed, and later, at home, scared. Heartbroken.

What I tried to convey to John, several times, was that my love for him had become diminished, in increments, over the years. That with each blow, each transgression, a withdrawal had been made. Without equitable deposits, I told him, the account would eventually be emptied. 'Where do you get this stuff?' he'd spat at me. 'Films?' – a barrage that would finally devolve into his wondering aloud what my new 'right-on' friends would think of me employing metaphors of finance.

One of the final withdrawals took place during the university strikes that year. I'd been on the picket in Glasgow with Rowan, Stephen and some other colleagues and students, protesting the recent pension reforms. John met us all later, at the pub.

'*Solidarity*,' he spat, after most people had left and the barman had rung last orders. 'The word sticks in my throat. Makes me choke.'

On another occasion, he had instructed me to be 'careful' around Rowan. 'Watch yourself,' he'd said, 'if you're ever alone with him. He's a strange guy.' And then, seeing my look of bafflement, 'I'm serious.'

Our final weeks in the shared flat were unbearable. We'd already agreed to a trial separation and handed in our one-month notice. When, however, I told John about a viewing I had for a flat in Glasgow, he wasted no time in accusing me of having progressively carved out the conditions that would enable me to leave. I wondered if this might have been true on a subconscious level, though I hadn't actively considered doing so until months after I'd started my new job. By that time, a sense of possibility cloaked

every one of my solitary experiences, as when I would walk home from Edinburgh Haymarket through the industrial West End, along the Union Canal, a route that I had come to love and would soon miss. Quitting the station's older, pillared entryway, I would stride over busy junctions, past tall, flashing office buildings, until I reached a commercial development that let out onto wooden decking and, eventually, a quiet canal-side path. Proceeding from its terminus, the canal was lined on one side by barges and the back ends of businesses (mechanics, takeaways, a kung fu gym), and on the other by a corrugated-metal fence guarding a shabby, rubbly grassland. I took plenty of photos of the lift bridge as I crossed it at sunset while heading towards our flat on Holy Corner, a crossroads so named because of its four facing churches.

It was a route one of my new colleagues, Farah, had shown me. One evening, after work, we'd bumped into each other stepping off the train from Glasgow. As we funnelled along the platform and moved up the narrow escalator, through the ticket barriers and over the station concourse towards the exit, it became clear that we were heading in the same direction. On our way home, Farah spoke without pause. Her topic was her long-term boyfriend, whose books, she informed me, were the dominant feature of their small flat. 'Shelves upon shelves of them,' she said, including second-hand and rare editions. 'Remnants of a former life.'

The week before he had come home to find that Farah had been frying fish on the hob. He had become angry and disturbed, had shouted and thrown things.

'Doesn't want the smoke to ruin the bindings,' she'd said, shooting me a nervous glance. And then, smiling weakly, 'It's his fear of the abject.'

*

'It's a great *healing* space,' said Katy, my soon-to-be landlord, as she'd first watched me look round. I'd just told her I was separating from my husband. She knew already that I worked at the

university, that my office was nearby. She was herself a curator at the Centre for Contemporary Arts. We had a few people in common – other curators, gallery workers, artists, writers . . . She'd have known John, if I'd named him. Maybe I didn't need to; she was bright, eager with me.

'It's lovely,' I said, taking in the tall windows and high ceilings. The tasteful mid-century furniture and custom-built bookshelves. These features largely eclipsed the flat's size, which was very small, more or less a single room with a galley kitchen. The windows provided an impressive view of the street: the crescent opposite and the parish church across the road. All of this underlined by bright-red flowers in terracotta window boxes.

'I'll be leaving those,' said Katy quickly, as she saw me register them.

'I'm not going to make this easy for you,' John said one morning, bearing down. He meant it. While packing for the move, I would leave the house for more sealing tape and return to find my boxes slit open, their contents disturbed. I had mistakenly taken some of his things, John would inform me, happily. Most of the things were books that I was either ambivalent about or could find other copies of. I let them go. One of the items John retrieved, however, was a small ink drawing his grandmother had made years earlier of her two whippets, Sidney and Daisy, long since dead. She had gifted it to me shortly after John and I were engaged, carefully wrapped in pale tissue paper. As with most of the objects he'd inherited, it was an object towards which John had always appeared indifferent; in every house and flat we'd lived in it had hung above the vintage school desk where I did my work. 'How can I explain this,' he'd said when I'd protested, bringing his hands together under his chin, aiming his forehead at me. 'This picture is part of my legacy. I realise that's difficult for you to understand.'

On moving day, Katy let me in and handed me two sets of keys, beaming as though I'd won a prize. Once she'd gone, I opened the sash windows, noting again the church, its blonde sandstone gleaming in the sun, before turning to take in the room, the details I'd come to overlook.

The flat smelled strongly of cleaning product that day and for some time afterwards: synthetic mint and something floral, something sweet. The sum of my things barely filled two-thirds of Katy's shelves. I padded out the empty nooks with postcards.

John and I could rarely agree on where we ought to live, on what 'home' ought to look like. My early attempts at decoration were crude, I know that now. I would buy textiles, small things that would make me happy in isolation, but which came to appear cheap and incongruous among the worn objects of John's birthright: dark hardwood tables and chairs, loom rugs, Italian majolica, original paintings in dull gilt frames. I knew my additions were wrong and yet hate filled me up as I watched John absent-mindedly destroy these imports with staining foodstuffs and cigarette ash, with trailed-in muck. I hated myself for hating that process of mindless destruction, in turn. I hated what I had become, the instincts I had developed in response to my situation. They were displacements of a much greater need – of the need for individuation.

Not long after I'd left, I dreamt that John and I travelled the southern edges of Britain in search of somewhere to live, somewhere we could agree on. We went to various seaside towns, real and imagined, speculated on whether we could live there. We never could. In one of the towns, perhaps the second or third we visited, a group of people were openly hostile to John. A blonde woman was particularly vicious. It became clear to me that John had been involved in a road accident there many years ago: a boy, a toddler, had been killed. The blonde woman was the boy's mother or possibly his elder sister. No arrests had been made but the town had not forgotten the tragedy. It had a deep scar running through it, and John's return had caused that scar to beat.

Why bring me here, I wondered, and then I woke up. ■

ARVON MASTERCLASS: YOU ARE A WRITER

Two hours of inspiring tuition from some of the finest writers at work today

TUESDAY 30 JULY · 7-9PM

SHAPING NON-FICTION
Jessica J. Lee

How you shape and structure your non-fiction is crucial. Gain important insights with Jessica.

FRIDAY 16 AUG · 11-1PM

ECOPOETRY
Holly Corfield Carr

New ways to listen to the landscape at a time of environmental crisis.

TUESDAY 20 AUG · 7-9PM

WRITING PERFORMANCE
Katy Schutte

Channel the power of improv to become unstuck in your writing, whether a performer or not.

FRIDAY 30 AUG · 11-1PM

THE POETIC LINE
Tim Liardet

Find new ways to control the poetic line through syntax, syllables and rule-breaking.

FRIDAY 20 SEP · 11-1PM

CRIME FICTION
Sophie Hannah

Build a connection with your reader by making them feel like they're solving the case.

FRIDAY 26 OCT · 7-9PM

HOW TO BUILD A POEM
Emily Berry

Reimagine what a poem can be - what it can convey - by focusing on its architecture.

TUESDAY 5 NOV · 7-9PM

WRITING NEW PLATFORMS
Alice Vincent

Grow your reach as an author by learning how to write across exciting digital mediums.

TUESDAY 19 NOV · 7-9PM

GETTING TO THE TRUTH
Hattie Crisell

Improve the authenticity of your writing by exploring how to control your narrative.

FRIDAY 17 JAN · 11-1PM

FREE VERSE
David Harsent

Reinvent your compositional methods by testing - and breaking - the rules of free verse.

ARVON

LOTTERY FUNDED

Supported using public funding by
ARTS COUNCIL ENGLAND

Book now
arvon.org/masterclasses

Online via Zoom
Concessions available

Zoë Hitzig

cache 9

at sunset, the steepest steps, never thought you'd
see me sweat, canter up and down the canyon,
landscape of terrycloth, sky with its machine-wash fade,
acid-wash shades of slate, dismount to mount again

the canyon, somehow you are your own meridian,
you hold the date line like a blade, your blade becomes
my only banister, just like that, your state is born, no state
of confusion, just like that, I'm just your state, state of play,

of the union, california, too late, too early, early too
so very late, claw its way into the day, selling fruit,
selling futures, futures north of food and fictions,
bottom-line the violent caption, no this is not

attraction, yes the fruit fields by the highway, yes
the berry heavy wind, yes I think the dolphin's dead,
why not just delete this clip, can't we uninstall the beach,
strangers' laundry, rolled up wet, dump it on the bench,

now I'm on the palisades, see you sailing there in parallel,
I turn around, sink to sit, shoulder blade against a baluster

cache 14

overexposed, too blue morning, was it you or me
driving that day, crossing the tracks, between switchbacks,
on the mountain pass, can't remember, who saw the train
first, who backed into the, who was driving when,

what of the whiplash after, whose idea was it to,
trap our months in that book, twitched out of grasp,
tape the moths on the film roll, watch their wings lace,
now when I look at you, here in the parking lot,

streetlights make nets on your face, the rain
on the windshield, nets on your face you say
undertow is the clockwork ocean, undertow is a fragile
tenancy, we'll twitch awake twice tonight, tomorrow

we spin the child, spin spin, fall down dizzy, walking
is falling, walking is falling, walking is when, we finally
stop moving, when the motion stops, you or me stops,
turn the headlights off, wait wait I love this song,

please don't turn the car off, disarm each streetlight,
blur out the lot, shivering outline in the dark

ADAM FARAH-SAAD
In this first year of my 30's I've had more sex than I did in my entire 20's (AMOR), 2023
Courtesy of Public Gallery, London

EMBRACE

Kevin Brazil

I 've always believed that the only constant in life is change. If we don't embrace change, we fail to grow. Even worse, we put ourselves at risk. We lose the capacity to change when change is forced upon us. I resolved long ago I'd never again be afraid of change. And that is why I am here today.

That was my opening statement. It was what I believed then and it's what I believe now. Perhaps even more so. I sat back down in the sharing circle to the sound of clicking fingers, a sound others might call snapping.

Thank you, said Hanno, our facilitator. That was so brave.

Yes, said the man beside me, so brave. He leaned over and whispered in my ear. Can I ask you something? Can I ask for your consent to touch you on the knee? I just want to express, physically, how much I admire what you said.

I said no, but politely. I don't generally enjoy being touched by strangers, and while this was also something I wanted to change, I've learned to be kind to myself and not to push myself too hard in situations that make me uncomfortable.

When the final round of clicking and/or snapping died down, Hanno walked into the centre of the sharing circle.

With these incredible acts of vulnerability the first part of our

opening ceremony has come to an end. Now, in order to embrace the community that has gathered here today, I am going to ask you to form what we call family groups. These will be groups of people who come together because they are arriving here with particularly important shared experiences. Your family group will be a space to which you can return for safe reflection, at any time, over the course of our journey together. So now, please stand up and begin to move through the room, connecting with those you see around you.

I am not a very sociable person. I have a small number of close friends who provide me with the emotional support I need. With them I am extremely affectionate and relaxed. They have often called me things like playful, silly, or boyish. I rarely work well in social situations with people I don't know.

I stood up and looked around the room, a converted barn, the walls painted white. I counted maybe forty people drifting across the wooden floor, forming small groups and clusters.

Eventually Hanno approached me. Ben, he said, glancing at the name badge I was wearing, my role as facilitator is to enable you to get the most out of your time here. So I was wondering whether you might be open to forming a family group with some beautiful people I have just met: Omar and Kemal. I think you three might have a lot in common.

These people seemed nice and I quickly agreed we could form a family group so I could return to my room for a rest. What I call my social battery gets very depleted by talking to strangers. The on-site accommodation was located in a renovated farmhouse close to the barn, a communal dorm with rows of bunk beds, but I had chosen to stay in my own room in a guest house a short walk up the road. I always like to sleep alone, in darkness and in silence. I like to have a space where I can go to recharge. The first day had come to an end and I wanted to be prepared for what I had decided lay ahead of me.

I'd recently witnessed a lot of change happening around me. I'd observed one of my best friends ruin a relationship because he became unable to communicate with his partner. He started lying about what he wanted, and ultimately ended up lying to himself. If we lie to ourselves, we risk forgetting who we are, and someone who doesn't know who they are is a dangerous person. I never want to be a dangerous person.

Around the same time, my friend Sam was diagnosed with cancer. At the age of thirty-five. My other friend Anna had decided to freeze her eggs, only to discover that none of them were viable. In fact, according to her doctor, her chances of conceiving naturally, or even via IVF, are now negligible to impossible. Other changes were more positive. Kasia, a friend who has inspired and challenged me like no one before, finally qualified for permanent residency and can now stay in London for good. All this reminded me of what I already knew: life is constant change.

I know exactly what you need, Kasia said to me when I told her that I was ready for a new era. When I was living in Berlin, many of my gay friends would go to this festival, a weekend of talks, workshops, exercises. It would transform them, transform their entire lives. You have to do it. I can get you tickets, I know the organisers, I'm buying you the flights, it's done!

It can be difficult to embrace change. But I believe the alternative is much worse. If we don't accept change, we deceive ourselves by pretending that things can stay the same. And when we deceive ourselves, we also deceive other people. This leads to deception in relationships and friendships and if we are not careful, this deception can lead to abuse. To violence. People pretend to be something that they are not and when this lie is discovered, they lash out. I have observed so many abusive dynamics within relationships in my life. How many people are killed in relationships? A woman is killed by her partner or a member of her family every ten minutes. I understand this is due to patriarchal dominance rather than the inherent nature of human relationships. However, this is the world in which we have all

been raised. I resolved years ago to break the cycle of abuse, and only enter into relationships where I felt that clear, verbal communication was possible in order to settle any conflicts that might arise.

If this meant that in the past I didn't enter into romantic relationships because many, many people are incapable of clear, verbal communication – of simply replying to a text message, even when sent multiple times – this has never been a permanent decision on my part. I know there are other ways in which people communicate. I've read a lot of books, I've spent a lot of nights watching videos online, I've bookmarked a lot of pages on my internet browser. I know other forms of communication exist – touch, movement, even the hormones we secrete when we orgasm – it's just that I've not yet been able to understand them. This might be because I only had a limited opportunity to learn other communication styles from my family, but after much reflection I concluded this isn't likely to be the case. I have a very good memory and I cannot recall a time when I didn't need clear, verbal communication. This is why, as a child, I never wanted a pet.

However, observing my friends navigate their recent difficulties did give me an idea. While I might not be able to change who I am, I might be able to change what I do. I might be able to understand other communication styles if I can translate them into the language I do understand: words. As someone who works as an audio engineer, translating sound waves in the air into electronic frequencies and back again, I realised this might be a technical problem I could solve, like dubbing a foreign film into English. I just needed the opportunity to actualise my will to change.

It is a festival, said Kasia, for anyone, how did she phrase it, for anyone in or attracted to the space of masculinity within a fluid gender spectrum. You go for a weekend and you stay in this farmhouse outside the city and you attend talks, workshops, healings. And you know, Ben, she said, I've always thought you would benefit from something like this. It's going to be so good for you.

I believe that many gay men are sick. I believe that many gay men

are deeply, deeply sick. This is because we are brought up in a society which is itself sick. The vast majority of gay men are raised in families where at least at first they are taught to be ashamed of who they are. I would call this a situation of emotional abuse. Many gay men have been taught to hate themselves. I don't believe this ever really goes away. People may get to the point where they no longer consciously hate themselves, they may look in the mirror and think they love and accept what they see, but where does that hatred go? It is taken out on others in the form of toxic behaviour and emotional abuse.

When I lived for a number of years in Singapore, working for an English-language television station, the only friends I had were a group of gay men who would come to the country twice a year. Once in winter, once in summer. They would spend a month visiting cities in the Asia-Pacific region: Sydney, Honolulu, Hong Kong, Bangkok. It is a lie that you cannot be openly gay in Singapore. It is in fact completely legal. However, I experienced a strong division between those who had been born and raised in Singapore, and those who were expats, like me. These men would come to Singapore for a week at a time, they would stay in their hotels or hotel compounds, they would work out in the gym all day, and they would organise sex parties in their hotel rooms at night. No one would have sex with me, so I didn't go. Perhaps it was because I was too small, perhaps it was because I was too brown, perhaps it was because I was too hairy. I have very hairy shoulders, so I rarely wear vests. Some men, I have seen this, they shave their shoulders every week. One night, when we had finished drinking vodka tonics at a hotel bar, one of them, Jamie, asked me if I wanted to come to their hotel room and take some drugs. I said no. That's a shame, Jamie said. You have a great face, Ben; if only you worked out a bit more maybe you could be one of us.

Men like this, they are sick. They are damaged. They are everywhere, and they are dangerous. In any relationship, I need to feel safe. Men like this do not make me feel safe. They are why my most important relationships are my friendships. However, I've realised

that in allowing men like this to hurt me, because I am not able to prevent observations like this from hurting me, I had unconsciously allowed myself to live in fear. And to living in fear, I say: no.

My flight arrived at the airport at six o'clock on Friday evening and I took a train to the village, which was located about an hour outside of Berlin. Most people were staying in the communal dorms, but there were also some men checking into my guest house. Or what they call in Germany a *Pension*. I like to plan situations in advance, to know what I am doing each day. On the train I had looked at the programme and selected the workshops I would attend. Since I'm not currently, and have never been, in a romantic relationship, I didn't think I needed to practise intimacy's choreography of gifts and requests. As someone who doesn't have a family, I didn't think it would be productive for me to go on a journey through my family constellation. I cannot ever see myself wanting to engage in plushie play. I also didn't think I needed to learn how to dare to demand. I am someone who is already very confident about verbally expressing what I think. I always tell people the truth. This is why many people think I cause conflict, when in reality they just cannot handle the truth.

I am someone who is very picky about being touched. I hate, I absolutely hate being touched without my consent. Even when consent has been explicitly articulated on both sides I enjoy touching someone else – particularly their back and shoulders – much more than I enjoy being touched. If I have to, I prefer to penetrate other men rather than get penetrated myself. Just because I am someone who prioritises friendships over relationships, and who gets his main emotional needs fulfilled by those friendships, doesn't mean that I don't have sex. I have plenty of sex. Often, however, I find it unsatisfying.

Over the years I've experimented with many types of men, and I've come to the conclusion that I'm only attracted to conventionally attractive men who are tall. Taller than me. I understand I've been conditioned to feel this way but so far this is something I've not been able to change. Conventionally attractive men who are tall only want

to have sex with conventionally attractive men who are also tall, or at least the same height, because someone cannot always be taller. If the tall always sought the taller, where would it end?

I am not conventionally attractive and I am not tall so when I message men looking for sex, or approach men in nightclubs, most of the time they reject me. When I'm not rejected, or when I'm accepted by someone who is tall but a little bit chubby, which is something I like, and who therefore will settle for someone who is short, like me, I enjoy sucking dick and rimming and licking men's armpits as much as anyone else. I just don't enjoy being penetrated. But many men underneath their conventionally attractive tall shells are just that: tall shells. They are empty inside. After sex they will rarely want to meet me again. Every time this happens, I ask them direct questions. I ask them: Why didn't you reply to my message? Why don't you want to see me again? What did I do that makes you not want to see me again? They rarely if ever reply.

This is something about myself that I wanted to change. I wanted to be attracted to different kinds of men. I wanted to embrace change. So I decided to sign up for the naked durational massage event, where apparently I would learn the pleasure of receiving as well as giving sensual touch. I showed up to a small room in the farmhouse wearing only a towel, as requested. There were maybe twenty men inside. The only windows were skylights in the slanting roof. There was incense burning and soft, chanted music playing from a Bluetooth speaker.

The instructor, Florian, reminded us that while this was a session intended to stretch the boundaries of what we would normally tolerate, if at any time we felt unsafe all we had to do was raise a hand in the air.

However, emphasised Florian, feeling unsafe is not the same as just feeling uncomfortable.

After dedicating a blessing to the space, we were told to drop our towels when we felt ready. I felt ready. I dropped my towel.

We were asked to begin moving around the room and when we felt the energy was right, to reach out and touch other people. For a

while I stood in the corner of the room, waiting to feel the right energy inside me. Two black men were already stroking one another and a white man came up and touched their shoulders. I noticed that, even though he was tall and was smiling, no one was reaching out to touch the one visibly trans guy in the room. An older bald man reached out and touched my testicles but the energy didn't feel right so I started to circulate around the room. I circulated again and again but then the older bald man appeared in front of me again and for some reason something about this room didn't feel safe. I could see there were people in this room who also didn't feel safe so I raised my hand and picked up my towel and left.

On the way back to my room, still wearing only my towel, I passed two members of my family group, Omar and Kemal.

I'm sorry about Hanno, said Omar.

Why? I asked, and both of them laughed, as if I were making a joke. They smiled at me and Omar put his hand around Kemal's shoulders.

Your towel looks nice, said Kemal. We are just going to practise massages in our dorm, do you want to join us?

I explained directly and politely that I don't enjoy massages and went back to my room. I remember feeling frustrated, and confused.

That afternoon, however, I had a very different kind of experience.

The workshop was called Sitting in Silence. This session, according to my brochure, would explore what happens when we connect through the simple act of looking. Participants were to gather in a room and stare into a stranger's eyes for an hour, without speaking, paying attention to the thoughts and feelings that arise in this period of silent intimacy. When the hour came to an end, we were to return to our rooms, or one of the designated quiet spaces, and write down our thoughts as part of our reflective journaling practice, or simply to engage in whatever type of processing felt right in that moment.

The workshop, led by Hanno, took place in the converted barn with white walls, filled that afternoon with a soft, golden light. As I removed my shoes, placing them side by side against the wall,

I observed that there were maybe thirty men in the room, everyone staring at the floor.

As we open this session, said Hanno, I encourage you to move through this space and attune yourself to the energy you sense around you. I will shortly ask you to stop moving, to close your eyes, and then to gently turn around on the spot. Then I will sound my gong, and the exercise will begin.

This time I was determined to follow the rules. I closed my eyes. I could sense other people around me. Due to my sensitivity about being touched, I have a strong sense of kinaesthetic awareness. I can feel when people are about to enter my personal space, and I could sense people turning around as I too turned around in the dark.

I heard the gong. I opened my eyes. I instantly made eye contact with someone who held my gaze in turn. His eyes were a deep brown, almost black. His skin was also brown, the colour of honey. He had a moustache, and short, curly black hair. He smiled at me before I smiled at him. He was exactly the same height as me. I remember feeling an impulse to look away. To look up, down, to the side. But I didn't. I realise how strange this sounds, but already I felt I had committed to something that, if I saw it through, would change my life.

I walked towards him, carefully avoiding the other men who, in my peripheral vision, were drifting slowly across the room. I kept feeling an urge to look at his body, just for a few seconds. To double-check how tall he was, to be certain we were the same height. I could see that he was wearing a white vest and black denim shorts. He seemed to be lean, not muscular, but lean. I decided he was older than me, but only slightly. As we approached one another and sat down, without ever breaking eye contact, I realised that we were exactly the same height and that this would be a relationship between equals. A relationship where, right from the beginning, there could be no imbalance of power.

I sat down cross-legged on the floor and he sat down in front of me, barely an arm's length away. I felt a rush of blood colour my neck.

Then, suddenly, I started to get an erection. I panicked a little bit and the feeling of nerves only made me even more aroused. I could feel my erection pressing against my shorts but I couldn't look down to see whether it was visible. I remember thinking: I have an average-sized dick. Sometimes men tell me, Wow, your dick is so huge, it's so big, and I feel sorry for them. They need to imagine they are having sex with someone with a huge dick in order to feel turned on. That they are so hot that someone with a huge dick would fuck them. My average-sized dick was pressing against my shorts but I realised he had been staring into my eyes the whole time. He hadn't been looking at my dick. That for some reason made me even more turned on and my dick even harder.

Even though I was staring into his eyes, I couldn't help it: I was imagining what his dick looked like. His skin was brown. He could have been Spanish, Moroccan, Lebanese, from anywhere in the Mediterranean or Arab world. He looked generically Middle Eastern. I needed to know where he was from because it would tell me what his dick would look like, whether he was circumcised or not. I wondered what he thought my dick looked like. He probably thought I was circumcised, even though I wasn't. This is a common misconception I have had to deal with. My mother was white, but I look fairly brown, which must have come from my father. This has always been a source of confusion to people, when they try to place me, as I assumed this person was doing now. I felt my erection shrivelling a little bit because suddenly I wondered what he was thinking about me.

My mother told me very little about my father, because, as she explained when I was eight, there is very little to tell. She met him when she was living in Sheffield, when he was working in a foundry for six months as an engineer. Making gun barrels. She got pregnant, and soon after he had to return home to Iraq. She wrote him a letter but never heard back. Then she moved to Coventry and had me, her one and only.

People assume that because I am brown, because I look like an Arab, that I must be a Muslim. Or, in the case of white gay men, that

I am circumcised and going to be an aggressive, violent top. While, as I have said, if I do have to engage in penetrative sex, I would rather penetrate than be penetrated, I am a very gentle person. I don't like being the object of someone else's fantasy. This happens especially frequently when I date men while travelling in the whiter parts of Europe. Denmark, Norway, Sweden. Even France.

I noticed he was still smiling at me and that, as he smiled, the muscles around his eyes relaxed and his cheeks rose slightly. My erection was now very hard. His eyes were telling me he was happy, that he was comfortable. I decided there was a high probability he worked in some kind of creative but caring profession. A dance teacher. He had a dancer's body. I decided he had come to this event to embrace change, and to expand his capacity for understanding people who have different communication styles than his own. People who are direct and always tell the truth.

Light from a candle was flickering in his pupils. I began to zone out and lose track of time to a certain extent. There are parts of this experience I cannot remember because there was no alteration to my field of perception for almost a whole hour, and I've read that our memories are anchored to changes in our spatial environment. If we spend extensive amounts of time in the same space, like our childhood bedrooms, all that time collapses into a single memory.

I realise in recounting this that what I am now going to say will sound absurd but I owe an explanation of my feelings to no one. No one else has the authority to decide whether what I feel is valid or not. Even though he had told me nothing, verbally, the fact that he hadn't looked away for all this time meant he must have been open to the possibility of falling in love with me. I can't tell you how I knew this, but I knew it. Love is a concept about which I have long been very sceptical. I have seen the damage that can be done, and can be justified, in the name of love. My mother, for example, must have been in love with my father, even just for one night, or otherwise she would have had an abortion.

Once I realised he was open to the possibility of falling in love with me, I felt open to the possibility of falling in love with him. I remember the moment specifically because I smiled with my eyes and then – I panicked. And not in the way that made me feel aroused. I panicked because I suddenly thought: I know nothing about him and yet here I am with the intense feeling that I'm falling in love. We have just been sitting here in silence. What if we were to enter into a romantic relationship – would he be capable of clear, verbal communication?

When I go out to gay clubs, I sometimes get approached by couples wanting to have a threesome with me. If I have taken a lot of drugs, I might say yes. But mostly, I say no. Because when I would have sex with these couples, they would completely ignore one another and give all their attention to me. Fuck me, let me suck you, and so on. I found this objectifying, and borderline abusive. Once I got over this feeling of being used, and most likely stereotyped, I realised there was something else going on. These couples: they were not communicating, not clearly and verbally. What couples ever do? Does anyone really know what the person they love thinks about them? Who would want to hear that truth?

So I decided to conduct an experiment. Rather than wait for couples to approach me, I started to approach them. I would go up to a couple and ask, Hey, I hope I am not intruding, do I have your consent to ask a question? Once consent had been granted I would ask: Would you be open to the possibility of a threesome with me? The results were revealing. Every time the couple had to look at one another before answering. Every time! Neither knew what the other was going to say. They didn't know because they hadn't been communicating. From this experiment I concluded that the vast, vast majority of men in relationships do not communicate openly about their desires.

I had been sitting down so long my foot began to cramp. Then I observed a confused look in his eyes. He had noticed something. My discomfort. My panic. What kind of person was he? Could he help

me build a brighter future or was he crippled by the sickness of the world as it is? Before I told my mother I was gay, I took a deep breath and braced myself for change. Even though I had workshopped various scenarios, I had no idea what was coming. When she didn't immediately respond I realised it was scenario three, so I told her I could move out the next day, I had saved up money, and I could work for a year before going to university. Which is what I did. I saw online that I now have a sister. But by the time I found this out, I had something better than a family of my own: my friends.

For in a friendship, unlike in a family, no one sticks with you out of some unspoken obligation. Likewise, in romantic relationships, people might not be attracted to you, as a unique individual, they might be driven by unspeakable needs, originating deep in their childhood, needs they could never explain to you because they can't even explain them to themselves. Whereas in friendships, you are making a choice to get close to someone and they are making a choice to get close to you, a conscious choice that can always be discussed clearly and verbally. This is why friendships have been the only relationships in which I've felt safe, where I've been certain the other person is not lying to me.

The only relationships: up until this point. I was now really starting to panic. Was he deceiving me, right now, looking at my eyes but thinking, when will this be over, when can I just get up and leave? My legs tensed, and, yes, for a second I began to stand up. I felt the blood rush into my cramped feet, I thought about what Hanno would say, that I was breaking the rules, that I hadn't stuck it out. And then I heard him begin to take a deep breath. Without once breaking eye contact, he slowly inhaled and sat up tall, stretching out his spine, pulling back his shoulders, and then he leaned forward and calmly continued to stare at me straight in the eyes. As he exhaled I felt my panic melt away. And then I knew. I was certain. He was different, unlike anyone I had ever met before. I just knew.

My panic had turned into reassurance. In fact, my panic had enabled reassurance. It had functioned like a test. I had momentarily

wanted to run away, maybe in my mind I had run away, but when I had returned this person was still here. I felt the possibility of romantic love open up before me. He had somehow sensed my needs. I was able to smell him now, to distinguish his smell from that of the incense that was wafting through the room. He smelled like tobacco. He also smelled like coconut, and slightly sour, in a good way.

This is what I remember. I remember taking a deep breath and trying to assess the proportion of tobacco versus coconut in his scent. I remember hearing the gong. We stood up at the same time and I remember we were still looking into one another's eyes. I understood that we had to leave and that I needed to begin the practice of reflective journaling that would lead to this revelation, the one I am able to share, in part, now. The relationship I had created had to come to an end, but I didn't feel panic or anxiety. I smiled at him and he smiled at me. We turned around at the exact same time, and then I walked out the door and back to my room in the *Pension*.

The next day was the closing ceremony. I knew he would be there. I got to the room early so I could see everyone as they arrived. I saw Omar and Kemal stroll in and I had an impulse to smile at them. To non-verbally express some empathy and, yes, a sense of solidarity. But when I tried to catch their eyes they ignored me and sat down beside a group of tall white men. I flushed with blood and wanted to walk over and ask them, directly, why they had ignored me, but then Hanno asked us to sit down in a circle.

Or what I call, said Hanno, an inverse circle. I want us to be in proximity but also to be able to give each other the freedom to say things that others might at first find difficult to hear. So as you arrive, I ask you to sit down on the floor, cross-legged in a seating pose, or in whatever kind of seated position that feels comfortable in this present moment, and to form a circle facing outwards. Become aware of what this arrangement makes you feel. What is coming up for you right now?

Hanno non-coercively directed me to sit down and face the wall and because I was early I was one of the first to form the circle.

I heard more people arriving. I couldn't see them but I knew there was no reason to panic. He would hear me.

Hanno invited us to begin the sharing. Normally I would have felt the need to verbalise my feelings right away but already I was learning: this is not something I always have to do.

I have something I would like to say, someone said. I would just like to express my gratitude to you all for coming here. We have all been so brave and I feel honoured to have experienced such intimacy with you all.

I would like to say something, said someone else. This is not an attack on anyone in particular, but I did feel that our discussions at times lacked a more materialist analysis of the oppression that we face but are also complicit in inflicting.

I saw Hanno glide past me while everyone sat in silence.

I have something complex to say, said another voice, and I am not sure how to say it, but I have never doubted anyone's good faith this weekend so I will just try my best. I would never want to police anyone else's desires, and I also understand that no one is entitled to be desired by anyone else. But I will say, especially in the durational massage event, I was made very aware that I was not attractive to anyone here. And I suppose I want to say nothing more than this made me feel sad.

It was finally my moment.

I have something to share, I said. I came to this weekend with the intention to embrace change. To push my boundaries. To maybe dissolve them, in a safe way. I believe that only if we are open to change are we able to survive. To thrive. I am someone who is very skilled at clear, verbal communication. In turn, I need clear, verbal communication from other people because if this isn't available, there is a threat of misunderstanding. Misunderstanding which can lead to conflict, conflict which can lead to abuse. To violence. I have always known there are other communication styles, but I have never been able to understand them. This has caused me deep anxiety and frustration. But this weekend I realised I no longer have to be anxious,

or to punish myself, because I discovered that I can translate other modes of communication into my preferred form. I can observe non-verbal cues like looks, blushes, postures, and so on, and silently, to myself, I can translate them into a verbal equivalent. I can then check in with other people and ask them questions. What do you mean? Is this what you mean? By doing this I can create a feedback loop of non-verbal and verbal communication and this can expand and transform my ability to understand and connect with people.

The circle remained silent, but this didn't upset me.

Thank you, said Hanno, that was very passionately said.

Wait, I said, there's more. I have learned that love needs silence, but silence is not deception. What I've also realised is that the silence that enables love – this is more powerful than the ideology of romance, which is only one kind of love. I believe we don't know even a fraction of what love could be if we brought a comparable level of sensitivity and awareness to non-verbal communication within friendships. I feel like I have this new power and while I may use it to open the door for romance, I am certain I can use it to help my friends. This is my mission.

When we had completed our blessing I stood up and turned around. I couldn't see him. He wasn't there. It didn't matter. This is what this person had come into my life to do. To give me this revelation. Sometimes, what I learn from observing people overwhelms me. I have to be very, very careful about revealing what I now know to other people, in case they use it against me. I cannot reveal everything I have learned, the danger would be too great. Just because I have changed, this doesn't mean the world has changed. The world is still sick. The world is still full of danger. But I've changed. I have completely changed. ■

NEW KINDNESS HATCHING

Jesse Glazzard

Introduction by Anthony Vahni Capildeo

The camera slips from place to place, fuzzy yet alert. He tells me, afterwards, that the photographs were taken over three or four days. I knew that it was days, not hours. But it could have been months. In this series of images, taken over the course of two summers in Leighton Buzzard at Camp Trans, time neither passes nor stills; it pauses just long enough for outlines and surfaces to thicken, like butter creamed with sugar.

Greyscale, a thick tree forks in two. More branches sprout from the trunk, slimmer, more pliant: legs, at a jaunty angle. Shoes hummock at the base. Gigantic, entwined roots are companionable and climbable. The image has a freeing effect. I feel lighter. Being at home with nature appears desirable, but the promise is fraught for viewers familiar with Western art, where 'the pastoral' implies a paradise lost.

Words like 'filament' and 'filial' come to mind as I contemplate the limbs, all the limbs, the branches, and the shining phantom-people. I think of how Francis Ponge describes vegetation as rooted in his poem 'Faune et Flore' (1942): he sees trees expressing themselves by means of gesture and proliferation, because they cannot pick up and move. This is not the case here. The trees are animate, ready to play. A quick and birdlike glee is somewhere in the past, present,

future of each image. A clamber, a lift, a jump, a lean, a roll – enjoyed, imagined; not 'captured'.

Move how you feel moved to move. No limit; also, no hurry. Camp Trans breathes an atmosphere of rest, like a treasured painting in a peaceful gallery. Some bodies are partly or wholly unclad. People meet the camera and there is no hardness, nothing posed, an absence of startlement. The invisible artist who invites us to stand beside him is clearly among friends; being kind, being of a kind; witnessing with-ness.

The flesh is like grass, brushing up against other soft blades. The sunlight and the shadows of leaves bring a glisten to tanned skin and darkness to paler skin, so that bodies partake of light more than of complexion; they are alike in dapple and dazzle.

Our gaze becomes tender. We can trust the focus of the photographs, which leads away from the effort to look, into seeing, and stillness; into seeing stillness. For a few days in life, we drift from sight into a sense of cocooning or spooning. A nude body is waterbird, a torso fruits in the tree. I want kindness to hatch our species-renewal, in the curves of these dormant volcano tents. ∎

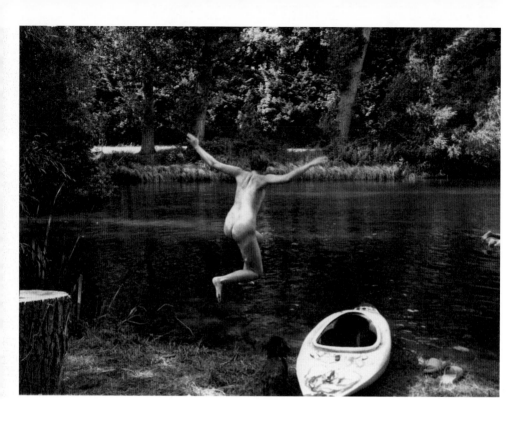

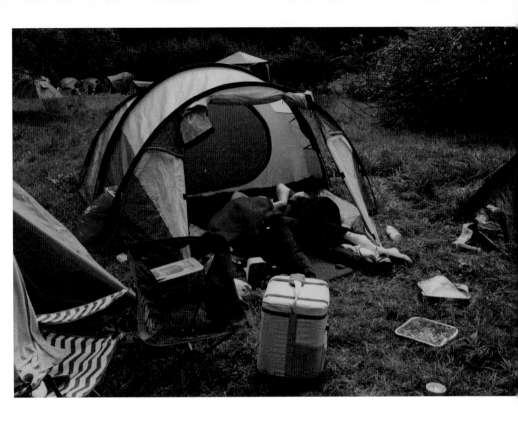

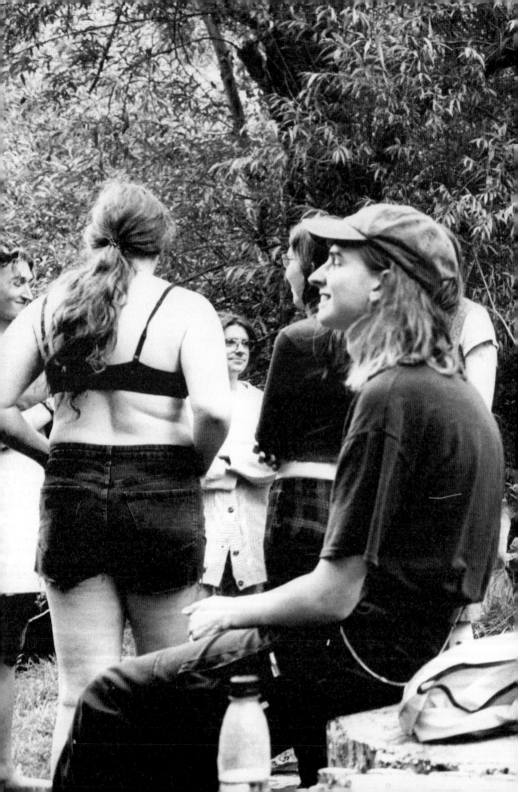

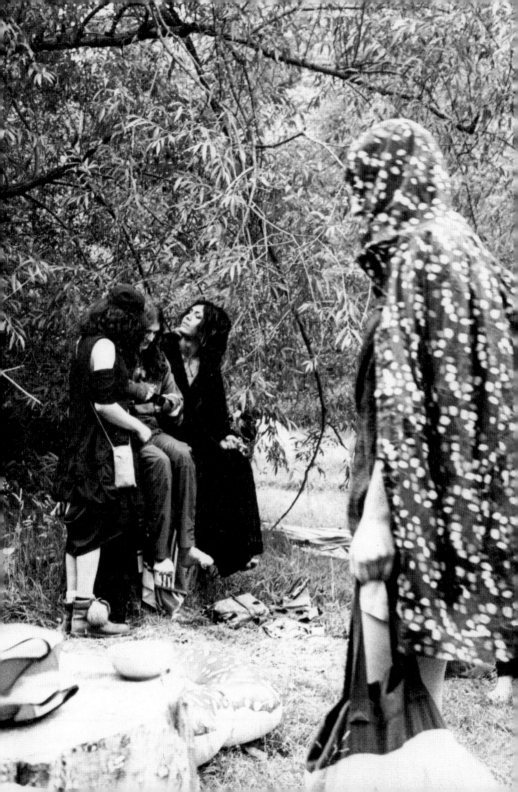

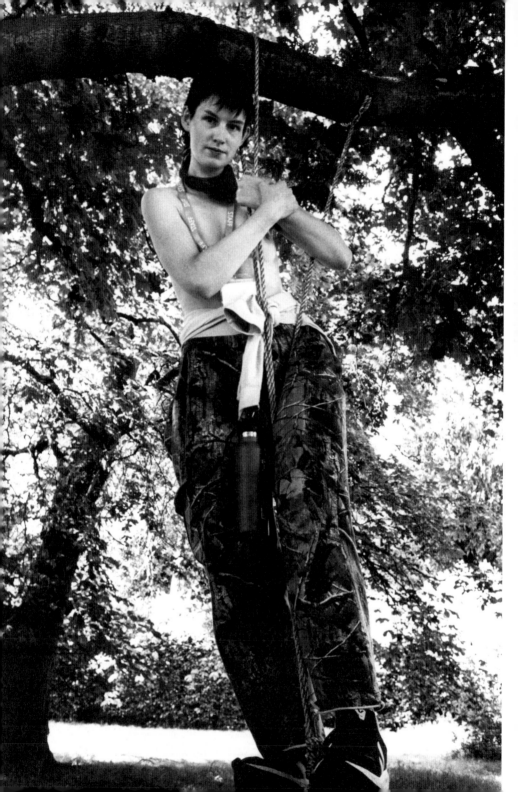

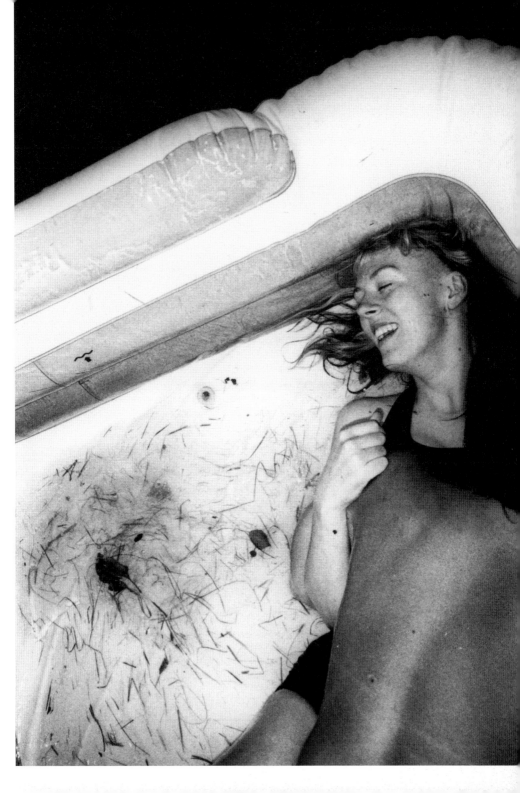

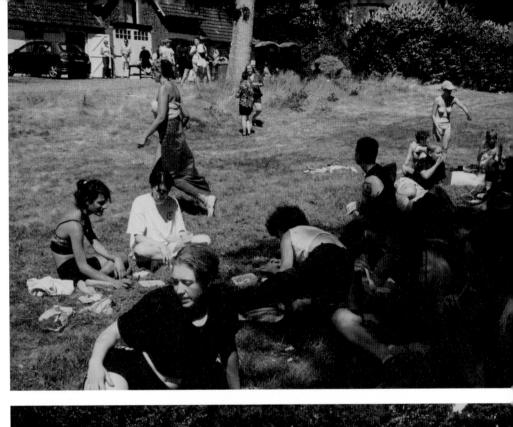

BRICK
A LITERARY JOURNAL

STARVE the ALGORITHM

113

IMAN MERSAL
HÉCTOR ABAD
ZOE WHITTALL
WILLIAM KENTRIDGE
CORNEL BOGLE

FADY JOUDAH
VICTORIA AMELINA
ANDREA LUKA ZIMMERMAN
SANNA WANI
JAN ZWICKY

In *BRICK* 113

Iman Mersal
Héctor Abad
Zoe Whittall
William Kentridge
Cornel Bogle
Fady Joudah
Victoria Amelina
Andrea Luka Zimmerman
Sanna Wani
Jan Zwicky

**ORDER THE SUMMER ISSUE
AT BRICKMAG.COM**

@BRICKLITERARY

Gerald Balfour, Winifred Coombe Tennant and Henry, 1913
Courtesy of Houghton Library, Harvard University (MS Eng 1825)

THE MESSIAH OF CADOXTON

Susan Pedersen

G erald Balfour is remembered today mostly for being the brother and political confidant of Arthur Balfour, the Conservative Prime Minister and statesman who later issued the famous declaration that the British government would 'view with favour' the establishment of a national home for the Jewish people in Palestine. Gerald had spent a few years in the 1870s teaching classics at Trinity College, Cambridge, and a few more trying to write philosophy in Florence, but in 1885 he joined the family business and entered Parliament for the Conservatives. He made little mark there until a decade later, when Lord Salisbury appointed him, in what the papers called a 'family arrangement', to the same post his brother had held in the late 1880s, Chief Secretary for Ireland. Administratively talented but never politically adept, Gerald ended his time in Ireland resented by nationalists for his superior manner and loathed by landlords for his surprisingly progressive land and local government reforms. Alongside his brother and another 200 Conservative MPs, Gerald lost his seat in the 1906 Liberal landslide.

Gerald Balfour left politics without regret. He did some of the things well-connected outgoing politicians do, joining company boards and serving on Royal Commissions, but he spent much of his time until his death almost forty years later in his study, sometimes

with collaborators but often alone, trying to discern patterns and meanings in a great heap of automatic writings – or 'scripts' – produced by a psychically attuned woman who walked into his life in 1911 and knocked him sideways.

For in 1906, at a loose end and at the urging of his sister (and Principal of Newnham College, Cambridge), Eleanor (Nora) Sidgwick, Gerald Balfour accepted the presidency of the Society for Psychical Research (SPR). Founded in 1882 by a tight-knit group of friends mostly associated with Trinity College, Cambridge (including Gerald and Arthur, who served in 1893 as its president), the Society spoke to a wide late-Victorian interest in spiritualism and the paranormal. Its most active members – especially Nora's husband Henry Sidgwick, Professor of Moral Philosophy – insisted spiritualist claims must be investigated 'scientifically'. For two decades, the Society researched mediumship and telepathy, debunked claims and exposed frauds, but in the early twentieth century it moved in a new direction. Gerald, in a public lecture in 1909, encouraged the Society to devise a means to assess evidence for 'spirit-return' after death. The prominent physicist Oliver Lodge and a Cambridge coterie were already working along these lines, collecting scripts – automatic writings produced by mediums in a trance state and ostensibly working in isolation from one another – and searching them for common phrases or motifs that might indicate telepathy or the presence of intelligences seeking to communicate from beyond the grave.

One of those recruited 'automatists' proved particularly prolific and talented, transmitting messages purportedly from the SPR's most prominent dead founder-members (and the current leadership's closest friends) themselves: Henry Sidgwick (who died in 1900), the poet Frederic W.H. Myers (who died in 1901), and especially the experimental psychologist Edmund Gurney (who died, possibly by his own hand, in 1888). This was one 'Mrs Willett', the nom-de-medium of a wealthy Welsh matron named Winifred Coombe Tennant, whose psychic activities would remain, through her life, a

closely-guarded secret. 'Mrs Willett's' scripts urged the production of children, exceptional children, and especially of one child – 'a genius . . . of a high order', a world-leader to be conceived by the automatist herself. In her not-strictly-private diary and in conversations with Lodge, Winifred expressed her amazement about that otherworldly request: she was not having sex with her husband anymore, and they had no plans for further children. 'If I do bear yet another,' she wrote, 'it will only be as a direct result of Edmund Gurney's repeated requests and my love for him.' She did bear another child. Augustus Henry Coombe Tennant, named to inaugurate a new Augustan age, was born on 9 April 1913.

What was known to only a few at the time, and was kept secret from the child Henry (as he was known) until his mid-forties, was that he was Gerald Balfour's son, conceived in a hotel on Langland Bay on the Welsh coast in early July 1912. Born to fulfill a prophecy, he was scrutinized through the first half of his life by Balfour, his mother, and a few in-the-know members of the Society for Psychical Research for signs of that world-transforming genius they confidently awaited. Through those decades, the automatists (all women) kept the scripts coming, and the interpreters – especially Gerald and his close friend and research partner J.G. Piddington – kept hard at work too, documenting those common motifs and patterns that, they thought, could not be explained by chance alone. This was the project of the 'cross-correspondences', the Society's protracted effort to 'prove' the survival of human consciousness. It was also, surely, one of the most elaborate justifications for an extramarital liaison ever devised.

Not that Winifred and Gerald's script practice was just a hoax. Winifred Coombe Tennant didn't fabricate psychic communications simply to draw this attractive older man into her bed (though she clearly wanted him there); Gerald didn't cast himself as the servant of higher powers to excuse a *folie à deux* that would give his wife much pain. All parties in this story – Winifred and Gerald, automatists and script interpreters – genuinely believed themselves to be receiving messages from the other side. They were world-making as well as

lovemaking, and if the rules of their practice seem only too familiar, urging a union of spiritual women and rational men, they acted in a period of such gender codes under pressure – pressure that turned our medium unreliable and changed the plot. 'Mrs Willett' would foretell, and then produce, a messianic child – a child, so the psychical researchers thought, who would be someone just like them: a man, educated at Eton and Trinity, launched into public life. So, Gerald Balfour shut himself up in a Surrey country house for three decades, poring over scripts, as the woman who produced those scripts became a suffragist and internationalist, a Liberal candidate for parliament and a delegate to the League of Nations.

Winifred Coombe Tennant was born in 1874 into a Cambridgeshire gentry family and raised mostly in Switzerland, Italy and France. A romantic girl, at twenty-one, in 'a sort of "bold pirate" mood', she married Charles Coombe Tennant, a wealthy barrister twenty-two years her elder with a landed estate, Cadoxton, in South Wales. She later deplored this 'hopeless irrevocable mistake', for Charles proved fussy and uninteresting, but the marriage had compensations: her mother-in-law had been Flaubert's mistress; one sister-in-law was married to Henry Morton Stanley, another to the poet and founder-member of the SPR, F.W.H. Myers. Winifred had a first child, Christopher, in 1897. A second, Daphne, was born in January 1907 and died at eighteen months – at which point Winifred's diary explodes in paroxysms of grief and anguish.

How does one bear a loved child's death? Like so many bereft parents, Winifred was desperate to feel her daughter near her. F.W.H. Myers was dead by then, but his widow assured her sister-in-law that, in the spirit world, Daphne lived on, 'fuller of Life now than ever could be here.' As she read up on spiritualism and psychical research, Winifred began an intense correspondence with the Newnham classicist, SPR member, and automatist Margaret Verrall, who had also lost an infant daughter. Coached by Verrall, Winifred practiced sitting with a blank pad of paper before her, emptying

her mind of conscious thought, and writing whatever came. This is how automatists usually work, but in early 1909 Winifred also began having what she called 'D.I.s' – 'Daylight Impressions' – where she heard 'Myers', 'Sidgwick' or 'Gurney' speaking, and wrote down what they said. To her joy, those communicators regularly brought Daphne with them, the little girl appearing first as a lisping toddler, and then as a mischievous child, her appearance and character changing as – in the spirit world – she grew. Slowly, Winifred began to detect a Plan: Daphne's death had been necessary, its purpose to draw Winifred into that world. Now in regular contact with (and persistently dreaming of) Oliver Lodge, Winifred produced script after script.

Winifred was thirty-seven in 1911; Gerald Balfour was fifty-eight. Very intelligent and always rather remote, Gerald was the second youngest and the most beautiful of the Balfour boys. Tall, slim, judged delicate in health, his longish hair thick even in extreme old age, Gerald turned heads his whole life. His Eton tutor Oscar Browning fell in love with him, bearing the teenage Gerald off to Sicily on holiday; so too his sister-in-law Lady Frances Balfour, wife of his architect brother Eustace, who worked hard to arouse Gerald's interest in politics and bring him back to England from Florence. Through the late 1880s and 1890s, Frances and Eustace, and Gerald and his intelligent and musical wife Lady Betty Lytton, lived with their growing families in adjacent villas in Kensington, as Gerald rose in politics and Frances became the women's movement's most effective parliamentary lobbyist. But that *ménage à quâtre* soured, and in 1901 Gerald and Betty moved their family to Fishers Hill, a lovely Arts and Crafts house in Surrey built for them by Betty's architect brother-in-law Edwin Lutyens. It was to that house that Gerald invited this whispered-about medium in February, 1911.

It was a *coup de foudre*. Winifred thought Gerald extremely beautiful – 'like a Greek head or an old ivory'. Gerald felt honored by the presence of a great adept. Oliver Lodge, Nora Sidgwick, and J.G. Piddington were there too; the group talked about its research plans.

In June 1911, Winifred visited again, and – at 'Edmund Gurney's' urging – she and Gerald began to work together, adapting solitary script-making into a game for two. Secluded in Gerald's study, 'Mrs Willett' declaimed while Gerald transcribed – although, from the evidence of the scripts, it is clear that the two sometimes wrote in tandem, as if co-authoring a play, 'Mrs Willett' acting the role of 'Sidgwick' or 'Gurney', and Gerald as himself. Betty approved the friendship, for she was (Gerald wrote) a 'wonderful woman', someone who knew that 'the affection given to one is not taken away from the other'.

But the spirits were restless, 'Gurney's' instructions growing more explicit by the day. On 6 August 1911, Winifred, alone, transcribed a long message thick with agricultural and sexual imagery. 'Write the word seed,' 'Gurney' instructed. 'Write again the word Plan.' And tell Gerald he is wrong to think his life's work lies in the past: 'It lies – quite distinctly – in the future.' Gerald and Betty visited Winifred and Charles a few days later that August while on a motoring holiday, and Winifred 'had a little talk with Lady Betty and wept in her arms'. A week later, in a hotel with her mother, Winifred had a 'very sacred & beautiful experience' which persuaded her that she and Gerald were bound together, 'soul & very soul'. Winifred then packaged up her seeds-and-plan script and this account, and sent them off to Gerald. (As he and Betty were still traveling, he would receive that packet on 27 August; the timing will matter.) Certain now that their relationship was 'too sacred a thing to be exposed to the microscope of any group', Gerald instructed Winifred henceforth to send him two editions of each script, one for him and one for the Society, 'with any too tell-tale or illuminating passages expunged!' They felt on the brink of something tremendous, the spirits massed behind to give them a shove.

When Winifred next visited Fishers Hill in early October 1911, 'Gurney' got down to brass tacks. Winifred's early automatic writing is almost illegible, the script running unbroken without the pencil leaving the page. But here, working *à deux*, the words are crystal

clear, as 'Mrs Willett' transmits 'Gurney's' instructions and deals with Gerald's troubled, penciled-in-the-margins interjections. 'S[idgwick] is most anxious that you should realize your freedom to act or to abstain – freedom yet under the Peak of Destiny', states 'Gurney'. Faintly, Gerald demurs: 'Henry you say that in agreeing I shall be following at once my own destiny and the purposes of God. This may be clear to you, but it cannot be so clear to me . . . It may end up in the breaking up of two families.' But his role is 'foreordained', 'Gurney' interjects – and besides, Winifred's 'present marriage' might not last. Gerald is shocked: 'But there is the consideration of my family', he writes. 'You know how close the bond is.' 'Yes. I do', replies 'Gurney' – 'but we want the CHILD.' 'She is practically alone for this month', 'Gurney' continued. Surely, the two of them could arrange a few trysts? That much, Gerald concedes, he could do.

The next day, Gerald and Winifred exchanged rings and vows in the lovely art nouveau chapel, all angels and flowers, that the ceramicist Mary Watts constructed at Compton after her painter husband's death; along with a cairn Winifred built to remember Daphne, and a garden Gerald laid out at Fishers Hill incorporating symbols of their union, it would become one of their many sacred places. Then, having dispatched Winifred's husband Charles off to France, these two chauffeured and servanted people somehow found a place to get down to it. Gerald's study? The nearby lodgings that Winifred had taken with her mother? Winifred underlined 11, 12, and 13 October in her 1911 diary, her usual code for sexual relations with Gerald. She also prudently rented a house near Fishers Hill from the end of November.

There was tumult to come. That November, Gerald told Winifred that Betty was expecting, hardly the first time a woman fell pregnant because her husband was aflame for someone else. Betty was surprised but happy. She was in her late forties; Ral, her youngest and only son, was almost nine; she had thought her childbearing days over. But Winifred was incandescent with rage, writing to Gerald that he'd betrayed her, crucified her, left her begging for death. A little out

of line, perhaps: after all, she was married too, and Gerald had done nothing worse than sleep with his own wife, before taking those vows with Winifred. But that's not all that was going on – for Winifred had been doing something exclusive and intimate with Gerald, something suffused with eroticism, something that made her vulnerable and left her exhausted: she was producing scripts.

When Winifred had her first 'Daylight Impression' with Gerald in the 'White Study' at Fishers Hill in June 1911, she wrote of being 'frightened and dazed' in her diary. But when she regained full consciousness he was 'divinely kind' and told her the script had come; she then went and slept for a few hours. At Cadoxton that July they had two more, after which she slept most of two days. For Gerald, those script sessions were the high point of his visits: he was, Winifred teased, a 'bad boy' who needed scripts but couldn't produce them himself. Scratching an itch to discern patterns and meaning that had driven his philosophical speculations decades earlier, he admitted that he was dependent on her 'mysterious powers', her ability to be 'my bridge between God & man'. Soon they were experienced partners. Left alone together, they could quickly make scripts come.

The script of script production rather followed the script of sex: it was intimate, exciting, boundary-crossing, and left the participants changed. The two practices bled together. While in *Human Personality and its Survival of Bodily Death* (1903) Myers had described trance-mediumship as a kind of 'unselfing', an out-of-body 'ecstasy' in which the medium was opened to the spirit world, according to Gerald (who would know), 'Mrs Willett' never lost awareness of her physical self: for her, 'extasy' (as she spelled it) was less a trance state than a state of physical arousal, both she and Gerald using the word to describe moments – nursing, intercourse – of intense physical pleasure. The erotics of touch are everywhere in Winifred's prose, surely part of the reason she, unlike most mediums, never performed for a group.

The practice also provoked jealousy. When Gerald left Cadoxton

after one visit, Winifred's husband Charles – we're suddenly reminded he's there too – insisted on watching her have a script come and, rather in the spirit of a certain kind of compensatory marital sex, Winifred complied, writing in her diary, 'I thought it best to get it over the next time I had any.' Gerald was jealous too, not of Charles but of Oliver Lodge, berating Winifred in March 1912 for giving Lodge three sittings in two days, and without telling him: much too much; she'd be exhausted; she must never do that again. But he needn't have worried, for working with Lodge really just showed Winifred that she only wanted to do it with Gerald: 'Thankful when I came to and saw him [Lodge] sitting there', she noted, 'for I had feared that without Gerald I might not "get off".' She was glad to see Lodge leave, and for the next two years kept him at arm's length.

She and Gerald were 'one', a true 'union'. But was 'union' a physical or psychic act? In September 1911, before they first had sex, Winifred was 'devouring' George du Maurier's *Peter Ibbetson*, an 1891 novel (and gift from Gerald) about two lovers who, separated physically, learn how to meet and experience connection psychically. The story spoke to Winifred, reminding her of her 'soul & very soul' experience of 'union' with Gerald that August, when he was motoring with Betty. This is why, too, Winifred felt so betrayed by Betty's pregnancy. For if Gerald dated 'union' with Winifred from October 1911, when they first had intercourse, Winifred dated it from that experience. When, Winifred obsessively wondered, had Gerald impregnated his wife? If it was after 27 August, when he had received those crucial scripts, he had committed 'the supreme wrong a man can do a woman' – that is, having sex with another woman (Betty) when already bound to Winifred, his true 'wife'. He had betrayed 'one who has given up all, who has laid up on Love's altar her one heart & seen it burnt to ashes'.

Remarkably, Winifred forced Gerald to adopt her view. Years later, Betty recalled Gerald's horrified response to the news of her pregnancy; to her bewilderment and unhappiness, he moved immediately from her bed to a cot in his dressing room. (He would

sleep in such monastic cells for the next six years; Winifred gave him a terracotta Madonna to guard his chastity.) No longer 'my Darling' in his letters, Winifred became 'Madonna mia', 'Madonna mia carissima', or – more simply – 'Mummie'. The Daphne story 'was but a preparation for <u>our</u> story, Madonna mia, and above all for the issue to which "they"'– the 'discarnate intelligences' on the 'other side' – 'believe our story is predestined to lead'. He now believed that his and Winifred's project of conception was the center around which all the scripts turned – although the SPR inner circle couldn't know that, as the lovers freely excised what they called private materials from those texts. In January 1912 the two managed a week at Nora Sidgwick's Cambridge house, the one place they could pass the whole night together without detection. Winifred's diary for that week is a host of underlined days.

Confident she had conceived, in early February Winifred sent the SPR a record of a vision where an angel appeared to her, pre-Raphaelite lilies in hand, along with Sidgwick, Myers, Gurney and Daphne, announcing her beatification. When her period came, she was devastated – but the scripts again rescued her. 'With a piece of mechanism as delicate & complex as she is in the <u>mind</u> & <u>body</u>', conception would likely not succeed on the first try. 'Made thee of Fire and Dew', the script intoned. 'That is a good description of her . . .' Through the spring of 1912, as Betty endured her sixth pregnancy, Gerald and Winifred honed the rituals that bolstered their resolve, kneeling at Daphne's grave, 'meeting in spirit' each morning, and sprinkling their correspondence with symbols and tokens – pressed flowers, sprigs of yew, ribbons from Winifred's undergarments – of their love. 'No obstacles', Gerald wrote in March 1912, 'are going to prevent the accomplishment of the Great Task that is laid upon us. The Great Gift is to be ours [here, as always, he circled the word 'ours'] in God's good time.'

Winifred couldn't bear even to be in the same country when Betty's child was born and went to Switzerland in May 1912 – with

Charles, though his presence is never mentioned – and released another torrent of agonized recrimination. She was 'in darkness . . . such depths of spiritual torture . . . a hell of misery', humiliated utterly by 'what is passing in my home' – she meant Fishers Hill – 'under my husband's' – she meant Gerald's – 'roof'. By having this child, one begotten (she again charged) 'after we had met & loved', Gerald had pushed aside the rights of 'Ours', their own desperately-desired child: 'oh Gerald the sound of its retreating little steps has been echoing like a death knell in my heart.'

Gerald still insisted he had not had sex with Betty after 27 August 1911 – the date when he received those critical scripts revealing his and Winifred's 'union'. Betty's baby was just late; his son Ral had been two weeks late too. When Betty finally went into labor on 4 June 1912, now so unhappy that she genuinely wished she'd just die, Gerald wrote Winifred that he would be with her in spirit, holding her hand – Winifred's hand, not Betty's hand – 'firmly, tenderly, lovingly' through the whole ordeal. During that long and difficult labor, Gerald went off to London and posted this letter. When a girl, Kathleen, was born (he and Winifred both assumed their child would be a boy), Gerald wrote: 'Thank God you are saved the last drop of bitterness.' But Winifred would not be consoled. Gerald must not feel his 'present self to be the Father of that other child.' 'Pray for me that I may die before I see that child.'

Gerald went to Wales so they could try again. Their script of 6 July 1912, written in a hotel on the Welsh coast right after Kathleen's birth, includes a passage in which Gerald says, 'The loyal knight wishes her to know that he understands.' 'She keeps crying, I want – I want,' says 'Mrs Willett'. 'Him to come himself, is that it?' asks Gerald. 'It's been such a long way,' sighs 'Mrs Willett'. The next day, 7 July 1912, Winifred fell pregnant. Augustus was 'descending from heaven and becoming incarnate', Winifred wrote in her diary on 31 July; 'be it unto me as according to thy word'.

She went to ground in Wales immediately. She had a full domestic staff, a resident husband and toddler, and a teenage boy at school, but

she felt herself mostly under the dead 'Gurney's' care. She produced a number of ecstatic scripts, Gerald visited her, and she wrote to him constantly – sometimes harping on the hardness of her lot compared to Betty's, but occasionally with the kind of intensity that gives one some sense of just why Gerald was willing to risk so much for her. 'I want all always,' she wrote that October. 'I want to be ever with you night & day & day & night . . . I want to know you love me from the crown of my head to the sole of my foot – even as I love – I want the touch which quickens delight to Bliss. I want to be one with your mind, one with your heart, one with your body' – a destiny 'for which sole purpose God made me'. After a long, hard labor, on 9 April 1913 – Gerald's own sixtieth birthday – Augustus Henry Coombe Tennant was born.

Gerald, officially the child's godfather, was over the moon. The inner circle of the SPR, who knew of the Plan but probably not of Gerald's paternity, simply assuming Henry was Charles's son, was excited too. Over the next years, that group – Oliver Lodge, Margaret Verrall, J.G. Piddington, Nora Sidgwick – would keep an eye on little Henry, waiting for him to reveal his godlike gifts. Gerald doted on the child and visited Cadoxton regularly. Winifred and Henry were duly absorbed into the wider Balfour clan. Gerald had told Betty in September 1912 that Winifred's coming child was his, and Betty – in Gerald's words, 'a truly noble type of womanhood' – told Gerald she would love the child too. Betty would welcome Winifred and Henry to Fishers Hill – where Betty's children, who cordially detested Mrs Tennant, gleefully led immaculately turned-out little Henry down the muddiest paths.

Almost thirty years ago, in *The Darkened Room*, the feminist historian Alex Owen argued that Victorian and Edwardian elites embraced spiritualist practices in part to play with gender roles, acting out behaviors in shadow that could never be allowed in daylight. Transgression – unsanctioned desire, forbidden touch – was allowable because it was enacted while entranced: mediums

were the vehicles for knowledge they could never own; unseemly emotions – rage, lust – were always the spirits' work. In just this vein, Winifred always insisted that Gerald's dead friends were speaking, not her, and Gerald heartily agreed: 'Do not doubt that in all these communications the same intelligence is at work, and that intelligence is not you.' Gerald did believe Winifred had a special gift, but that it resided in her psychic sensitivity, not her intellect; indeed, it was important to him that she was not an intellectual but a 'wild glad frolicsome being', 'sweet and wild'. Gender complementarity runs riot in their letters: Winifred accesses 'spirit' and Gerald interprets text; Winifred births the Messiah, so that a male Balfour can save the world.

But by 1911 this astonishingly conservative vision was everywhere under pressure. Other heterodox movements springing up, after all, did not require such strict gender codes. Theosophists welcomed women not only as adepts but as teachers and found their own Messiah in a teenaged Indian boy. The 'Panacea' movement, founded by a vicar's widow named Mabel Barltrop, honored a 'Divine Mother' as well as God the Father and treated the automatic writing Barltrop produced as direct communications from God. Gerald and his collaborators thought such women credulous and weak-minded, but the trends of the time were against them, for the women's revolt was spreading, its tentacles reaching even into the Balfour home. Betty's sister Emily embraced theosophy, while her sister Constance became a famous suffragette: when Christabel Pankhurst went into hiding in March 1912, as the militant movement turned to property damage, to Gerald's mortification the police came to search Fishers Hill. Frances and Betty Balfour were both constitutionalist (not militant) suffragists and sought-after speakers, and marital unhappiness made Betty throw herself still more into that work.

Surrounded by suffragists, small wonder Gerald was happy that Winifred wanted sex from him, not the vote. 'My (one) is a woman from head to foot,' he wrote her on Christmas 1912. 'She is not "unhappy or rebellious", she is only a woman, and not for anything

would I have her otherwise.' But, in a comeuppance for Gerald, by 1912 Winifred too felt the suffrage movement 'very near my heart'. In January 1914, with Henry weaned, she accepted the presidency of her local Neath suffrage society. Gerald felt rather mixed about her new feminist convictions. When he had said the two of them were 'like in difference', he meant they were complementary and made one other whole, but Winifred, he began to realize, thought they just disagreed – on labor militancy, the Irish question, and much more. Gerald found their disagreement painful and suggested they not discuss it. He was 'hungering for her', but Winifred was not a woman to fly to a man who had told her to be quiet.

The war deepened that rift. Winifred became desperately worried for her firstborn, Christopher, who was in the Officer Training Corps at Winchester at the war's outbreak and then a cadet at Sandhurst. In August 1917 he was sent to France, a boy in charge of 150 men. For two weeks he wrote faithfully to his parents, disclosing his location in a code he and Winifred had devised that easily eluded the censors. He was killed on 2 September 1917, his first day in battle.

Winifred had always luxuriated in feeling; now, a grief Gerald could not share consumed her. 'You must be prepared to find me a changed woman,' she wrote, her only comfort to 'work for the destruction of the social order' that had killed her son. She asked him to write a memoir of Christopher, but then found his production inadequate. Christopher had become a transcendent genius in her eyes, not the nice but quite ordinary boy Gerald remembered. On impulse she wrote to Oliver Lodge, who had in 1916 published a famous book giving claims for his dead soldier son Raymond's communications. Lodge, eager to get his star medium back, happily replaced Gerald as her collaborator for the memoir.

Gerald, sidelined, grew frantic, and stupidly told Winifred he couldn't detect the references to Christopher she discerned in one SPR script. Why, Winifred retorted, must he 'throw lumps of ice at me as I stand bleeding from every pore'? Gerald protested: wouldn't he have been 'almost more than human' if he could calmly accept that

the woman to whom he felt himself 'solemnly wedded in the sight of Heaven', loves him no longer? No, Winifred replied, if he truly loved her he would have thought 'solely of her': ask Betty to explain it to you, she added spitefully. Told to take his case to his wronged wife – 'the latchet of whose shoe neither you nor I are worthy to unloose' – was more than even Gerald could bear. He fell ill, and two months passed before he wrote Winifred again. 'You have destroyed my faith, so that I rock on a sea of doubt, questioning even those things of which I once felt most sure,' he told her. 'Tell that to E.G. [Edmund Gurney] if you ever see him.'

If Winifred could simply throw him over, then the foundation for Gerald's six years of faithfulness – the conviction that their love and its fruit would engender a reconstructed world – was undermined as well. Gerald had little to cling to, for Winifred was fed up with the Society for Psychical Research and the whole scripts project. Nor was she alone: other automatists had also had as much as they could take of its male leaders and resented (and often flouted) their rules. 'I will not be pot-bound by SPR mania about "evidence",' Winifred wrote in her diary, 'which has kept us all – Margaret Verrall, Helen Verrall, Mrs Lyttelton and myself – living in water tight compartments.' It was time to try 'other and more human methods . . . now, when broken hearts are all over the world'.

Winifred would go on to try those human methods, out in the world and leaving Gerald behind. A fervent Liberal, she grew close to Lloyd George: by 1920, she would be explaining to her tolerant husband that she had to stay overnight at Downing Street, so that the Prime Minister could talk with her in confidence about the political situation in Wales. She stood (unsuccessfully) as a Liberal candidate in the 1922 election, and Lloyd George appointed her Britain's first woman delegate to a League of Nations assembly. In later years she became a prominent Welsh cultural nationalist and a patron and collector of Welsh art. She would still bring Henry to Fishers Hill to see his adoring 'godfather', but her tumultuous liaison with Gerald Balfour was over.

D ecades later, Gerald's daughter-in-law Jean would place the whole project of script production and Henry's conception within the febrile atmosphere of that pre-war era, with its spiritualist strivings and psychological naiveté. She recalled that Winifred had been a narcissistic and intensely ambitious mother; of course her scripts were about her exceptional children and their world-historical destinies. Through the twenties and thirties, however, the SPR 'interpreters' still assumed that the scripts revealed plans and patterns beyond the automatist's ken. J.G. Piddington would claim in 1923 that the scripts indicated A.J. Balfour would reemerge as a world leader. When those hopes went unfulfilled, Gerald extracted evidence that Henry nevertheless was, in psychic terms, really his brother Arthur's son, destined for greatness. But Jean, noting the plentiful Dido references in the scripts, concluded that Betty had been in a sense 'the leader of their enterprise', the success of the messianic project quite impossible without her sacrifice. Gerald and Piddington published their conclusions in limited editions marked 'secret'; some survive in Trinity College's Wren Library, their pages still uncut. Jean's feminist re-reading remained in the SPR records, where it moldered as our principals died. Nora Sidgwick died in 1936, Oliver Lodge in 1940, and Betty in 1942 – after which Gerald moved to Scotland, to be cared for by Jean and Ral, the son he never had much time for. Jean read all the scripts through to him in his last months, for Gerald was still waiting on Henry.

Henry was sent to Eton (of course), and then to Trinity (of course), where he got a first in moral sciences (of course), and then into the Welsh Guards (of course), just in time for the Second World War. Although Winifred, now in her sixties, went nearly crazy with anxiety, Henry had a good war. He was captured but made a famous escape out of wartime Germany; after the war, he went into the intelligence service. He was a dutiful son and never married, confiding his anxieties about his attraction to men to Ral; he was polite but the SPR devotees found him curiously flat. 'If Henry is really going to inaugurate a new Golden Age', the SPR secretary

wrote crossly in 1956, when Winifred died, 'the sooner he gets going the better'.

It was left to Jean to tell Henry the story of his mother's mediumship and his own parentage. Henry was enormously upset. Through the whole of his childhood, he told Jean, he had felt as if 'certain things mysterious to him . . . had always been expected of him'. He never knew what they were, and it had 'puzzled and disquieted him'. He was very bitter, and after 'considerable inner upheaval' became a Benedictine monk. Conceived to be a new Messiah and kept in ignorance of that plan for more than forty years, he sought shelter, and quite possibly absolution, in a more established faith. Augustus Henry Coombe Tennant, now Dom Joseph, died at Downside Abbey in Somerset in 1989. ■

The online version of this text on granta.com includes the full set of archival references.

All images courtesy of Houghton Library, Harvard University (MS Eng 1825).

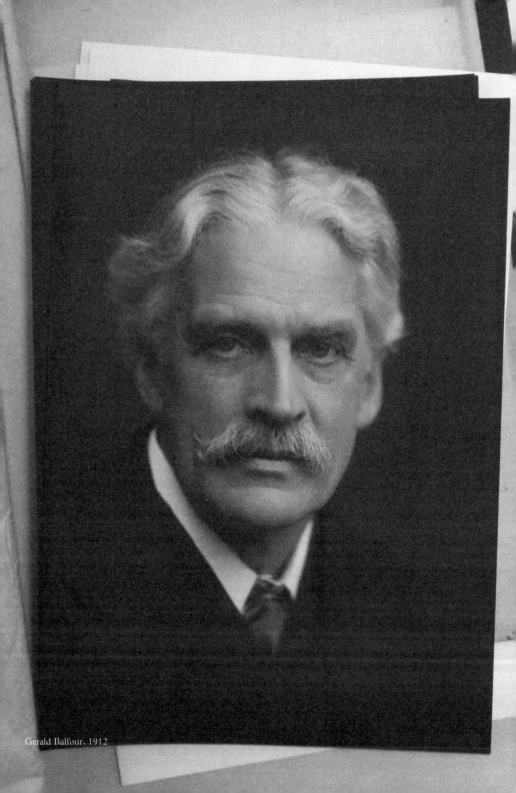
Gerald Balfour, 1912

White Study, Fishers Hill

Alexander Coombe Tennant, Lloyd George and Henry Coombe Tennant

Henry Coombe Tennant as POW

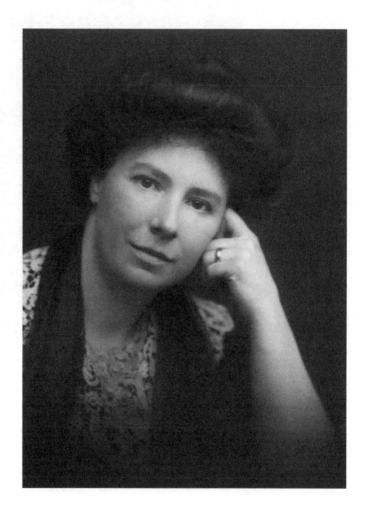

Winifred Coombe Tennant

British Journal of Photography's latest Ones to Watch issue presents cutting-edge image-makers recommended by experts from around the world. The 15 talents selected hail from Sudan to Seattle, and make work from found photography to fashion – but they share an intensity of vision. Also included are exhibitions, books and industry insights.

thebjpshop.com

British Journal of Photography

Najwan Darwish

Three Mukhatabat

He said to me:
'If the sea were ink for the Words of my Lord,
the sea would still run out
before the Words.'[1]

Is it becoming of me
– I who have run completely out of words –
to covet the Words of my Lord?

1 The Glorious Quran, 18:109.

He said to me:
The serpent that bit me,
its fangs alone
contain my antidote,
that's why it sees me waiting
at the entrance to its burrow.

He said to me:
Love led me
to pity my own self,
to grieve it
with a vertical grief.

That's what war failed to achieve,
along with all my enemies.

Translated from the Arabic by Kareem James Abu-Zeid

TRANSLATOR'S NOTE: These poems, which are called *mukhatabat* ('discourses') in Arabic, are modeled after a genre of text called *mukhatabat*, probably the most famous of which were written by the Sufi mystic Al-Niffari (died *c*.965 CE). Those texts by Al-Niffari are spiritual discourses of sorts, with each text beginning with the words 'He said to me'; the 'He' referring to God or the spiritual presence or the higher Self of Al-Niffari himself. Najwan Darwish is playing with that genre here, and diversifying its themes.

A WOMAN I ONCE KNEW

Rosalind Fox Solomon

Introduction by Lynne Tillman

> I made the nude self-portraits at times when I was
> feeling vulnerable. I never planned to publish them.
> At a certain point I asked myself, why not?
> – Rosalind Fox Solomon

Rosalind Fox Solomon's nudes portray a particular woman, and her experience of her body. These self-portraits stun with their unexpected compositions – a body posed in unlovely and awkward postures. Idiosyncratic images collide with historical and traditional representations of female nudes.

Fox Solomon's self-portraits work toward upending the seminal critique that, in cinema, 'woman [is the] object of the male gaze', Laura Mulvey's theory that appeared in her 1973 essay, 'Visual Pleasure and Narrative Cinema'. Mulvey proposed that onscreen women were subjected and subjugated to the male eye, objectified to satisfy his desire. Yet, an audience of others – gay men and women, straight women – see with their own eyes.

Fox Solomon took up a camera when she was forty, studied with Lisette Model, and found an abiding interest and pleasure in making photographs. From the start, she contemplated and investigated the problems that come with directing a camera at people of various backgrounds and points of view. She brought to photography her

previous and prevailing interests – family and other relationships, social and cultural differences, and, in a sense, turned into an artist of ethnographic persuasion.

Photography revolutionized how she lived. Drawn to picturing other lives, she pursued projects in Peru, Mexico, South Africa, and in New York City and the American South; she sought permission in photographing people, proposing a kind of collaboration by asking her subjects to choose how they wanted to be seen. Behind her camera, Fox Solomon, who was a shy person, now engaged with strangers, new and different kinds of people.

In photographing her nude self, Fox Solomon is no stranger to controversial subjects. With the advent of the Aids epidemic in the US, experienced first in NYC, people – generations who had seen polio cured and relied on penicillin – were overwhelmed and horrified, while gay men and women with Aids were further stigmatized. PrEP has eliminated the fear of getting Aids, for those who have access to it, but has not cured it.

During the scourge, Fox Solomon photographed people with Aids, spending time with them, often becoming friends. Her 1987–88 exhibition, *Portraits in the Time of AIDS*, at NYU's Grey Art Gallery, was revelatory and controversial: photographs of men, mostly, their bodies scarred, a face covered by Kaposi's sarcoma, a wasting body lying in a hospital bed, a friend or family member at the bedside. The love and affection shown in those photographs rebuked those who would not even touch people with Aids.

Some reviewers and the public objected to the display of these troubling images – infected bodies. But showing humanity is primary for Fox Solomon.

Fox Solomon shot these photographs over fifty years. In this series, she declares her independence as a woman, and as a photographer. The first photograph here shows her seated on a stool, her legs spread out – woman-splaining, I could say now. Her hands lie on her knees, but not in a restful manner – one hand forms a fist. She wears plain black pants and top, and running shoes. It is night, and behind her a black sky and large, screened windows frame her.

Not looking at the camera, her face is turned slightly; she might be thinking or looking off into space, her white hair creating another frame inside that of the night sky.

The composition of the space is plain, unadorned, a few objects in it. Her figure is somewhat off-center, one of her knees bent toward the door, perhaps. The running shoe is angled, intimating that this woman may want to run away, out of the picture. The self-portrait is far from still, and far from the usual representations of women: she is uneasy, restless, not making up a face for the camera.

Several nudes – in fact all of them – object to the familiar approaches. Fox Solomon is lying on her side on a wooden floor. Her left hip, in the forefront, seems to guard the body from complete vision. Her raised left arm partially covers one breast, her hand fully covers one eye. Much of her body lies in shadow.

A covered eye incites several interpretations. You can look at me, but not see me completely, since looking is not seeing. Another: you can't see me, and anyway I am hiding from myself. The covered eye is a pun.

In another, Fox Solomon is seated, perhaps in an imperfect yoga pose. Her legs are crossed awkwardly, one knee up, the other under it, while she grasps the foot of the raised leg. Her head juts forward, her dark eyes hooded, again playing with sight. Her nude body is effectively not available, her breasts, her genitals covered. The pose depicts ambivalence, especially to 'performing' nudity.

A photograph of hands is an artistic trope, the hands that create work, Michelangelo's finger reaching for God. Fox Solomon's version does not aggrandize hers; instead, they seem *unheimlich*.

The index finger of one points to the other hand, where four fingers are visible. A curious image, the four long fingers stretched out and flat. I spot a wound on that index finger, a detail mostly absent from pictures unless depicting the hands of workers. Behind her, a cross-hatched wall imitates the position of the crossed hands.

Her pose in another picture resembles an odalisque, but her look disarms the spectator. Her body is foreshortened, legs cut off after the thighs. Not fully supine on what seems like a bed, her body is angled, only one breast visible.

Her eyes look out of the frame and disrupt the viewer's gaze. Her face is accentuated by the V of one arm, which mimes the shape of her chin, emphasizing it. Eyes will find her eyes and, with her enigmatic, grave expression, lips closed, she frustrates satisfaction – for whose pleasure has she shot this? Her look claims her body for herself.

Fox Solomon hides as she exposes: her photographs insist that exposing is not revealing. The self-portraits demonstrate interiority, an effect in a photograph or movie that is particularly elusive. A subject's demeanor and visage can suggest thoughtfulness, melancholia, contentment, and so on. There may be nothing behind their expression.

Harry Mathews once commented, 'The writer is their own first reader.' Here, Fox Solomon is her own life model. But no artist who is a woman can escape the criticism that photographing herself is narcissistic. Men who do it – for example, John Coplans – won't be. Oh, that silly double standard. Fox Solomon says that she shot the nudes 'when she was feeling vulnerable'. It seems counterintuitive to bring herself forward, then, unless you understand it as resistance, an act against retreating from the world, forcing herself to face the world even then.

Her intent is different. The sculptural aspect of her nudes makes her body appear solid. Those unusual poses, hands and legs, focus attention on her physicality. These are not gentle, passive female bodies. They are strong women who strike poses that show aggression. And in the very last image of this photoessay, Fox Solomon wears a black bra and high black socks, she is crouched over, her hands in fists. Her determination to exist is powerful. ■

Photography by Rosalind Fox Solomon, from *A Woman I Once Knew* (MACK 2024). Courtesy of the artist and MACK

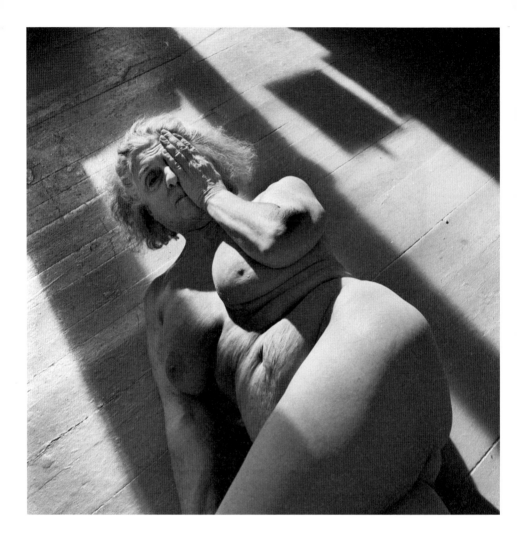

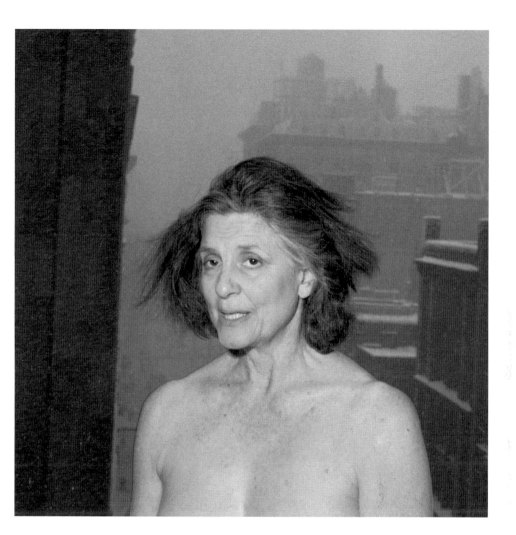

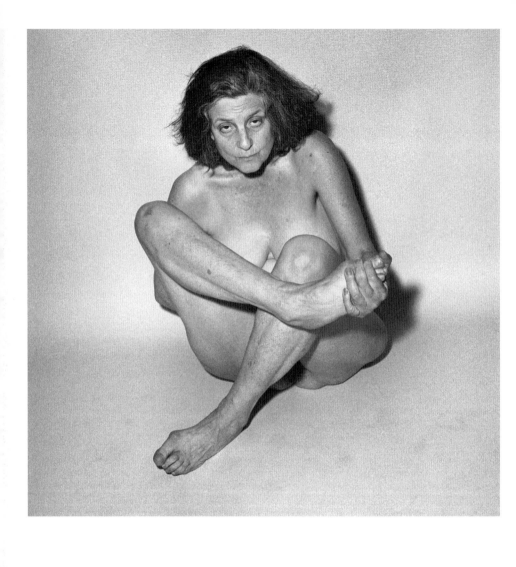

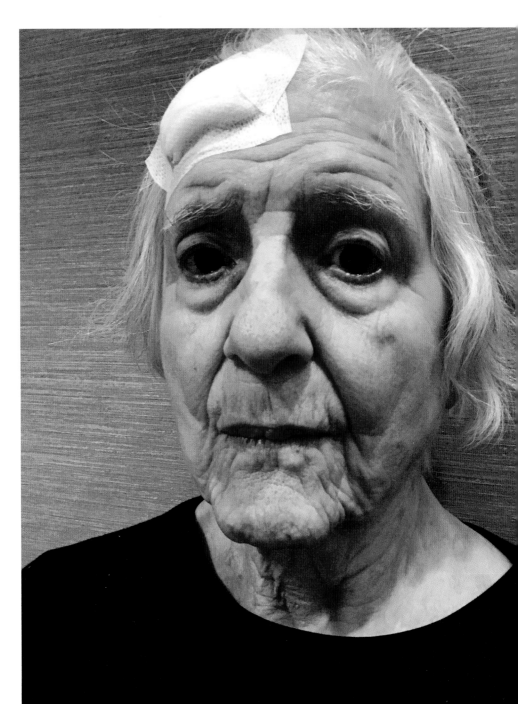

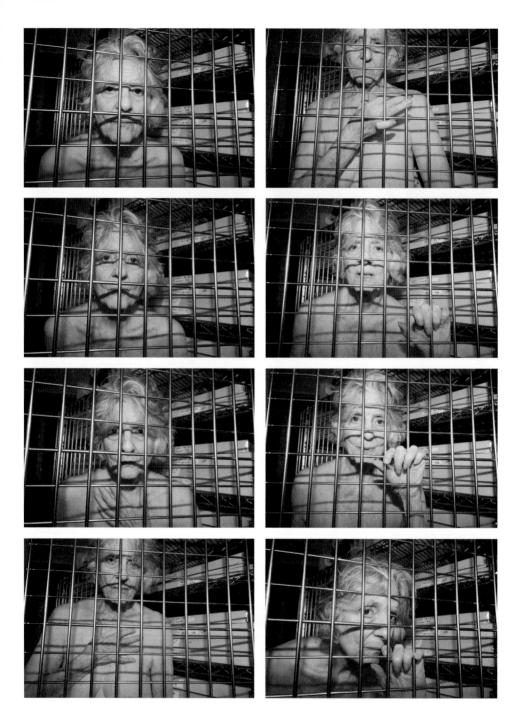

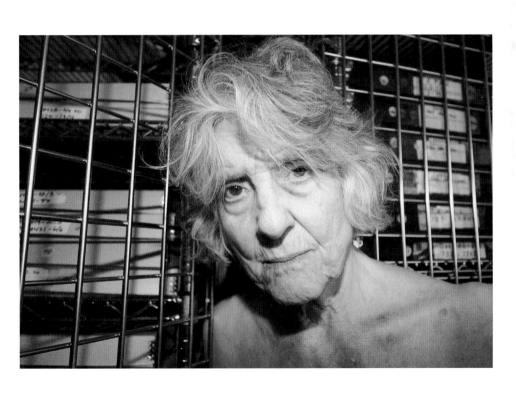

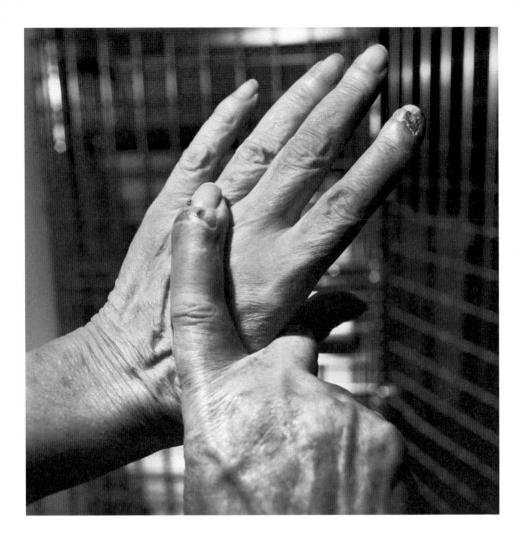

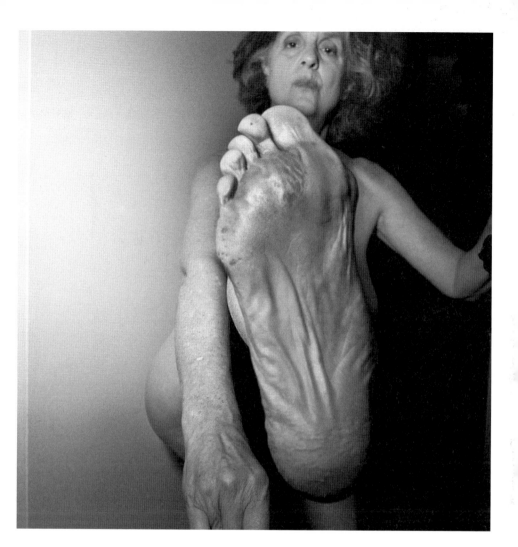

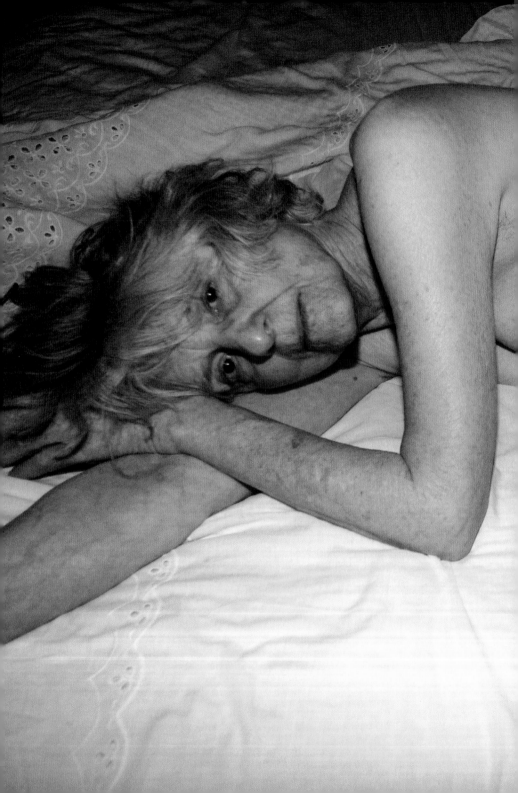

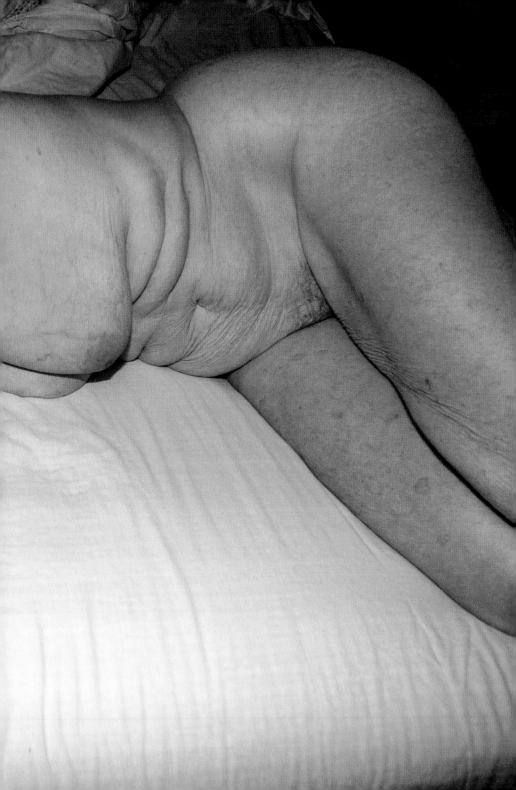

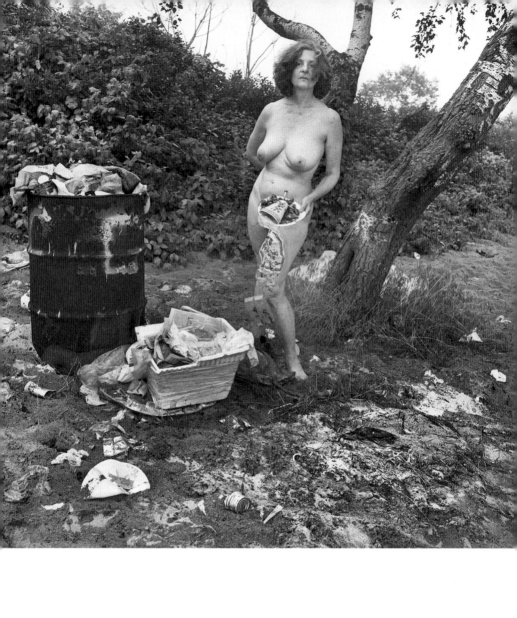

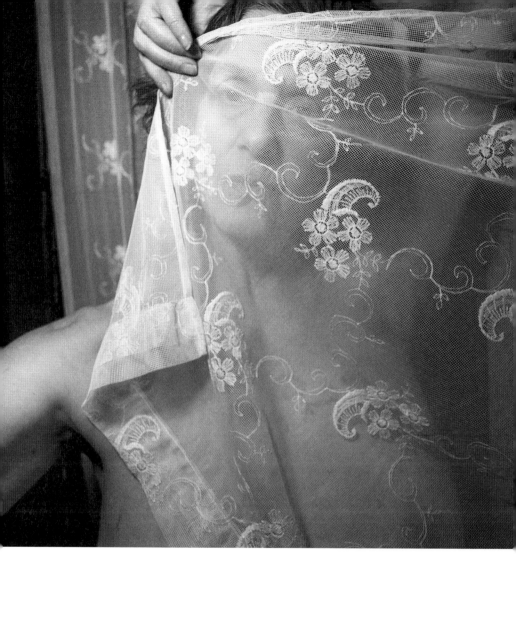

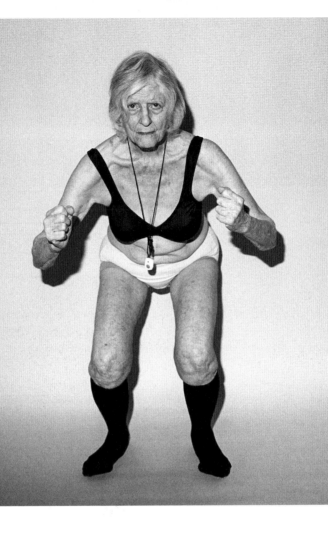

Crafts Council

Become a *Crafts* member.

Unlock a world of craft storytelling, live experiences, community and learning from £4 per month.

→ craftscouncil.org.uk/crafts

Image: Crafts magazine, Spring/Summer 2023 edition.

Supported using public funding by
ARTS COUNCIL ENGLAND

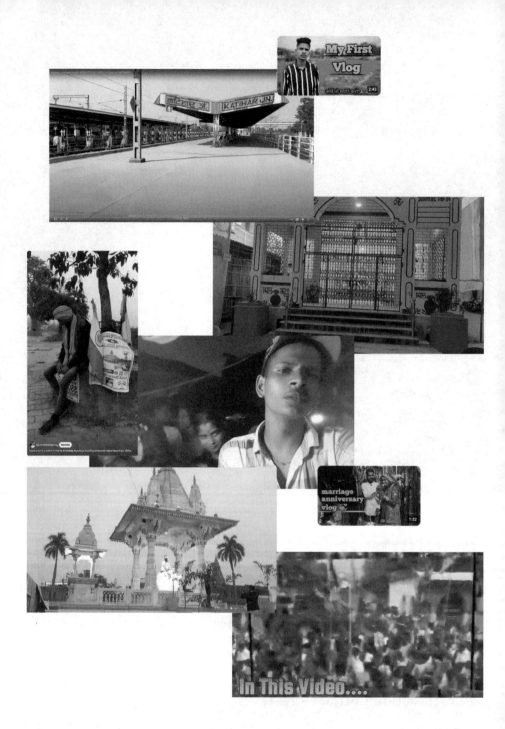

ANAND CHOUHAN
Stills taken from anandchouhanvlog/youtube

A JOURNEY TO AYODHYA

Snigdha Poonam

I

In early January this year, sixteen-year-old Anand Chouhan started the 825-kilometer walk from his village in Bihar to Uttar Pradesh. His destination was Ayodhya. Chouhan had scarcely left his village save for the time when he joined the wedding procession of a friend's sister to a neighboring district – an experience he livestreamed on his YouTube channel.

The trip to Ayodhya would take much more planning. If he only stopped for meals and rest, he reckoned he could cover the distance in fifteen days. Over a few weeks, Chouhan persuaded three of his friends to come with him. They stuffed their backpacks with blankets to endure the cold and deep-fried snacks to keep up the energy. When their parents heard their sons were going to Ayodhya, they opened their wallets and gave their blessings. Each young man contributed Rs 5,000 (£50) to the joint mission.

Chouhan departed from his village just before dawn, dressed in a gray shirt, faded jeans, a sturdy sports jacket, and a saffron shawl wrapped around his head. Lacking proper shoes, he had no option but to set off wearing only an old pair of slippers, but he didn't mind. He had invested in something far more crucial to the journey: a three-

foot-long flex banner that he strapped to his backpack. It served as a walking advertisement for his social media presence, featuring his Instagram details and a QR code that directed passers-by to his YouTube channel.

Stopping for their first break that morning, Chouhan uploaded a video of himself shot on his mobile phone. 'Hi, guys. I am Anand Chouhan. I am starting on an 825-kilometer journey on foot to Ayodhya from Bairbana village in Purnia. Please support me. Like my videos and subscribe to my channel. In the comments, write, *Jai Shri Ram*.'

(Glory to Lord Ram.)

II

'Tell me, great one, who is the most virtuous man in the world of humans? Who is the most honorable, dutiful, gracious, and resolute? Who is the most courteous, the most dedicated to the welfare of all beings, the most learned, the most patient and handsome? Who is the man with the greatest soul, the one who has conquered anger, who is intelligent and free of envy? Who is this man, whose anger frightens even the gods?'

Thus begins the legend of Ram. It was sometime between 750 and 500 BCE that Valmiki, a Hindu ascetic, composed the epic poem in Sanskrit about a warrior-king who embodies every virtue known to humanity. *Ramayana*, the most enduring of all Indian tales, puts its hero through a series of trials. Some are inner tests of strength, others on the battlefront. Through them Ram demonstrates how to live by the principles of *dharma*.

The story is set in Kosala, a majestic kingdom on the banks of the River Sarayu. Its capital is Ayodhya, where the mighty king Dasharatha lives in a palace with three wives and four sons. Ram is the oldest of them and the most deserving heir to the throne. But on the eve of his ascension, Dasharatha exiles the righteous prince to keep a promise made to his jealous third wife, who wanted her own son, Bharat, to become the king.

Ram, along with his devoted wife Sita and loyal brother Lakshmana, withdraws into a forest south of Ayodhya. The defining event of their exile is Sita's kidnap by Ravana, the mighty rakshasa king of Lanka. To rescue his wife from Ravana's fortified kingdom, Ram has to traverse an ocean and defeat a formidable army. He assembles a diverse group of allies, including a brigade of combat-ready monkeys, steered by their leader Hanuman. By constructing a bridge across the ocean, a remarkable feat of engineering, Ram and his battalion of monkeys reach the island of Lanka, and after a fierce battle, he kills Ravan and rescues Sita. The story culminates with Ram's triumphant return to Ayodhya fourteen years later, when he is anointed king. His reign, known as Rama Rajya, ushers in a period of unparalleled peace and prosperity.

Valmiki gave no indication that the cities and kingdoms in the *Ramayana* were inspired by real places. But in 1574, while India was under Mughal rule, the wandering saint Tulsidas authored a new rendition of Valmiki's epic, elevating Ram to divine status and affirming Awadhpuri (also known as Ayodhya), where he began writing the manuscript, as his birthplace. But even his text did not fuss over the physical location for the mythological kingdom. If the god can be found in a devotee's heart, so can his birthplace, went his message. *Avadh tahan jahan Ram nivasu.*

(Wherever Ram is, there is Ayodhya.)

Once written down, the events associated with these *Ramayanas* entered the realm of facts.

Half a century before Tulsidas completed his adaptation, a Mughal general built a mosque in Ayodhya reflecting the architectural style of that period. Named for Babur, the first Mughal emperor of the subcontinent, the Babri Masjid featured a large prayer hall, several smaller rooms, and a spacious front courtyard. It was distinguished by tall spires and three domes.

By the seventeenth century, however, it was widely believed locally that the Mughals had demolished a Ram temple to build the mosque, and that this temple was located at the birthplace of Ram. And when

the East India Company annexed the area in the 1850s, they found that Hindu–Muslim conflict over the site was frequent. Following an outbreak of riots, British administrators erected boundary walls to create separate worship areas for Muslims and Hindus. The Hindus were allowed to conduct worship at a provisional setup a hundred paces from the mosque. On a raised platform in the southeastern corner of the compound, Hindu priests placed the idols of Ram and other deities. It was separated from the area around the mosque by stone walls on the east and south, and iron railings on the west. Called Ram Chabutra (Ram's Platform), it had its own entry through a small gate built into the eastern wall.

In 1860, a group of local Muslims submitted a petition to the district magistrate for the removal of the Ram Chabutra, complaining the 'Azaan of the Moazzin was met with the blowing of the conch shells by the Hindus', but it went unheeded.

At midnight on 22 December 1949, a Hindu priest and his followers jumped into the inner courtyard with an idol of Ram as a young boy. Moving quietly in the dark, they planted the idol inside the mosque, in the hall beneath the central dome. Using a trowel, the vandals scraped off Islamic carvings from the inner and outer walls and wrote 'Rama' and 'Sita' in the hollow spaces.

Its 'miraculous' appearance was interpreted as a sign that Ram wished to reclaim his ancestral home. Once again, Ayodhya had new rulers: Indian officers working for the first government of the newly independent India. Many of them openly backed the Hindu stance.

The Muslims in Ayodhya feared these district authorities were supporting the Hindu conspiracy to seize the mosque. By this time, Hindu mobs were regularly beating up Muslims on their way to the daily prayers, and some had even dug up Muslim graves and destroyed their shrines in the vicinity of the mosque. And yet, the authorities repeatedly failed to act. Claiming there would be riots if they removed the idol, they locked up the mosque and put a stop to worship.

That is largely where the dispute stood when the Bharatiya Janata Party (BJP) came into being on 6 April 1980. The party brought

together strands of Hindu nationalist thought that had, in earlier times, been reflected on the right of the dominant Congress Party but had found little purchase in the politics and constitutional practices of independent India. As the social coalition between castes and religions that kept the Congress in power declined, the revivalist ideology of the Rashtriya Swayamsevak Sangh (RSS), a volunteer-driven quasi-militant organization, gained adherents – and the BJP, its political wing, sought to forge a voter base unified by religious identity. That could only happen if India's billion Hindus set aside their endless differences – languages, castes, sects, deities, rituals – to aspire to one overarching ideal. Ram was the obvious answer. 'As all rivers flow into the sea, so all good and noble people come to Ram,' as the celestial sage Narada informs Valmiki at the beginning of the *Ramayana*.

What had been a provincial issue until this point was on its way to becoming a binding mission for Hindus all over the world. The Hindu nationalist movement hit the ground with a one-point slogan: *Mandir wahin banayenge.*

(We will build the temple there only.)

III

Like Anand Chouhan, Santosh Dubey was sixteen years old when he embarked on a journey with Ram on his mind. He joined the temple movement in 1984. Like other boys his age in Ayodhya, he spent much of his time roaming the city, where several popular spots were linked to Ram's legend. They climbed the steps to the Hanuman Garhi temple on the top of a cliff, built for Ram's devoted soldier, Hanuman; walked in circles around the Dasharatha Kund, where the last rites of King Dasharatha were believed to have been performed after he died of grief; and squeezed into a narrow lane to reach Sita ki Rasoi (Sita's Kitchen), where a tableau of clay figurines and artifacts shows Sita cooking a meal for Ram and his brothers.

In January 1986, Dubey's older cousin, Umesh Chandra Pandey, an independent lawyer in Ayodhya, filed a court petition on behalf

of the public, requesting the removal of the locks that had been placed on the Babri Masjid's gates decades earlier. On 1 February, the judge ordered the district collector to open the mosque to Hindu worshippers. That evening, Dubey's cousin came to his house in the old quarters of Faizabad, Ayodhya's twin city, where he lived with his parents, with a box of sweets. His cousin asked him if he was prepared to commit to the next task at hand. The temple cannot be constructed, he explained, until the mosque is broken down. 'Leave everything,' he said, 'and focus on your sole purpose.'

Dubey couldn't sleep that night. Restless, he went to the banks of River Sarayu the next morning to seek an answer. Sitting under an Ashoka tree, he felt someone pat his head from behind. He turned around to find a Hindu ascetic whose face shone with divine radiance. He prostrated himself at the man's feet. The saint knew the question keeping him awake: 'Aren't you asking yourself how to bring down the mosque?' The task, he said, won't be easy to carry out. The ascetic asked him to meet him the following morning at the gates of the Babri Masjid.

A huge crowd waited for a glimpse of the idol of Ram. It stood in the same place where it was planted in 1949. Despite the heightened tension, Muslims continued to pray in other parts of the mosque.

When Dubey went in, following the holy man, he saw some of the most influential people in the town – saints, government officers, businessmen – bowing before the deity. Not one of them would do what was needed to build the temple, he thought to himself. He ran out of the premises, filled with rage. On his way back home, he took a vow: he would only return to the mosque armed to raze it to the ground.

In 1989, the Vishwa Hindu Parishad (VHP), a prominent Hindu nationalist organization with close ties to the BJP and the RSS, launched a campaign to collect bricks for a new Ram temple at Ayodhya from Hindus all over the world. Millions of bricks came in, including many sent via airplanes from Britain, Germany, Canada, South Africa and beyond. The campaign was more than a logistical

exercise – its real purpose was to take the measure of Hindu unity: one god, one holy book, and one place of worship.

The next year, the fiery BJP leader L.K. Advani launched a 10,000-kilometer procession across the north of India. It was to end at Ram Janmabhoomi (birthplace) in Ayodhya; but he began it from the Somnath temple in Gujarat, which had been repeatedly destroyed by Afghan invaders and controversially reconstructed in the early years of Indian independence. The procession's intention was obvious.

He stood in the front of a specially designed Toyota, styled to mimic a chariot, the vehicle Ram used in his final battle with Ravan. Hundreds of thousands of supporters joined the procession – on foot, on motorbikes, in cars – all converging toward Ayodhya with fervent determination.

Santosh Dubey was one of them. Since taking the vow to break the mosque, he had been working on the ground to gather support and resources. He led the Hindu nationalist outfit Shiv Sena in eastern Uttar Pradesh. Going from village to village, he had been organizing meetings and enlisting foot soldiers, known as *kar sevaks*. Now, he listened as Advani bellowed into giant loudspeakers tied to the front of his chariot, calling for the end of the opposition parties' 'pseudo-secularism'. Indian constitutional secularism disadvantaged Hindus unfairly, the argument ran, and the inability to build a temple at Hinduism's holiest site was an example of that. Raising their fists to the sky, his supporters chanted an updated version of the old slogan: *marenge, mar jayenge, mandir wahin banayenge.*

(Ready to kill, ready to die; we will build the temple there only.)

The rath yatra did not reach its destination. Two avowedly secular state governments blocked its way. A few hundred kilometers ahead of Ayodhya, the Janata Dal-led government of Bihar ordered its police to arrest Advani. Though many of those marching retreated to their homes, around 40,000 continued toward Uttar Pradesh. The state's chief minister, Mulayam Singh Yadav of the Samajwadi Party, said he wouldn't allow even a bird to fly into Ayodhya. His officials placed the

SNIGDHA POONAM

city under a strict curfew and stopped buses and trains from entering it. Some 30,000 armed guards of the state constabulary were deployed around the Babri Masjid. Still, nearly 10,000 *kar sevaks* managed to sneak inside, some of them swimming across the River Sarayu.

Dubey and a group of believers broke through barricades at the mosque and clashed with the security forces. Tying cotton towels to the pointed niches circling the outer walls, he and a few others pulled themselves up to the domes. At the summit, they hoisted a saffron flag. The police opened fire from below. Dubey and his cohort dispersed, and for the next two days they remained underground. On 2 November, in a tense encounter on a crowded street, police shot and killed several *kar sevaks*. Dubey fled with four bullets inside him: shoulder, chin, arm, and back. His friends took him to a hospital where he was treated for his injuries. After two weeks, Dubey returned to his house in Faizabad. He resumed his mission right away.

IV

In 2020 Anand Chouhan embarked on a personal venture: his own YouTube channel. He was twelve years old, and he had decided to post tech reviews of free mobile phone apps. He had time to burn. The government school he attended in his village had barely any teachers, and students regularly cheated on exams. After graduating, he would have to choose between attending the local college or migrating to a city to work at a factory or construction site. If he stayed in the village, he would have to work at a local shop or open his own. Chouhan wanted a different life: he wanted to become an influencer. As he had outlined in a video on his channel, this was his one shot at becoming rich and famous. That would only happen if his videos reached millions of people. Should he manage to amass 10,000 followers, he could earn ten times that number in rupees, he estimated, through commissions from promoting products and services, ad revenues from the platforms, and paid appearances at local events. 'I have only one dream: that my videos become viral.

138

I hope that people will know me one day. That I will become a person of some importance', he told his followers.

Chouhan closely observed the trends that made other influencers successful. There was an unmistakably growing interest in religious material. He began livestreaming Hindu festivals and processions to his modest base of friends and followers, who were primarily from his village and its surroundings.

In January 2023, the RSS announced its plan to install Ram's idol at the temple in exactly a year. Some popular Instagram users Chouhan followed began posting videos to inform their audiences about the upcoming event. YouTube, too, was exploding with videos building up anticipation.

A number of social media influencers were going to attend the inauguration. Some of them were officially invited as part of a VIP cohort that featured Bollywood celebrities, business moguls, Hindu ascetics, and the relatives of some of the *kar sevaks* who died when the police opened fire in the 1990s. Chouhan told himself he had to be there too. He posted a video directly conveying his wish to Lord Ram: 'Ram-ji, I am coming to you. I am telling you in advance: I want my videos to get at least 100,000 likes.'

After reaching 600, Chouhan's follower count had stopped rising. At first, he blamed himself and his shoddy mobile phone. Then he shamed the online world for passing up his content in a video tirade. 'Is it because I am from a village? Is it because I am poor? Because I don't have a fancy phone? Why do you refuse to like my videos? Why wouldn't you share and subscribe?'

The pilgrimage to Ayodhya could change everything. Wouldn't everyone support an arduous pilgrimage by a sixteen-year-old? The question was not unreasonable. Within a day or two of leaving home, his channel was attracting new followers. At their first stop in Champaran, a stranger donated Rs 200 to his digital wallet via another QR code printed on his flex banner. Another man they met on a highway east of Gorakhpur took them to his home for a night's stay.

SNIGDHA POONAM

By 11 January, Chouhan and his companions had covered a quarter of the distance. With their resources nearly depleted, they could no longer afford to stop for proper meals. Once in a while, a restaurant owner would feed them for free as an act of devotion. Otherwise, they walked on hungry stomachs, slowing down until they came across street carts selling vegetable biryani for Rs 20 a plate.

Each day, Chouhan posted a video sharing updates from their journey: spending a night at a temple, meeting other pilgrims on the way, and getting lost inside a jungle near Gorakhpur in eastern Uttar Pradesh. 'As you all can see, it is completely dark out here. Can't see anything. Another five kilometers to walk before we exit this forest. We are scared out of our wits. Only a short while ago, we came across a pack of wild boars. Two of them started chasing us. They seemed to be attracted to our saffron flags. We have managed to escape them, at least for now.'

On the fifteenth day, he removed his sandals to show the blisters all over his feet. At the end of his videos, he urged his followers to drop 'Jai Shri Ram' in the comments. Before falling asleep, he reviewed the likes and responded to the comments. He prayed that not only his followers but the lord, too, was watching him overcome every obstacle to complete his pilgrimage. 'I am sure he will reward me after seeing everything I have been through.' He posted this video from Basti, fifty-kilometers from Ayodhya. He had two more days to go. Chouhan kept marching.

V

After the 1991 general elections, the construction of the temple became a real possibility. The BJP had performed strongly: it was now the second-largest party in the Lok Sabha, and had for the first time captured power in Uttar Pradesh. Santosh Dubey, proudly demonstrating the scars left behind by the four bullets that had been fired into him at Ayodhya, embarked on an extensive recruitment drive across the state. This time, he only selected volunteers willing

to break down the mosque. Five thousand – 4,000 men and 1,000 women – filled out a form stating they were prepared to die on the appointed day. Each signed with a finger dipped in their own blood.

The next phase involved preparing these volunteers for their mission. Dubey transported groups of *kar sevaks* to an ashram in the mountains of central India, where the VHP set up training sessions under a militant sect's guidance. The drills, spanning from dawn to dusk, focused on mastering the skills necessary for swiftly ascending and descending large stone structures. If strangers saw them haul themselves up by ropes, they explained they were training themselves for an expedition to Mount Everest.

After their training, the volunteers who had pledged their commitment with blood received postcards from the VHP instructing them to converge in Ayodhya on 5 December. Dubey was in charge of organizing supplies. He compiled a detailed inventory of the equipment required, including swords, tridents, rods, spades, hammers (1,000 of each), along with 500 meters of rope equipped with hooks and a cash fund of Rs 50,000. This list was handed over to a minister in the BJP-led Uttar Pradesh government, who arranged for the materials. An arms factory in Kanpur manufactured the tools, while local artisans in Ayodhya produced the swords and tridents.

On 3 December 1992, the same minister came to Dubey's house to collect him for a meeting with an important person. In a Hanuman temple in Ayodhya, he was introduced to L.K. Advani, who, he claimed, spoke with unwavering clarity: 'I don't want this Babri structure to remain after 6 December. You will get whatever you want to raze the mosque; we have our government in the state.'

On 6 December 1992, Dubey started his day with a prayer to Ram, and marked his forehead with a saffron tilak. He set off toward the mosque armed with a pickax and a rope. By 10 a.m., *kar sevaks* were converging on the domes. This time they would not be opposed. The police stepped away, apparently on orders from the BJP chief minister's office. From the base of the mosque, volunteers

threw hooked ropes to latch on to the domes and pulled them down with their collective strength. Others stationed at the sides attacked the structure with hammers and pickaxes, while a group ascended to the top, waving swords and tridents. Nearby, leading figures from the BJP and associated Hindu nationalist groups took turns on a makeshift stage to motivate the vandalizing mob.

Ek dhakka aur do (One more push).

Babri masjid tod do (And the mosque will fall).

The demolition unfolded one dome at a time. Each dome's fall kicked up clouds of dust and debris. Ayodhya's skyline was shrouded in a dense, brown haze.

VI

Driving around Faizabad on 21 January 2024, Tahir Shams was working out a solution to an odd new problem. He had just been informed that the Bollywood actor he was meant to drive to the temple on the morning of its inauguration was only willing to leave the airport in a Mercedes. Caught off guard, he had less than twelve hours to find a new car.

Until a few months ago, Shams ran his family's local shop for sanitary hardware. Their Muslim family had lived in Ayodhya ever since Shams's grandfather migrated from his native village in a neighboring district. His father, a hard-working businessman, cemented his family's local status one venture at a time. 'First, he opened a paan shop, then moved to trading coal, and finally took a bet on the sanitaryware business,' Shams said, his voice gathering feeling as he recalled the deep reserves of goodwill his father drew on all his life.

He believes this supply of goodwill is what saved them from the sweeping violence set off by Babri Masjid's demolition in 1992. Shams was eight years old then. Groups of *kar sevaks*, armed with swords and tridents, were scanning every neighborhood for isolated Muslim homes. 'Like my siblings and cousins, I hid inside a large

trunk in which our families stored our winter clothes. My father and uncles were standing guard outside the house – not to fight them but only to protect us.' The fact that they lived in a cluster of 3,000 homes defined by close relationships between neighbors, regardless of religion, came to their rescue. 'In the thinly populated areas, the Muslims weren't spared,' Tahir said. Chanting 'Jai Shri Ram', the Hindu mobs destroyed 400 homes and killed eighteen people. Hundreds of Muslims left the city afterward. But Shams's family stayed on.

In 2019, when the Supreme Court handed over the contested site to the Hindu litigants, he did not see the point in complaining. 'We are citizens of a functioning democracy. We must believe in the integrity of our Constitution and respect the decision of our highest court,' he told his Muslim friends and acquaintances.

In 2023, when work began on the new temple, Shams welcomed the possibility of the city's overall development. Then, all of a sudden, their shop was leveled to the ground. The reason the Shams were given by the district administration was that the building stood in the way of Ayodhya's ongoing transformation, with plans for four-lane roads, luxury hotels, towering arches, sprawling parks, and multi-level parking. Spearheaded by Prime Minister Narendra Modi himself, the $10-billion project aimed to turn the small town with serpentine streets into a spiritual destination competing with Mecca and the Vatican.

Municipal authorities gave Shams's family, as well as thousands of commercial establishments, houses, and roadside temples and shrines, terse notice before the bulldozers rumbled in. Once again, Ayodhya was in the headlines because of a large-scale demolition linked to the making of the Ram temple. This time, though, the victims, both Hindus and Muslims, were supposed to be compensated for every square meter of property destroyed in the process. Not only were the locals offered a minimal amount, but few could hope to build a new house or shop in a city where real estate prices had skyrocketed since temple construction began. Many homeowners and shopkeepers

appealed against the order; some took the matter to the courts. 'Only Hindus. Not a single Muslim raised an objection,' Shams told me. Few of them would risk the ire of a government that flaunted a bias against Muslims.

Shams was determined to turn the crisis to his advantage. After the temple opening, district authorities expected some 400,000 tourists every month, exceeding Ayodhya's resident population. He coaxed himself to think like an entrepreneur – this could be a chance to redeem the failure of his previous start-up, a manufacturing unit for adhesives that closed shortly after his brother, who was his partner in the business, died of a sudden illness.

No, he wouldn't be opening another shop, he informed his family. With a modest loan from his wife, who had a stable government job, he started a tour-and-travel company he hoped would serve hordes of new visitors from India and abroad. He would provide them with chauffeur-driven SUVs to take them to the mythological sites, and knowledgeable guides to explain their links to the *Ramayana*. Working against the clock, he created a website and a WhatsApp channel. He named his company Ayodhya Darshan (Ayodhya Viewing). Its logo showed Ram in his martial avatar: an arrow stretched across his famous bow.

With all of the arrangements in place, he waited for the temple to open. But something worried him: what if Hindu visitors shunned his services because he was Muslim?

The opening of the Ram temple would put Ayodhya on the tourist map. But it also promised to become a flashpoint in the rising tide of Hindu bigotry that the BJP encouraged against India's more than 200 million Muslims. Across India, Hindu hardliners were calling for the commercial boycott of Muslim-owned establishments.

Ask anyone in Ayodhya, and they will say the city's Hindu–Muslim harmony can withstand any test. Shams himself is not immune to the sentiment. Like many proud locals, he believes outsiders – whether sword-wielding *kar sevaks* or scheming politicians – are to blame for causing trouble in Ayodhya. But he admits something has changed.

'A landlord will ask for your name before agreeing to show you his house to rent,' he told me. In the markets, Hindu buyers steer clear of Muslim-owned shops. In the schools, Hindu children mock their Muslim classmates.

Even on the streets of relatively integrated Ayodhya, the completion of the temple movement had fulfilled a core Hindu nationalist agenda: the creation of a line of contagion from Babur, the subcontinent's first Mughal ruler, to the youngest of Indian Muslims.

It laid another foundation stone for their alternate version of history, which fixes as the starting date of India's colonization not the advent of the British Raj, but the arrival of Islam. In declaring freedom from 'centuries of enslavement', they aim to consolidate a national identity that is unarguably Hindu. The new temple in Ayodhya bolsters the portrayal of Indian Muslims as inheritors of a foreign, oppressive legacy, and casts them as outsiders within their own country.

'But we did not accompany Babur to India. We do not belong to Uzbekistan. We don't have roots in Saudi Arabia. We did not come from Turkey. We come from the same stock as the Hindus of this country. We have the same ancestry. We are the same people. We look similar to each other, we eat the same food, and we speak the same language. The only thing that makes us different is that we accepted Islam,' stated Adil Mustafa, a childhood friend of Shams's, on the eve of the temple's opening.

For Shams, the future seemed split between two possibilities: 'Either this grand temple becomes something that all Indian citizens, irrespective of their faith, can take pride in, or it divides us forever.'

VII

On 22 January, Modi's special helicopter, a Russian import with military capabilities, landed in Ayodhya at an airport built as part of the city's $10 billion transformation. His cavalcade proceeded to the Janmabhoomi along a new thirteen-kilometer corridor named

Ram Path. Standing prominently in the middle of an open-top vehicle, he waved to the throngs of people chanting his name from behind the barricades. In the kind of careful choreography he has practiced from the beginning of his career, Modi scooped up rose petals in both hands and threw them in the air. Anand Chouhan elbowed his way to the edge of the rope to record the moment for his followers.

Chouhan had arrived in Ayodhya the previous night. The city was more packed than he imagined. He had been told the temple authorities had set up tents for pilgrims to rest at night, but he couldn't find any. On a pavement close to the Janmabhoomi, he sat down to rest his feet and took in the scene. To his right, he saw a raised platform where visitors with nowhere to stay were spreading blankets to claim their spots for the night. To his left, an influencer moonwalked to the beat of a hymn anticipating Ram's return from exile. All around him, he could see construction workers seize the final hours: laying bricks, operating cranes, polishing rows of pillars.

During Modi's visit, the construction of the temple complex was only partially complete, but a three-story structure had been readied for the placement of Ram's idol. Chouhan had only seen it online. Crafted from pink sandstone and white marble, this structure sprawled across 70,000 square feet, boasting five pavilions, 392 pillars, and forty doors, some of which were made of gold. Entry to the site was highly restricted: Chouhan walked up to the temporary gates only to be shooed away by the security guards. He went to make some short videos of the new tourist attractions in Ayodhya. But there was barely a place to stand in any corner of the temple town, let alone get a good view of the fourteen-ton sculpture of a veena, a plucked string instrument, installed at a roundabout officially named 'selfie-hotspot', or the floating screen on a bank of the River Sarayu that showed the facade of the new temple.

On the positive side, his follower count was steadily rising, from 607 to 3,200 between leaving home and reaching Ayodhya.

Chouhan slept on a bench and got up early the next morning. Along with tens of thousands of people, many of them completing

their journey on foot, he positioned himself on Ram Path. Adorning the walls on both sides of the corridor were intricate murals depicting scenes from the *Ramayana*: Sita's poignant wait for Ram beneath a tree during her captivity in Lanka, Hanuman's awe-inspiring flight over the ocean with a mountain clasped in his palm, and Bharat's reverent placement of Ram's wooden sandals on the throne. He lifted his heels to get a 360-degree shot.

Nearly three hours passed before he saw the prime minister waving in his direction. He posted the video as soon as he had shot it. As always, he urged his audience to leave comments saying 'Jai Shri Ram'. This would be his last video from Ayodhya.

Away from the hustle-bustle, Santosh Dubey was tending to loudly mooing cows in the narrow lane outside the crumbling house left him by his parents. Wearing a faded kurta, an old sweater, and a thick woolen hat, he looked older than his fifty-six years. A large part of his day is spent on domestic errands these days. He had just returned from the local market with vegetables to be cooked for dinner. His wife and son were close by.

Dubey had not yet laid eyes on the new temple or received an invitation to the inauguration ceremony. For years now, he had been drifting away from the official Hindu nationalist establishment. 'Neither Shiv Sena nor BJP or VHP helped me with the trial that dragged on for twenty-eight years,' he said. Dubey, who was named the main accused in the court case litigating Babri Masjid's demolition, was cleared in 2020, along with thirty-one others including L.K. Advani. Throughout the trial, Advani and other BJP leaders maintained that they played no role in the demolition. Dubey saw that as craven retreat.

He began to suspect they were never serious about building the Ram temple. He now questioned Modi's dedication to the temple project. 'I did not have faith in him. By then I knew better than to trust politicians,' he said.

In 2016, he started his own volunteer-led organization, called Dharm Sena, literally an 'army' of people fighting for a holy cause.

'I did that to mobilize the public so that the political class would feel the pressure to act on the Ayodhya issue. Thousands of people joined me. We were openly saying that if the Supreme Court did not decide in our favor, we would not shy away from another event like the one that took place on 6 December 1992.'

When the judgment came that the Hindus could build the temple, he considered his life's work complete. With a Ram Mandir standing 'on the same site', he reckoned, it would be a good time to build a new house for himself and his family. He looked at the walls of his house grown black with mold. He wondered whether the cows would appreciate a new shed.

As for the temple, there was no rush. He might visit on his own after the VIP crowd had dispersed or assemble a crowd of *kar sevaks* from the 1990s. 'Those of us who are still alive.' He did not have a date in mind.

A nand Chouhan walked back to Purnia, his mind swirling with plans for the future. He was alone this time. His friends had retreated much earlier, telling him he was wasting his and their time. But he knew he had done the right thing. He was already planning his next pilgrimage, with the target to hit 10,000 followers. At the end of the year, when he had saved some money working at a friend's shop, he would go on a tour of the *char dhams* – a set of four sacred sites Hindu pilgrims visit in a sequence, from Yamunotri, up in the Himalayas, to Rameswaram, at the tip of the Indian peninsula, where, according to the *Ramayana*, Ram built a bridge to cross the sea to Lanka. Chouhan felt confident that if he kept on walking, he would find a way.

T ahir gave up on the quest to find a Mercedes. 'I made several calls, even reached to acquaintances in Lucknow [the state capital], but every luxury vehicle had already been booked for the day of temple inauguration.' He turned his focus to less demanding clients. But even then, a major hurdle stood in the way: 'If I sent

a Muslim driver, some of the customers would refuse to sit in the car.' As always, he stayed positive. 'I would ask the driver to put them on the phone with me. I spoke to them courteously. I showed them my good nature. After talking to me, or meeting me, everyone drops their prejudice.' ∎

The quotes from Ramayana *are from Arshia Sattar's translation of* Valmiki's *epic.*

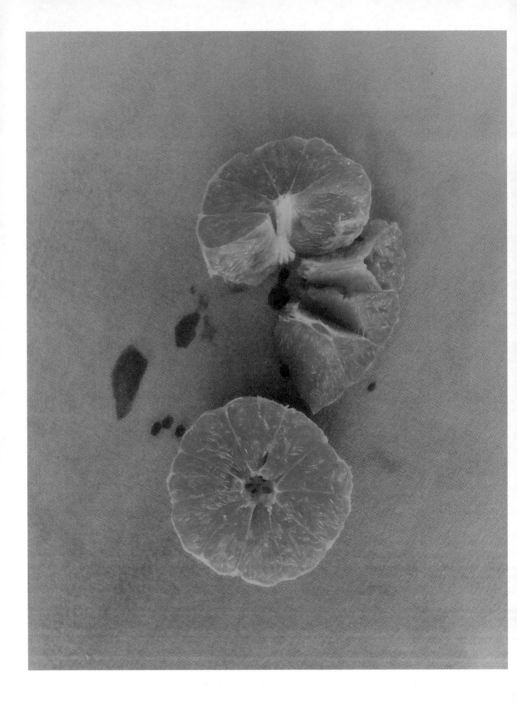

BITTER NORTH

Alexandra Tanner

H al had a bad shoulder. Danna had no patience for it. She felt Hal was selective about what the shoulder could take. They could fuck in whatever position, he could carry her bags at the airport, but if Danna wanted to book a duo Pilates session ever, Hal was in agony. He often said it like that: *I'm in agony.* Hal and Danna were sitting on a restaurant patio, eating cheeses. Hal had the ball game up on his phone. In the morning, they'd leave on a short vacation in celebration of Danna's birthday; the night before a vacation, they never ate at home.

Hal was moving his right shoulder in circles: forward, backward, forward. When he did his shoulder exercises his face always became vacant, upsettingly so.

'Who's winning?' Danna asked.

'Not us,' said Hal. He rolled his shoulder harder. 'Jesus Christ,' he said. 'Fuck.' He made a disgusting noise of relief and rubbed his right shoulder with his left hand.

Hal had no shame about pain. He'd grown up loved. Danna had been loved too, but by parents who were doctors. There'd been no room for pain in Danna's house; her parents were amputating feet and resecting bowels. The only person who'd ever cared to hear about Danna's pain was Hal. It was what made her love him right away: how

seriously he took everything about her. When Danna had a headache Hal brought out his special headache hat, an ice pack in the shape of a crown. When Danna had strep, Hal shone a flashlight in her mouth to look at her tonsils twice a day and gave her creative descriptions of how they looked. *The left one looks like a striped candy. The right one looks like a blobfish.*

Hal held his silverware in the European style because his mother had grown up holding it that way. He could flex his butt cheeks independently of one another, on command. He'd published a chapbook straight out of grad school about an empty field and time passing and dedicated it to Danna. Danna had intrusive thoughts sometimes about Hal getting crushed by the train or stabbed by a bum on the train or stabbed by Danna herself in the middle of the night while she sleepwalked, which she'd never done, but which she always feared she might spontaneously start doing. The thoughts made her very sad most of the time. But sometimes when she had them she didn't feel anything at all, and she wondered what she'd feel if Hal died for real. Sometimes she thought nothing. She wondered if that meant she didn't love him. She wondered if that meant she shouldn't marry him. She wondered if anyone should marry anyone. She wondered if she'd have these thoughts if she were marrying someone very rich. She wondered if she'd have these thoughts if she were marrying someone who wasn't very rich but who wasn't Hal. Eight years in, Hal felt like another her, somehow. She knew his body better than her own, she loved how silky he was, she could tell by the hitch of his voice exactly what he was thinking and exactly why he was thinking it, she could watch him struggle with a jar and know whether he would be able to get it open, she could tell by the way he headed toward the bathroom whether he was going in to shit or trim his nails, she could tell from how he looked at his phone who he was texting. She could trace his behaviors and failures and strengths to the behaviors and failures and strengths of his parents and of his brothers. She could make the worst and thickest noise when she orgasmed and feel safe in the certainty he'd love it. When he couldn't

penetrate her, which was often, because Danna had a tight pelvic floor, she knew exactly the sorts of phrases to whisper in his ear while he jerked himself off with one hand and cupped his own balls with the other, the order to say them in, which ones to repeat, which one to save for last, which one would make Hal get that sad look in his eyes that meant he was about to bust. She felt liable for him. She had the capacity to hate him. She had the need to manage him, protect him. She and Hal cared for each other. They popped each other's pimples. They fingered one another's assholes. They did each other's dishes. And so, they'd recently decided, they would become engaged to be married at the end of the summer.

Danna's great dream was to commit double suicide with Hal at sixty-five so that neither of them would ever have to endure the humiliations of old age. Danna's mother had had a pair of patients who'd done just that about five years ago, walking into a canal together with rocks in their pockets. They were elderly communists and they'd had enough. When Danna imagined herself and Hal as old communists who'd had enough, walking together into death, it felt realer to her than the present. For this reason Danna wondered if maybe what she really wanted was just to die.

Now Danna's mother was texting. *Have fun. I am very happy for you.*

Danna blinked at the text. 'Um,' she said out loud, 'why does my mom think we're getting engaged this weekend?'

Hal didn't answer her. He had his hand over his mouth: that meant Brandon Marsh was at bat. Danna knew better than to press him. She went on the website of the jeweler who was making her ring and looked at the piece that would be ready for her in nine to twelve weeks: sometime in August. It was a gold band, channel-set with small squares of lapis lazuli. It wasn't one of a kind. Probably several other girls had it. Danna hoped that in a year she'd still think it was chic. It was what Hal could afford. Danna had never dreamed of an engagement ring; she'd dreamed of being someone's favorite. The ring proved that she was Hal's.

'Because we leave tomorrow? Or because they're fascists,' Hal said, after a time. 'Fascists without a dream in their heart.' Danna ignored it when Hal deployed these kinds of non sequiturs; they were an affectation he'd shaped for the purpose of getting attention from his father – a radical who hated children, a deadly serious writer of dense, unpopular novels. Hal had *had* to say things like *They're fascists, fascists without a dream in their heart* from the time he was a child, probably, just to get his father's head out of the *London Review of Books*. To Danna, understanding the roots of someone's tics or pains better than they understood them themselves was the purest love could get.

'Ah,' said Hal. Marsh was out. Danna handed him a piece of cheese and he ate it without looking at her.

'It's just ball,' they said at the same time; it was what they said when something was wrong.

Hal drove. Danna texted and listened to lo-fi beats and watched Instagram stories and checked the weather and looked at photos from May 2018 and November 2017 and searched StreetEasy for one-bedrooms under $3,500 in Fort Greene Park Slope Crown Heights Prospect Heights Gowanus Williamsburg Greenpoint Carroll Gardens Columbia Waterfront District Brooklyn Heights Clinton Hill Windsor Terrace Prospect Lefferts Gardens and checked the stock market and opened TikTok and watched a TikTok of a dog licking a baby's head and one of a woman talking about being diagnosed with stage four cancer while pregnant and one of a woman showing off her collection of Chanel ballet flats and one of a man adding jam to yogurt to make a high-protein dessert and one of a baby allegedly seeing a ghost and one of a nonbinary relationship advice expert who was saying that the thing women are looking for in a relationship is a man who will fight for them and then Danna closed TikTok and took a picture of the highway and uploaded it to Close Friends and checked Slack and looked on Depop and read all of the notes in her notes app and googled *can you buy car over*

100k miles reddit and opened Maps and zoomed all the way out and scrolled to Russia and zoomed in on parts of Russia and thought about vastness and Stalingrad and goats by the roadside and coldness and fur hats and how society had been constructed and how race had been constructed and how borders had been constructed and about one of her beautiful acting-school classmates from Kyrgyzstan and about visiting Kyrgyzstan, and then she googled *visit kyrgistan american legal* and *americans visit tibet legal* and paused the music and opened TikTok once more and watched a TikTok of a Tibetan girl that popped up first thing and a video of a Kyrgyz girl that popped up second thing, which made her think about her Kyrgyz classmate's eating disorder, which made her think about her own eating disorder, and her mother's eating disorder, at which point she began to feel huge in her body, so she went back to looking at apartments and requested a tour of an apartment on Lincoln Place for Tuesday, when they'd be back, and then she rested her head against the window, breathed in heavily twice, thought hazily about the Lincoln Place apartment's wide wood floorboards – so much wider than the floorboards in their current place – and fell asleep to the dream of them.

'Danna,' Hal said in his emergency voice, 'Danna,' rousing her.

Her stomach squeezed in on itself. Her arms went numb. She braced for whatever.

'Am I getting off here,' Hal asked, frantic, 'or am I going *straight?*'

'I'm asleep,' Danna said. Her ears hurt. Her big headphones were still on. She lifted the right earpad and placed it behind her right ear. She looked through the windshield. They were veering right, toward the exit. 'I don't know, I don't know, I think –'

'Fuck,' Hal said, whipping his neck left. 'Fuck.' He pulled the wheel hard. Then they were on the grassy triangle between the exit and the highway.

'Ahh,' Danna said. 'Jesus *fuck.*'

They were stopped just in front of a murder of sturdy orange barricades, little cylinders bunched together like kindergarteners. The car lilted to the left. They were upstate-ish; there were hills.

'Fuck,' Hal said again, and tried to merge back on to the road.

'Stop,' Danna said, 'stop, is the car okay?' It was a rental; she had a sudden vision of being taken to court and squeezed for everything she had.

'Nothing happened,' Hal said. 'We're just on this part.'

'Something happened,' Danna said. 'You're not on the road.'

'This is the road,' Hal said.

'It's not the road,' Danna said. 'It's the triangle. Stop. Stop moving. Put it in park. Put it in park.'

Hal wouldn't put the car in park. Danna pulled up on the emergency brake.

'You're, like, freaking out,' Hal said, shifting furiously into park.

'You drove off the *road*,' Danna said.

'Because I didn't know where to go. You were supposed to be on Maps.'

'Stop gaslighting me,' Danna said. 'This is serious.'

'This isn't serious. I just need to know which way.'

Suddenly Danna's head was vibrating. Her fancy German headphones were letting her know she was getting a call. 'Mommy,' said the lady who was the automated voice of Danna's headphones. 'Mommy.' This was what the headphones said when Danna's mother was calling. Danna declined the call.

'Hold on,' she said to Hal. She looked at Maps. 'It says go straight.' Danna looked up and ahead. 'It's a toll road here.'

'I know,' Hal said. 'Which is why I got confused. We didn't rent the – the thing, the whatever –'

'What thing –'

'The pass, the special pass that beeps. For tolls.'

'They can bill by *plate*,' Danna said. 'There's a whole bill-by-plate *lane*,' she said, pointing to it, 'right *there*.'

Hal followed her point, but he was making the face he made when he didn't want to have things clarified or simplified, when he wanted to be confused, when he wanted to shame Danna with his confusion. 'Where?' he asked, squinting.

'The – the far lane, there,' Danna said. She pointed harder.

'Fine,' Hal said, pissed. He looked over his shoulder, disengaged the emergency brake and put the car in drive. He hung a hard left and floored the gas. The car rocketed across all four lanes. Lots of people honked.

'HAL,' said Danna, grabbing at the wheel, yanking it toward her, stopping Hal from smashing into one of the toll booths. Hal braked. A worker inside looked up like: *Whoa.*

'Do you need to get out?' Danna asked. 'Do you need to get out and let me drive?'

'I'm a good driver,' Hal said.

'So why is this happening, why are we doing this? You need to calm the *fuck* down. Take a fucking breath, dude.'

'Don't call me dude,' Hal said. 'I hate it when you call me dude.' He took a breath. Hal was good at parallel parking and little else when it came to cars.

'Let's switch,' Danna said, unbuckling. 'We need to switch for a little.'

'There's cars,' Hal said.

'We need to switch,' Danna said, and they did. Then she guided them through the toll booth and onward, toward the place they were paying money to visit.

The resort was not as nice as it had seemed online. Nothing ever was. Danna should've known better than to expect real comfort; she'd first seen it on TikTok. There was a small woodstove in the cabin, a laminated card on a table nearby that said I WORK. Danna dreamed for a second that later they'd gather some firewood together and get cozy, maybe trade lazy oral on the floor before it.

'Fuck, my eyes,' Hal said, taking off his glasses to paw at his lids. 'They're so dry.'

Danna's phone buzzed. Giada – her oldest, simplest friend.
I SAW STORIES
ARE YOU THERE NOW

*RING PIC IMMEDIATELY AS SOON AS IT HAPPENS IM
DEADASS
IS THERE CHAMPS IN ROOM
OR FRUIT
??????????*

There were some photogenic mandarins, stems attached, on a low
table near the woodstove – Danna squeezed them, testing for realness.

Hal looked at the mandarins. 'Aww,' he said. 'I love when they
have the stems.' He took a picture of Danna's hand around the fruit,
and Danna could tell by the way he moved his thumbs that he was
tagging and posting.

thers fruit, she wrote Giada, *but its complimentary*
like he didn't put it there
***theres*

'You didn't order these, right?' she asked Hal, double-checking.

Hal made a face that indicated he hadn't. Danna's ribs crackled;
she felt rageful, out of nowhere. She never would've thought to want
special hotel fruit. But now that there was fruit, and not because of
Hal but because it was always here for everyone, she felt unspecial.

Giada texted a screenshot of Hal's story of the mandarins, then
three messages:

*IS HE PROPOSING OR DID HE JUST TAKE U TO THE
CATSKILLS FOR BDAY*
*IS HE PROPOSING OR DID HE JUST ORDER THE MOST
AESTHETIC FRUIT FOR U*
BLEEEEEEBS

Bleebs was what Giada said when she was feeling excited.

'Is the ring secretly ready?' Danna asked Hal. 'Do you, like:
secretly have the ring right now?'

Hal looked frightened. 'No,' he said. 'You're on the emails with
them too. You'd know.'

Danna had wanted a full-transparency proposal. No surprises.
No pictures. She would not make the engagement face. She would
not put her hands over her mouth. She and Hal would go to the store

and pick up the ring, and they would walk to the waterfront, and he'd put it on her finger, and they'd walk home slowly, talking as they often did on walks about how much they loved one another, and nothing about their relationship would be different. But now Danna felt a lack.

Hal could see it in her face, apparently. 'Is your mom bugging you about this? Is your mom making you feel like you should be engaged to me already when she doesn't even want you to be engaged to me? Like I'm a dick for not proposing on your birthday when you told me you didn't want me to propose on your birthday? Because your birthday was about your birthday and our relationship was about our relationship?'

'Stop shitting on my mom,' Danna said. 'It's Giada.'

'Stop texting with Giada.'

'You're being *really* scary today.'

'Oh, my God,' Hal said. He put his hands in his hair. 'We need to, like: I don't know, dude, hit reset.'

'You can't call me dude if I can't call you dude.'

'Oh, my –'

'You got so mad at me for calling you dude in the car. Like, *so* mad.'

'I wasn't so mad. I'm not mad. I haven't been mad. I'm never mad at you, because you are the light of my fucking life.'

'Shut the fuck up,' Danna said, feeling crushed by love.

'Don't say fuck just because I said fuck,' Hal said.

In minutes they were kissing. Sometimes they got their wires all – it was stupid. Why was it so hard for them to hear each other? Sometimes it felt like they'd never met before.

'Do you sometimes feel like you've never met me before?' she asked him, breaking the kiss. He tried not to let her. 'Do you ever feel like we don't know each other and we're strangers?'

'No,' Hal said, so simple. 'Do you?'

'I don't know,' Danna said. 'I think it's the driving.'

'I made one fucking mistake. Because you weren't navigating. Because you fell asleep. And I'd never begrudge you sleep. But I asked you to navigate.'

Danna knew Hal was right. Only babies could get away with falling asleep anywhere. 'Two mistakes, right next to each other. Two bad mistakes.'

'Nothing bad happened.'

But she felt like something bad had happened, even though it was, to be fair, objectively true that nothing had. In moments like this one Danna felt like something was growing out of her brain. Like she'd never know a moment of surety, or quiet. The *might'ves* were always branching, branching, carrying ugly blooms: the fear of missing something obvious, the fear of everyone but Danna knowing some great truth about what her life really was.

Early the next morning Danna dreamed that she was one of two finalists for a prestigious magazine job. Then the other finalist died and Danna got the job by default. She woke up feeling so boundless and powerful that she suggested a hike; there was a four-mile loop that started behind the resort, and though Danna was not an outdoorswoman, she'd inferred from the Instagrams of others that shared experiences in nature could deepen the connection between two people in an exponential way.

'Great,' said Hal, 'lemme shower.'

'But we're going on a *hike*,' Danna said.

Hal looked around as if at an audience. 'So I can't shower?'

'No, it's just: why would you? If you're gonna get sweaty?'

'I don't get that sweaty walking,' said Hal. 'That's you.'

While Hal showered, Danna dressed and applied SPF to her face, her vulva already sweating through her lululemon tights. 'You're making it so hot in here,' she screamed through the frosted glass of the sliding door to the bathroom, but Hal didn't respond. He emerged from the bathroom as he always did after a shower, fully dressed; Danna was dismayed to find that he was wearing chinos and a button-down. 'We're going on a *hike*,' she said.

'I didn't bring hike clothes,' said Hal.

'We're dressed for totally different things.'

'So?'

'So I want it to be an athletic walk.'

'It'll be an athletic walk.'

'I want to get sweaty, though.'

Hal looked at her.

'And when we're dressed differently for the same thing it makes us both look retarded in completely different ways. Like: when I'm dressing for an athletic walk and you're dressing for a casual walk, it's like I'm alone in the pursuit of an athletic walk, and it's like you don't really want to be on the walk with me in the way I want to be on the walk.'

'I want to be on the walk,' Hal said. 'In whatever way you want to be on a walk. I literally forgot the clothes. I wish I could be in the right clothes. I'm sorry.'

'Thank you,' Danna said.

'But don't say retarded, Danna,' Hal said. 'It doesn't make you sound cool.'

The hike was simple and beautiful, but Hal seemed to have decided that he wanted to use it to make a point to Danna about her self-absorption. Each time they passed anyone on the trail, a few minutes later Hal would go, 'Do you remember what they were wearing?' and Danna would have to admit she didn't and Hal would poke her shoulder and Danna would tell him to fuck off. Things grew tense and, at a certain point, when they heard someone around the next bend, Danna looked at Hal and said, 'Don't you fucking dare ask me what they're wearing,' but when the path straightened out on the far side of a deep curve there weren't people there at all. A mother bear with three cubs was crossing the trail many yards ahead of them, one cub swiftly climbing into the brush on the trail's western side while the other two stopped in the middle to play, like dogs, pawing and biting. The mother bear turned her head. Danna made eye contact with her, and she felt the quality and the length of their eye contact to be profound. Then the bear turned back to her cubs, urging them along. The babies walked into the yellowing brush, and their mother followed behind.

Hal smiled at Danna and squeezed her hand. He didn't say a word, and neither did she. They walked forward: cautious, linked, studying the animals' prints in the dirt.

After the bears, Danna started noticing the smells around her more intensely, and Hal started periodically going 'Ah, Jesus', and reaching up beneath his sunglasses to wipe tears from his eyes, and both of them became more vocal about pointing out flowers and leaves they liked to one another.

At the rough midpoint of the loop they stopped to sit on some large rocks and kiss and look at their phones and share some water from Hal's water bottle, and Danna thought about what a perfect moment it would be for the moment of their engagement. Upon sitting down, Danna had pulled an expensive oversized sweater of real wool over her head to cut the chill in the air. Now, she felt thin and glamorous in the lazy way belonging to mid-errand celebrities. Once she'd seen Dakota Fanning in the old Chelsea Bed Bath & Beyond wearing an amazing plaid tunic, her hair silky and undone. Danna felt like that now, and it made her want to be seen and coveted and claimed. It was a pure, succulent moment, and she wasn't prepared for it.

She was furious with herself for abandoning belief in life's rarity and insisting on having everything out in the open, within her control; for having rejected such a distinct milestone of the female experience, such an ancient love ritual, in demanding no surprises. She became hateful of herself and deeply crabby, and because she'd taken a ten-milligram weed gummy right before the hike, her crabbiness pursued itself inward toward no terminus she could see.

'Did you take a video of the bears?' Danna asked Hal, knowing he hadn't.

'No,' Hal said, like it was the dumbest question ever. 'We were standing in front of *bears*. I thought I was going to have to get big.'

'The men we passed,' Danna said, 'early on the hike.'

'Yeah,' Hal said.

'I asked you if you thought they were a couple or a father and a son or a father and a grandson or half-brothers or whatever.'

'Yeah,' Hal said.

Danna beamed victory at him. 'The old one was wearing a windbreaker and the young one was wearing a chore coat and suede boots.'

Because there was no video record of the bears' sweetness, the memory of it quickly faded. By the time Hal and Danna reached the end of the loop, Danna's high was gone, replaced by a dry throbbing that seemed to come from her amygdala. When she complained about the pain, Hal put an arm around her and offered to cancel their dinner reservation in town and order them room service instead so they could eat while watching *Neon Genesis Evangelion* in bed. Danna, who'd found comfort in anime since she was small, and who was often made anxious and queasy by the specific emotional pressure of eating in a nice restaurant anyway, agreed that that was what they should do.

The resort had a little spa, and, on their last day, Hal and Danna went for massages there. They were instructed to remove their clothes and don robes in a locker room, then head down the hall to a quiet room full of couches and armchairs to await the commencement of their appointments. On a long table at the far side of the room was a tall white pot of hot water, cups and saucers, tea bags, and a glass drink dispenser full of water, ice, and fruit. Hal got them both fruity waters and they sat together, sipping them, waiting for their masseuses. Another guy-and-girl couple was in the room too. They were talking angrily at a tall, visibly gay, managerial-looking man holding an electronic tablet.

'He booked it like that online,' said the girl of the couple.

The manager tapped around on his tablet. 'I'm not seeing on my end here, ah, a request for a female masseuse – on *either* of your reservations.' He looked right at the guy. 'I'd be happy to rebook you with one later on in the week. Or I can offer you your appointment right now, with our masseur Jay, who's great.'

'That's a male,' said the guy.

ALEXANDRA TANNER

'Correct,' said the manager.

The guy pointed to his girlfriend. 'But she has a female.'

'You know what,' said the girl, 'I'll take the male.'

'Babe –' said the guy. 'No –'

Hal and Danna squeezed their pinkies together, hard. Danna felt grateful that they were themselves, and that they hadn't requested masseurs of any particular sex because they were good and open-minded, because they understood certain things about sexuality and gender and the universe that not everyone could understand; they had found each other because of this fact, the fact that they were so much more specially attuned than most people; they were going to spend their whole lives stumbling into shining moments like this one, moments in which their love felt like it conferred onto them a lucky kind of righteousness. Then Danna thought of Hal pulling across four interstate lanes at once. She thought of how he'd probably been the one who gave her the non-warts kind of HPV, the less embarrassing but worse kind. She thought of how Hal never wiped the table quite right. She thought of how one time he'd gotten $4,700 into credit card debt and she'd cried and sat on the toilet googling *number 47 spiritual significance,* wondering if there was something to learn. She remembered, even now, that 47 was the atomic number of silver and the country code for Norway, that Mars took 47 years to complete an orbital cycle. She remembered coming out of the bathroom and telling Hal what to do to fix things, which was to call his father, and how Hal had said *He's not a rich man* and how she'd said back *Didn't he win a Pulitzer?* and how Hal had said *A Guggenheim, Danna, in fucking 1989,* and how Hal, then, had cried, and how she had walked to the door and said *I'm gonna go get a bagel, and when I'm home, this is going to be fixed,* and Hal had said *It's going to be fixed,* and how things had been fixed because she had demanded they be fixed. She had put her mouth to the hose that reached into the gas valve of Hal's soul and sucked a fix out of him. Danna thought about Hal's father's second novel, whose name she could never remember though it was the one that had gotten him the Guggenheim, though she could

remember that it was about two young parents who hated each other and loved each other and fought physically and made up from the fighting by fucking and who once, in a pivotal scene, fucked in front of the newborn, which healed them emotionally. He'd published it when Hal was a toddler. There was a single copy hugged up in a shiny cellophane jacket displayed on a high shelf in Hal's parents' living room. Danna tried hard to picture the book and its title. Nothing. When Hal had first read the novel as a teenager, he'd stopped speaking to his father, and he'd started acting out and doing drugs, and he'd had to see a child psychologist, who told Hal that his father was, though an adult, really a lot like him – a boy doing his best – and that his mother, too, was just a girl doing her best, and that marriage was a difficult pursuit, and that by showing grace and understanding to his mother and his father, who were themselves just grown children pained and warped by their own parents' insufficiencies, Hal would be able to live his life free of the burden of their mistakes, which did, in real life, include fighting and fucking loud and hard across all of the rooms of the house Hal had grown up in. Hal's problems, Danna told herself now, came from that terrible disgusting incestuous novel, and the shelf it sat on, and the LED lamp that hung just above it, insisting upon the book's rare specialness, prizing it even above Hal's.

Danna's pinky felt numb. Hal was still squeezing it because the horrible couple was still giving the resort spa manager a tough time. Danna squeezed Hal's pinky once, firmly, to tell him to stop squeezing so hard, and he stopped squeezing, but he kept his pinky locked with hers, and he gave it a little tug when the horrible couple said something particularly nasty to the manager, who was fixing their registration on an iPad. When the manager finally bowed his head and walked away, tucking his iPad under his arm, Danna let herself look at the couple straight on. They were smiling at each other.

A fter their massages, Danna and Hal met up again in the waiting room, where they made cups of tea and sat in glowing silence. There was a video playing on a loop on a television in the corner; it

showed escalatingly gorgeous drone shots of lavender fields in what
looked like the south of France. When they'd had enough, they took
their cooling teas with them to the steam room, and as they were the
only ones, it seemed, left in the spa, they unbelted their robes and
sat together half-naked and sweating and talking about how good
they felt and about how horrible the horrible couple from the waiting
room had been and about how excited they were to go back to the
room and watch more anime and order more room service.

'You want to fight for a life with me, right?' Danna asked Hal.

'Baby,' Hal said, and kissed her shoulder.

'Because I want to fight for a life with you.'

Hal looked at Danna, seeming pre-upset. 'You don't have to fight
for a life with me,' he said. He said it without malice or strangeness,
but Danna, for some reason, picked up both malice and strangeness
in how he said it.

'What do you mean?' she asked.

'All I want out of, like, my whole life is a life with you,' Hal said. 'So
you don't have to like – fight me for it. What do *you* mean?'

Danna looked up at the wet ceiling and thought of how to answer
in a way that wouldn't destroy the womby post-massage safety they'd
both just been feeling. She didn't know how to explain that her whole
life felt like a fight for itself, a struggle against her own every thought
and fear; that she nightly had vivid, lucid dreams of having to stab a
shadowy home invader with a dull knife over and over again until he
finally died and relented his claim on her and her possessions; that she
felt she'd never reach a place of true openness in any arena, possibly
not even in her relationship with Hal, whom she often thought of as
her twin, her brother, a pearl she'd formed from the grit of her own
ugliness; so instead she told him she'd meant nothing, and she asked
if Hal liked the flavor of tea he'd chosen. He said that he did, and then
he asked if Danna liked her flavor, and she said that she did too. Then
all at once Danna felt pretty bad; she felt hungover, like there was a
nauseous ache in her chest and her head and her butthole; then she
was asleep.

When she woke up Hal was patting her face and saying, 'Whoa whoa whoa.'

'Did I just pass out?' Danna asked Hal.

'Yeah,' Hal said, looking toward the door. He was holding Danna's shoulders with both hands. She was slouching pretty badly. She realized his hands were kind of all that was holding her up. 'Hello,' Hal shouted, 'excuse me, can we get a little *help* in here? Jesus fucking Christ,' he said, because ceiling steam was dripping into his eyes. He blinked hard, trying to get it out, as he pulled Danna's arms through the armholes of her robe.

'I've never passed out before,' Danna said.

'It's hot,' Hal said. 'It's way too fucking hot in here. *Hello?*'

'Have you ever passed out before?' Danna asked.

'No,' Hal said. 'I don't think?'

'How would you not remember?'

'I think I blacked out for just a second that time I hit my head,' Hal said, referring to a time a year ago when he'd hit his head, 'but I'm not sure.'

'How could you not be sure?' Danna asked. She felt radiant, warm, in touch with a higher consciousness. She'd fallen out of her own existence and fallen back into it. As someone who'd now officially passed out, she felt part of a community, part of a new experience; she needed to know whether Hal could share in it, or whether he couldn't.

'How can I be of –' said the tall gay iPad manager, pushing open the steam-room door, but he didn't get to the word 'service'. Danna watched Hal make desperate eye contact with him, and then she watched the manager prop the door open with a towel and duck out. She heard him press something outside and the steam stopped curling up at her from the floor. Soon the manager was back with a tall, sweating glass of water and a wet cloth. He handed both of them to Hal, who handed both of them to Danna, who felt no need for either of them.

'I'm fine,' she said. 'It wasn't like I thought it would be. I'm feeling fine. It was kind of the best I've ever felt?'

'Please drink some water,' Hal said. He took the cloth from Danna and put it on top of her head. Her pleasure deepened.

'Can we go – can we go back to the room with the lavender video?' she asked, and Hal nodded, and the manager nodded, and together they helped her stand and walk down the dim hallway toward the staging room, and they sat her down on the couch in front of the television, and masseurs and masseuses were bringing her cooler and cooler washcloths, and she couldn't tear her eyes away from the drone footage, and suddenly there was a squat glass bottle of apple juice before her, and she felt like a baby, and she thought of Hal kissing her shoulder and calling her baby, and she looked over at Hal and told him that she was his baby, and she hugged him, and she sipped her juice, and she thought about her ring, and then, for practice, she made the face she hoped she'd make when Hal gave it to her. ∎

HARLAND MILLER
I Am The One I've Been Waiting For, 2016
Courtesy of White Cube Gallery

LITERATURE WITHOUT LITERATURE

Christian Lorentzen

R eaders of books from the New York publisher Knopf will be familiar with the leaping dog that appears on their spines. In 1915, when Alfred Knopf started the firm, his wife Blanche was 'crazy about borzois', and she suggested the animal as the publisher's colophon. Though the logo lingers more than a century on, Blanche's enthusiasm for the breed was brief. 'I bought a couple of them later,' she told the *New Yorker* writer Geoffrey T. Hellman in 1948, 'and grew to despise them. They were cowardly, stupid, disloyal, and full of self-pity, and they kept running away. One died, and I gave the other to a kennel.' Hellman relates the story of a weekend in the country when Joseph Hergesheimer, a Knopf bestseller and one of the most critically lauded American novelists of the second and third decades of the twentieth century, came down to breakfast on Sunday morning complaining that the 'moans and whimpers of the surviving borzoi' had kept him up all night. 'I bet Charles Scribner has no such goddam dog,' he said. 'The Knopfs exchanged glances,' Hellman writes, 'and Mrs Knopf went in for Yorkshire terriers.'

It's an amusing anecdote and telling in a few ways. The Borzoi logo remains, and is one of the most recognizable symbols in corporate publishing. But its original meaning was erased, at least in the mind of the publisher and his wife, who as vice president, director and part

owner of Knopf, took a strong hand in bringing in new authors. An advertisement from the 1920s reads: 'Take home a Borzoi Book and spend a pleasant evening . . . It is obvious by their nature that books can never be uniform in quality of contents. But they must conform to certain well-defined standards of excellence to achieve the imprint of BORZOI . . . Look for the Borzoi label and then buy the book!' Marketing of this kind has long been out of style. The image of the borzoi was immediately vestigial, and so, forty years after Alfred's death, is the name Knopf itself.

Blanche's line about her pets – 'They were cowardly, stupid, disloyal, and full of self-pity, and they kept running away' – you can imagine publishers saying it of authors or authors saying it of publishers. I have heard versions from both sides, though mostly from authors. The metaphor of the story, surely not lost on Hellman, is the irritation caused to the talent by the living representatives of management. The talent jokes about leaving for other management. It's a chummy arrangement, an author weekending with his publishers in the country, but they're still all actors in a marketplace.

Then there is the presence of Joseph Hergesheimer. I thought that I'd never heard his name until a couple of years ago when I first read Hellman's profile of Alfred, but he is mentioned a few times by Alfred Kazin in *On Native Grounds*. Like the culture at large, I forgot about Hergesheimer. Kazin groups him among the 'Exquisites' championed by H.L. Mencken and George Jean Nathan after the First World War, along with James Branch Cabell, Thomas Beer, and Elinor Wylie. 'The vogue of the new decadence was to seem shabby and vain soon enough,' Kazin writes, 'but it is easy to see now that it had its origin as a protest against the narrowness and poverty of even the most ambitious writing of the day.' In place of 'the evangelical note that had crept into pre-war modernism' and 'grubby provincialism and romanticism' – think of Jack London and Theodore Dreiser – the Exquisites delivered glossy prose styles and glorified wealth as aristocratic amateurs. Kazin writes that Hergesheimer, 'the slavish celebrant of the new rich, intoxicated' the public 'with endless visions

of silver and brocade, introduced them to the very best people, and tittered verbosely on a veritable Cook's tour of colonial America, nineteenth-century Cuba, and the feudal South'.

Hergesheimer's third book, *The Three Black Pennys*, was the first original American novel that Knopf, whose initial specialty was bringing out translations of European works of modernism, published, in 1917. Into the 1920s, he was their bestseller, until his fortunes waned with the rest of the Exquisites. During the Depression, encomia to industrialists and contempt for the canaille were less in demand, and the style of the day turned in the direction of Hemingway. (Kazin remarks that Hergesheimer and Wylie inverted Hemingway's aphorism, 'Prose is architecture, not interior decoration.') Clifton Fadiman later remarked that Hergesheimer's novels were 'deficient in mere brain-power', but in 1962, when asked which American novels he cherished, Samuel Beckett said: 'one of the best I ever read was Hergesheimer's *Java Head*'. Hergesheimer published his last book of fiction in 1934.

In the autumn of 1948, H.L. Mencken visited Hergesheimer at his home in Stone Harbor, New Jersey, between Atlantic City and Cape May. He found his friend drinking mug after mug of beer, suffering from an eye infection, and full of complaints about Knopf, which had let his books go out of print. 'In theory, he has been at work on his autobiography, but in fact he has done nothing,' Mencken wrote in his diary. 'He has written nothing fit to print in more than ten years. It is a dreadful finish indeed.' Hergesheimer died in 1954, and was buried on the South Jersey Shore. A friend of mine who hails from nearby and read a couple of Hergesheimer's novels after coming across his name in one of Mencken's books assures me that there's a plaque by the beach, on a pleasant street with an ice-cream parlor and a mini-golf course, that bears the name of Hergesheimer. Such is the nature of most American literary immortality.

We could say that Knopf abandoned Hergesheimer or that history left him behind, that he failed to change with the times, or that the success, including eight film adaptations, that followed years of toil in

obscurity in Pittsburgh, robbed him of the hunger that is crucial to an artist. We could, like Kazin, look at him dialectically, as a casualty in an unforgiving turn in the saga of American literary style. Certainly a glance at a few chapters of *Java Head* leaves the impression of a prose that Hemingway was born to demolish. Kazin's quip about interior decoration holds: the novel opens with an eleven-year-old looking at all the fancy chairs in her family's house. (There is some charm to the passage: it is the girl's birthday and whereas all the different chairs enchanted her the night before – she sees one as a dragon, others as deacons and dwarfs – now as a big girl she sees them just as someplace to sit: omens of her author's fall from grace.) But Hergesheimer's story as we would tell it today is a story of the market.

Among publishers, editors, scholars, critics, and even writers themselves, the stories we tell about literature are more and more stories of the economy of prestige, of one generation's preferences righteously overturning those of its predecessors. Inside the academy, professors attribute great power to the publishing industry and to creative-writing programs. The syllabi of university courses in literature are yielded to student preferences, redefining the objects of literary study as matters of consumer choice rather than recognizable aesthetic criteria. Outside the academy, critics begin to stake their worth on the size and devotion of their audiences. And in the journalistic sphere, two opposing modes have emerged: that of therapeutic literary careerism, on the one hand, as writers make public confessions about their struggles to survive in comfort as authors; and that of accusatory literary consumerism, on the other, as critics express dissatisfaction not with books themselves but with the ways books are marketed, usually to somebody else, somebody they don't like very much, such as a stepparent or a person they kissed a few too many times and would rather forget.

These warped views of literature reflect a shared tendency to explain art with minimal reference to the art itself. Novels are instead considered as commodities and demographic specimens, the products of structures, systems, and historical forces. They become

expressions of brands, their authors threadbare entrepreneurs. Fiction recedes behind the chatter it generates and is judged according not to its intrinsic qualities but to the sort of reader whose existence it implies. Authors are turned into role models and style icons, mythologized for their virtues, and crucified for their sins. The numbers, as if they have meaning, are counted. The dream is of literature that can be quantified rather than read.

One critic who has made a stalwart case for reading literature sociologically is the Stanford professor Mark McGurl. Across three books he has charted a descending and demystifying course across the brows, from high to middle to low, and from pre-war modernism to post-war boom to the digital present, from salon to AWP Conference to algorithm. In his first book, *The Novel Art: Elevations of American Fiction after Henry James* (2001), he recast novel writing, on the one hand, as a matter of 'product differentiation', appealing to 'status-conscious' readers that, on the other hand, resisted the crudities of mass production and offered at least the illusion of aesthetic resistance. His most recent book, *Everything and Less: The Novel in the Age of Amazon* (2021), largely examined mass-market, often self-published genre fiction, from traditional romance and adventure to diaper-inflected fetish porn, with readings that exposed the books' plots as allegories for Amazon itself, fictional erotic partners performing customer service or other exploitative labor for each other, also an allegory for reader–author relations, of course. For all its cleverness, *Everything and Less* faced two disadvantages: the readers of these genre-fiction books don't read literary criticism, and the readers of literary criticism don't care about these books.

In between came McGurl's 2009 study *The Program Era: Post-war Fiction and the Rise of Creative Writing*. It ends with an ode to the 'unprecedented' 'systematic excellence' of the fiction produced under the regime of university creative-writing programs: all the new graduate students being taught the craft of fiction writing led

to 'a system-wide rise in the excellence of American literature in the post-war period'. A side effect of all this excellence has been an overproduction of creative writing students from America's more than 350 graduate writing programs, who are statistically more likely to become holders of day jobs than published authors (or writing professors) but also constitute an audience for the ever-burgeoning genre on how to make it (or not) as a writer.

Against 'tedious prejudices' such as the 'conservative modernism of T.S. Eliot and his ilk' that 'has ingrained in us the notion that art never improves', McGurl arrives at his conclusion of excellence by an insouciant method: 'to crudely convert historical materialism into a mode of aesthetic judgment, putting literary production in line with other human enterprises, such as technology and sports, where few would deny that systematic investments of capital over time have produced a continual elevation of performance'. Crude indeed, in that having only one pair of eyes, each of us tends to read one book at a time and to make particular aesthetic judgments rather than judgments of scale. A golden age of abundance: whether or not art has improved, there is more of it.

McGurl writes that 'there is no way for a literary scholar, these days, to engage in strenuous aesthetic appreciation without sounding goofily anachronistic'. What he means can be grasped in John Guillory's *Professing Criticism*. Taking the long view, Guillory tells the story of the emergence of literary criticism as a discipline embedded in the university after a long history of competing practices dating back to the eighteenth century and before: philology, belles-lettres, and scholarly literary history. He presents a picture of a discipline that was consolidated on campuses in the middle of the twentieth century on a par with the sciences at the cost of giving up its public role in the shaping of society, a task literary critics had long assumed as an adjunct to their popular expressions of judgment and taste.

Recent decades have seen the discipline enter a crisis on multiple fronts: overproduction of qualified doctoral students for too few jobs, resulting in a semi-autonomous professional sphere

of underemployed would-be professors; dwindling enrollment of undergraduates in literary studies; pressure from those students who do enroll to see curricula shaped according to their preferences for diversity and relatability, leading to a shift toward works written after the Second World War and an erosion of attention to the past; and within scholarly production an emphasis on methodology over interpretation, which long ago surpassed judgment as the academic literary critic's main task. Guillory predicts a split in the English major along two tracks: a retrospective program treating works from the age of modernism and before, akin in its historical outlook to the study of the classics; and a track focused on the contemporary, satisfying students' current desires. He has described a situation where the 'subfields' of literary study 'dominate over the fields' (traditionally historical periods and the broad genres of poetry and fiction), and called for a 'recentering of literature' in academic literary study.

It is strange to hear of a subject needing to be restored to the discipline that claims to study it. But it's characteristic of an age when literary discourse is in flight from the literary, in favor of the personal, the political, or, more often, the consumerist and careerist, in favor of thinking about systems instead of individuals, which is to say writers. At the conjuncture of these tendencies is another set of institutions perpetually said to be in crisis – because of the public's failure to read enough books; because of questionable business decisions; because of the threat of new technologies to books themselves; or simply because of the rising costs of paper – that is, the publishing industry.

Petri dish of digital commerce, zone of many a reader's most sentimental memories of shopping, scapegoat for the grievances of unloved and under-compensated authors: the book business has never lacked for eager explainers ready to unspool its secret workings to the public. With latent writers at every level from corner office to cash register, the investigations of an outsider would seem superfluous. But the turn to political economy in the academy and the intellectual press after the financial crisis of 2007–08 created a

sense that every sector of society was in need of materialist analysis: surely publishing would not be exempt. Adopting something like the combined sociological and literary approach McGurl and Guillory have applied to creative-writing programs and English departments, Dan Sinykin, a professor at Emory University, arrived last autumn to teach us what it means, as he told an interviewer, for 'books to be recognized for what they are: industrial products'.

Sinykin's book *Big Fiction: How Conglomeration Changed the Publishing Industry and American Literature* is a thorough and occasionally diverting history of recent trends in book packaging, marketing, and sales. Around 1960, when the consolidation of the independent publishers in New York began through a series of mergers and acquisitions that continue to this day, commercial and literary fiction were sold in mass-market paperback editions that you could purchase at a pharmacy, a gas station, or anywhere with a wire book rack. By the 1970s, blockbuster genre writers like Danielle Steel and Stephen King started to command big advances for hardcover and paperback editions of their prolifically released novels. Publishers adopted a series model for fantasy and science-fiction books that were big sellers at mall chain stores. Literary fiction was sold in trade paperback editions, with less trashy cover designs, to appeal to pretentious readers who liked to get a latte on their trip to Barnes & Noble or Borders. Over the last few decades, independent and nonprofit publishers were founded and staked their identities in opposition to the Big Five, championing marginalized voices, poetry, and, occasionally, difficult (or not obviously marketable) writing.

Students of old-time publicity strategies, obsolete retail models, and fundraising from the government, the Ford Foundation, and miscellaneous charitable entities and persons will find much fascinating material in these pages. There's ample trivia about publishing poobahs whose names you've never heard and will soon enough forget. They wrote catalog copy, filled out profit-and-loss forms, paid out advances, and even at times, if less and less over the years of corporate consolidation, selected books for publication based

on their own personal taste. Certain numbers of them invented the transcontinental book tour (Charles Dickens would beg to differ); others set off revolutions in the field of paperback trim size. They were trailblazers of novel marketing categories that found expression on chainstore bookshelves, now largely shuttered. Above all, they ate expensive lunches they didn't pay for themselves.

Sinykin's larger claim about American literature – that conglomeration changed it in a meaningful way – is founded on a category error. Whereas creative-writing programs and the MFA system generally can reasonably be thought of as a site of literary production – places where novels are written and environments that in some ways shape the books written in their confines – the publishing industry is in fact the first stage of literary consumption. Unlike, say, the series of *Star Trek* novels published by Pocket Books in the 1980s and 90s, literary books are not the brainchild of publishing houses. Agents typically represent clients who have already written their manuscripts and editors purchase the rights to publish those manuscripts, a process that involves putting covers on the books, sending advance copies to reviewers, advertising campaigns, and so on (the hypnotic effects of TikTok being the current industry obsession). The work that agents and editors do on literary novels is more akin to tree trimming than tree planting.

Sinykin is aware enough of these realities that he hedges the claims of his theory of 'conglomerate authorship' behind a series of trite and familiar ideas: that writers 'internalize' the demands of acquiring editors; that the 'authorship' we typically attribute to individual writers is but a mask for a process diffused among the 'conglomerate superorganism'. 'Myriad figures introduced or empowered by conglomeration,' he writes, 'exercise influence on each stage of a book's life, from conception to its acquisition and editing to publicity: subsidiary rights specialists, art directors, marketing managers, sales staff, wholesalers, chain book buyers, philanthropists, government bureaucrats . . . Each working interdependently with the others produces conglomerate authorship.' So the idea of 'conglomerate

authorship' equals the book plus its marketing apparatus. But who could possibly care about the last part of that equation besides someone professionally engaged in the marketing of books?

Sinykin proposes a new method of reading, according to the publisher's colophon:

> To read a book through its colophon is to read it anew. Aesthetics double as strategy. Author and publishing house might be – often are – in tension, a tension that plays out between a book's lines. The game a book plays is significantly different depending on whether its colophon is Bantam's rooster, Doubleday's anchor, Graywolf's wolves, or W.W. Norton's seagull, for reasons this book unfurls. I linger over books in these pages, reading them through the colophon's portal, in light of the conglomerate era. I show how much we miss when we fall for the romance of individual genius. In novels, the conglomerate era finds its voice.

The cynicism of this notion is impressive, if also disgusting. To reduce aesthetics to the results of sales strategy is to equate the pleasure we take in reading to being duped by a marketing campaign. Falling 'for the romance of individual genius', in Sinykin's schema, is akin to thinking there's something special in the soda aisle when you see the Sprite insignia but fail to comprehend that it's just another product of the Coca-Cola Bottling Company.

Big Fiction resembles a systems novel in which the heroes find themselves navigating situations the scope of which they can't comprehend. In Don DeLillo's *Underworld*, Nick Shay and other characters are only flickeringly aware of the way the dynamics of the Cold War and its aftermath shape their lives; a late scene sees Shay – by the 1990s a waste management executive with an international portfolio – visiting a clinic for survivors of the mutating effects of experimental nuclear blasts set off near their native villages in

Kazakhstan and noticing that the victims are wearing surplus T-shirts from a gay and lesbian festival in Hamburg, Germany, 'the result of an importing ploy gone wrong', a detail that signals the evacuation of meaning under globalization. In *Big Fiction*, the hero is the reader and the children are novels on the shelf by Jonathan Franzen, Sally Rooney, Scott Turow, Jeff VanderMeer, Marilynne Robinson, and John Waters, all clothed in book jackets with the Farrar, Straus and Giroux colophon: three fish (adopted when the firm acquired Noonday Press in 1960). Are the fish meaningful? Was the goddam dog who kept Hergesheimer up all night cowardly, stupid, disloyal, and full of self-pity?

'If this book has a villain,' Sinykin writes – as if a book that purports to be a work of literary criticism should have villains and the villains should turn out to be writers themselves – 'it is the romantic author, the individual loosed by liberalism, the pretense to uniqueness, a mirage veiling the systemic intelligences that are responsible for more of what we read than most of us are ready to acknowledge.' Those 'systemic intelligences' are responsible for what we read only in the sense of manufacturing, distributing, and selling us books. Ultimately, Sinykin insults the reader's intelligence, suggesting a consumer of books in the twenty-first century who lacks awareness of the workings of publicity and marketing, doesn't understand how to read a book review, judges novels by their covers, and can only believe the hype.

As in many works of autobiographical fiction – or autofiction, as we call it these days – there is an episode of personal shame and trauma at the heart of Sinykin's book. He tells the story of his own 'aesthetic education' as a reader: Tolkien, Piers Anthony's 'Xanth' books, Fitzgerald, Hemingway, Salinger. His parents were 'avid readers', and had shelves full of bestsellers and book-club picks. 'That all of these,' he writes, in a startling revelation, 'from Conroy to Salinger, were white men reveals as much about the homogeneity of the publishing industry as it does my family's gendered and raced purchasing habits.' For a time, he broke out of the gender trap, and his favorite book was Ayn Rand's *The Fountainhead*. Then, following

a list of recommended reading for the AP English exam, he bought a copy of *Gravity's Rainbow*:

> No one I knew had heard of the book, so it felt like I had made a discovery. (No matter that it was in print and in stock at Barnes & Noble.) It became my talisman . . . Carrying the book made me feel unique, and reading it made me feel smarter than everyone else, but it was more than that. The language was exhilarating, the sensibility hilarious, the politics strange and enchanting. *Gravity's Rainbow* gave me everything I needed to become, years later, an English professor: a talismanic object, with its teal spine and blueprint design, later to be held together with a strip of duct tape; a lesson in how to distinguish myself from others based on my taste; a fondness for liberatory politics; and a love of challenging prose, lush language.

But the fun could not last:

> It would be many more years before I learned to narrate my aesthetic education not as a triumphant journey of self-discovery but as a slightly embarrassing cliché: my pretension to uniqueness, through Pynchon in particular, was repeated by cocky young white men across the United States. I was a type and played to it. In graduate school I met iterations of myself, again and again.

How awful! It is not a stretch to understand how an individual who prided himself on being smarter than everybody else and then was embarrassed to find that fellow English-department graduate students shared his taste for the bestselling winner of the 1973 National Book Award would go on to distinguish himself from the crowd by writing (or at least putting his name on) a book (authored in truth by the Columbia University Press/Emory University English

Department/Modern Language Association superorganism) that reduces aesthetics and their pleasures to market strategies and susceptibilities, that elevates the holders of placeholder jobs in the publishing world to the heights of scholarly scrutiny, and that demonizes and erases writers themselves (or at least the idea of them). It's not hard to see the 'game' he's playing: academic careerism.

Along the way, Sinykin's method of reading through the colophon when he lingers on novels, typically for a page or two, leads him to some ridiculous, tedious, irrelevant, and dubious arguments, and others broad to the point of meaninglessness. 'Danielle Steel is deeper than you think,' he writes, bemoaning the fact that 'Toni Morrison generates 3,109 hits on MLA International Bibliography, Danielle Steel six'. I read forty pages of a Danielle Steel novel to check his claim, and found she was less deep than I could have imagined, her characters skinny-dipping in a shallow pool (a river, actually) of simplicity, cliché, and soft pornography. Of Morrison, he writes, '*Beloved* capitalized on the new market for horror created by the success of Stephen King,' as if the book's true literary forbear were not William Faulkner, as if ghost stories were not as old as time, and as if the novel's more pertinent rivals in the cultural marketplace weren't, per Stanley Crouch, works of Holocaust literature. Sinykin picks up on a remark of Morrison's about writing *Beloved* after quitting her day job at Random House, and so – in his favored mode of reading novels – it becomes an allegory for the conditions of its production. He admits that the claim is 'ludicrous' but makes it anyway.

It's also the dullest possible way to read that novel, and the same goes for his readings of E.L. Doctorow's *Ragtime* and David Foster Wallace's *Infinite Jest*, both of which treat the corporatization of American entertainment. That their lessons also apply to publishing isn't exactly a surprise, especially in the case of Doctorow, who like Morrison worked as a book editor in New York. Of Wallace and his crusade against addictive corporate entertainment, he writes: 'His dream of saving America from itself was a fantasy that allowed him to complete the project but had little to do with the phenomenon that

spurred decades of debates, listicles, and personal essays about the myth of genius, his bandannas and misogyny, and the cultural politics of men recommending books to women.' Alas, the achievement of *Infinite Jest* has been felled by a cannonade of listicles.

Sinykin writes that after decades of modest sales, consistent critical admiration, and scant fame – following the death of his long-time editor Albert Erskine – 'Cormac McCarthy fell in with an ambitious agent, editor, and publicist and transformed his style from dense prose and aimless plots to more crowd-pleasing literary Westerns.' But in fact, at the time McCarthy published *All the Pretty Horses*, he told an interviewer from the *New York Times Magazine* that he had been at work on the Border Trilogy (of which *Horses* is the first volume) for a decade, since before the publication of *Blood Meridian*. His shift in style (not the first in his career, nor the last), the death of his editor, and his move to more effective management were a coincidence, not a case of cause and effect.

Along with Joan Didion, whose final novel *The Last Thing He Wanted* happened to be a thriller, McCarthy and Morrison are, in Sinykin's account, writers of 'literary genre fiction', an umbrella term for books by writers with fancy prose styles that partake of forms usually associated with commercial fiction. As usual he sees this as a market strategy, not a purely aesthetic choice (no such thing) by writers who grew up in a culture saturated by film, television, comic books, and pulp fiction, many of them imported from the novel tradition before 'literary fiction' was coined as a marketing category. Perennial genres now often sold as literary fiction include the social novel, the domestic novel, the comedy of manners, and so on, but Sinykin doesn't dwell much on these because they predate the era of conglomeration, and their persistence tells us little about it, other than that corporations continue to sell things they can reliably sell.

One of those things is autofiction, a term borrowed from the French that came into vogue among anglophone critics and writers of jacket copy over the past fifteen years, after the rise to prominence of Karl Ove Knausgaard, Sheila Heti, Ben Lerner, and Teju Cole.

'Just because autofiction is old, though, does not mean its mode of deployment is unchanged,' Sinykin writes. 'That it has a new name ought to tip us off. It, for one, is another kind of genre play that makes a bid for a large readership under the current market dispensation.' What genre isn't a 'genre play'? Were Augustine, Margery Kempe, and James Joyce not making bids for large readerships under their market dispensations, furthering their brands? Sinykin quotes a remark of mine, from an essay in *Bookforum*, that autofiction 'restores at least the illusion of autonomy in the hands of an authorial alter ego', but I wasn't talking about the publishing. I was rather drawing a contrast between characters in books of autofiction and those in systems novels. Sinykin's theory of literature is what Guillory would call a 'strong theory': it is broad and reductive. When everything a writer does is a market play, nothing written is not a market play. And if everything we read is just a highly evolved marketing campaign, why read at all?

The most perverse of Sinykin's readings is of Percival Everett as an exemplary nonprofit author during the era of conglomeration. Sinykin uses a computational model of analysis he developed with another scholar to analyze the differences between a set of novels published by Random House and a set published by nonprofits. He describes their findings:

> We found that nonprofit novels tend to privilege embodiment, craft, and localism. They give more attention to what it feels like to live in a body, describing perception, sensations. They draw on the language of artistic practice and the world of craft: forms, colors, shapes, surface. They tend toward rural settings. By contrast, Random House novels tend to privilege language of law and power, bureaucracy, and dispositions. They give more attention to the results-driven world of ambition, the linguistic formalism of administration, and the manners and mores of polite correspondence.

Leaving aside the vagueness of these terms and the question of whether the model has an irony filter, I wonder what can be gained by such a method that couldn't be gained by reading the books in question, aside from time saved. Sinykin subjects Everett's novel *Frenzy* to the model and finds that it's 'a borderline case, hovering in its language between the poles of conglomerates and nonprofits' – could be Random House, could be Graywolf. After this nonsensical waste of time (the model also thinks *Beloved* must have been published by a nonprofit – 'By placing Black women and their embodied experience at the center of her account, she overwhelms the arid institutionalism and racist epistemology of schoolteacher, and thus of conglomeration, leading the model to recognize her novel as nonprofit' – ah yes, the iron logic of a model you made up, performing a task a human can do better than a computer – reading a book – and performing it incorrectly), Sinykin summarizes the novel, a retelling of the myth of Dionysus, and writes: '*Frenzy* is an allegory for the plight of the writer in the conglomerate era. To speak in the city is to be subject to the rationality and instrumentality of capital. To speak in the wilderness is to submit oneself to the embodiment of frenzy.' The split between the Apollonian and the Dionysiac is an old one, and no doubt it applies to the divide between corporate and independent publishing. After explaining the business model of nonprofit publishers as in part relying on donors who favor multiculturalism and lists that include writers of color, Sinykin concludes of Everett:

> Close reading Percival Everett reveals a struggle – embedded in his sentences, his characters, his plots – between author and institution. Ironically, Everett, in his essays, interviews, and personal correspondence, fails to recognize that Graywolf and its fellow nonprofits operate according to a parallel racial logic as the conglomerates, one the image of the other in a funhouse mirror. He praises Graywolf as exempt because it publishes him, when, for Graywolf, he serves as a vessel for its mission

of liberal multiculturalism, a prized commodity for its niche markets. Although it contradicts his stated motives, Everett's literary project could be read not to condemn markets, but to condemn those markets that propagate inauthentic and constraining racial fantasies; his novels, that is, espouse one more liberal multicultural vision.

Actually, close reading is not necessary because the struggle between artists and institutions is often Everett's explicit subject, as in *Erasure* and *So Much Blue*, to name two of his dozens of books. But poor Everett: all that writing and he turns out to be just another tokenized sellout to the nonprofits. Good thing he took his new book *James* to Doubleday for a decent paycheck.

'This book defers judgment about whether conglomeration was good or bad in an effort to explain what it has meant for US fiction and how we should read it,' Sinykin writes. But if what it has meant is that aesthetics are marketing strategies and how we should read fiction is through the colophon on the book's spine, certain judgments are inevitable: that conglomerate publishing, with its reliance on comp titles in its selection of books to bring out, stifles originality by ignoring it until it has a proven track record of profitability (as in the cases of Knausgaard and Roberto Bolaño, whose books were picked up by FSG after they were hits for Archipelago and New Directions); that taste and quality count for less and less if they can't be translated into marketing terms; that even the nonprofit publishers are just checking boxes for their plutocratic donors out for a tax break and for self-perpetuating charitable foundations; that any pleasure we take from contemporary literature is at best an accident and more likely a hoax.

The editor-in-chief of an independent publishing house recently told me that she believes there are about 20,000 serious and consistent readers of literary fiction in America and publishing any novel of quality is a matter of getting that book to them by any

means necessary. Another editor at an independent house, a veteran of Penguin Random House, called her current method of acquiring books 'throwing shit at the wall' to see what sticks. During the trial that resulted in the government's enjoinment of the merger of PRH and Simon & Schuster, the prosecution argued that the industry proceeds by rationalized methods that can be measured and ought to be regulated while the defense likened the work of acquiring manuscripts to casino gambling. They both had a point. Sinykin is invested in a highly rationalized view of the business because it brings his own efforts closer to the realm of science than to subjective judgment – the longstanding agon of literary study in the academy. But the fact remains that new literature has become a minor and diminishing concern of the publishing industry. If corporate publishers could eliminate the risks inherent in peddling literature at all – by, say, moving to a model whereby they gobbled up the hits produced by independent presses, often called 'the minor leagues' at the merger trial – they would do so. The point of the government's enjoinment of the merger was to maintain the competition between the Big Five corporate publishers, which is the only reason authors receive high or even moderate advances. Fewer and fewer of such authors are those we would deem literary; more and more are celebrities.

Corporate publishing is the channel through which literature happens to flow at this moment in history. The legal and political economic imperatives of the moment mean that the rights to backlist titles will tend to accumulate in a few hands to be exploited for as long as the copyright lasts. Most books will go out of print forever, as most deserve to. Those that last will retain trace impurities from the conglomerate system, but the presence of the corporate taint – I mean, the colophon – won't be the reason we continue to read them, nor was it the reason we read them in the first place. Year after year our culture compels people to think of and understand themselves as consumers. This dreary view of life, which advertises itself as critical or at least conscious of commerce, capitalism and complicity, quickly

becomes another form of marketing, and when applied to our reading habits it amounts to a distracting narcissism, looking in the mirror when our eyes should be on the page.

'Books serve our self-image,' Sinykin writes. 'The books we like say a lot about us, whether we know it or not.' He is, like many in his profession, operating under the influence of the French sociologist Pierre Bourdieu, who drew upon and expanded Thorstein Veblen's ideas about conspicuous consumption and 'the regime of status' and applied them across classes, especially in the realms of education and culture. I am unqualified to comment on France, but I have always been skeptical when Bourdieu's program is imported wholesale to America. In my experience, most Americans are hostile or indifferent to reading and glad to have gotten done with it in their schooldays if they did it all. They prefer the pleasures of sport, television, and various online distractions. And why not? Those things are fun and mostly painless. In an anti-intellectual country, reading books at all says more than enough about you, and you already know this because the rest of them don't let you forget it.

Bourdieu, Sinykin, and many of those he quotes view reading and writing primarily as social activities, inextricable from our relations with others. Anyone who has read a novel knows this is true and it would be pointless to deny it. One of the reasons we read literature is to experience the author's purchase on society and to see how it corresponds with our own. Literature's perennial advantage over sociology is that it can do this through the means of irony, paradox, and beauty. It is not restricted to the empirical, it is free to invent, it has recourse to fantasies that are truer than real life. It is less enamored with disclosing the obvious. The greater the novelist, the richer the picture of the world depicted within it, but also the more resistant the work becomes to being reduced to sociology. There is a reason why, when Thomas Piketty wants to add flourishes to his map of the economy in nineteenth-century France, he turns to Balzac, and why Lionel Trilling thought there was no better guide to property in Regency England than Jane Austen. But for the novelists themselves

this sociological richness is a byproduct of their aesthetic ambition, never the main chance.

Though reading is a social activity, the opposite is also true – something novels and their characters are always telling us. Silent solitary reading, removed from religious ritual and the scriptorium, is a recent development in human history. As Guillory points out, in the beginning, reading alone was the subject of moral panic, linked to the sin of masturbation. These suspicions of impurity, corruption, and self-indulgence remain with us today in the menace of book-banning. Like whimpering dogs, philistines will always be with us.

Pleasure is why we read literature, but the pleasures literature delivers are complex and not easily described, defined, or fixed in time and place. As Guillory writes, the pleasures of literature are often only gained at the expense of pains: the initial pain of learning to read, the pain of understanding difficult books, the pain of grasping the literary history from which books emerge, the pain of looking at something we can't yet comprehend though we know we could, the pain of examining the nature of our own pleasure. Perhaps it's these pains that turn our eyes away from the pleasures of literature to the disenchanted explanations of political economy, to the suspicions of paranoid reading, to the preening pondering about what the books we enjoy say about us rather than what they say to us.

Life is lonely, painful, and punishing. On behalf of the freelance book reviewer/London litmag office/Downtown Manhattan scene superorganism that speaks through me, I assert that reading and writing are best done in perfect solitude; that sometimes what you read and what you write should be kept a secret; that when you're by yourself popularity doesn't matter, nor does money, nor does fame, nor does status; that when you are a teenager and you have shut yourself into a room to read Kafka for the first time, your parents and your little sister should stop knocking on the door because you are turning into something else, something they will never understand. ∎

THE WEIGHT OF THE EARTH

Debmalya Ray Choudhuri

Introduction by John-Baptiste Oduor

The subjects of Debmalya Ray Choudhuri are encountered by a viewer who appears washed up in a new city. They play ironically with social codes and are equal parts desiring and reticent, longing and withdrawn. Flirtation and its denial are the dominant mood of these photographs: *Touch me not*, they seem to say to us. Isn't this the look that Choudhuri's lying model gives? The head rests on sheets ruffled into folds by the erotic grip of a hand; the arms flex just slightly. The presence of another person at the scene is suggested. The image invites you to imagine their position and to mentally assume it. Look again and you see that the model's eyes are open, which is not unexpected, given the circumstances. But in the gaze, there is something strange: not rapt sexual pleasure, but circumspection, even hostility, directed outwards. Suddenly you feel yourself pulled from the position of the participant – thrown off the model's back, so to speak – and out of the tableau entirely. It's a look that says, *Desire is here, and you have no part of it.*

Choudhuri has said he met many of his models online, on Craigslist to be specific. His photos share the intimacy of a rendezvous with a stranger. These are people willing to show you their naked body, but not very much else. In one image, a man shakes his hips in a dancing motion, his body bending into the shadows of the photograph which obscure his face and engulf much of his right side. Superficially, what

we're seeing here is some bravura: a bit of queer machismo, maybe. But it is, of course, the anonymity of the darkness – as well as the encounter with a stranger – which makes the self-confidence of the sitter possible in the first place. The slow shutter speed both blurs the image and creates a space in which a form of self-expression – fully exposed yet obscured – can exist.

Largely, Choudhuri's images track onto a certain kind of immigrant experience, albeit not in the hackneyed ways that these things are often discussed. This is an experience of being confronted with a place which has its own rules, to which newcomers must bend. Many of the models seem to have their own agenda. Their poses are not the product of the comfort of familiarity, in contrast to, for instance, Peter Hujar's portraits of Manhattan intimates. Each subject has something they are willing to reveal about themselves, a hard constraint with which Choudhuri seems to have to make do. Much like a new city, the models come as they are and must be navigated rather than shaped. This is what we can see in the image of the woman who kneels with her back to the camera and her face shrouded by hair she has flung over it. Again, the gesture is that of superficial self-confidence made possible by an illusion of control. Her hands appear to tease seductively at her body. But this is a contrivance, like the props placed in a PG-13 film to cover up nudity. The whole image swims in a space of ambivalence: who has drawn the boundary here, the model or the photographer?

Choudhuri's world is one from which concerns about authenticity and sincerity, as well as naïveté and cynicism, have long ago taken flight. In one image, two people walk along a New York street, perhaps thirty feet separate them. They seem indifferent, not just to one another, but to their surroundings, which are unremarkable with the exception of two lines of graffiti at the centre of the photo and written on a white residential picket fence. It reads, simply, REMAIN FREE. The injunction is unbearably empty. It is hard to imagine a context in which anyone would say it, let alone write it. The image as I've described it would seem saturated with irony, but the people in the photograph pay it no mind. The words are as much a part of the general sense of obliviousness as the two passers-by. ■

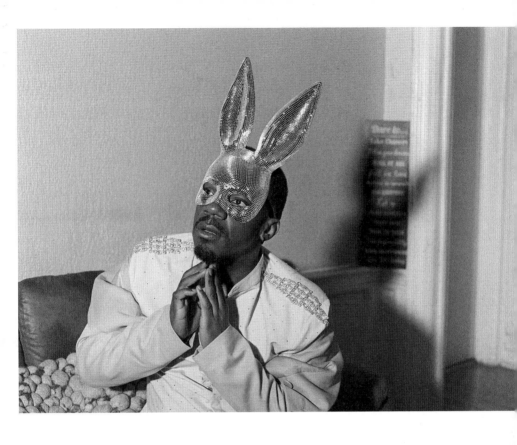

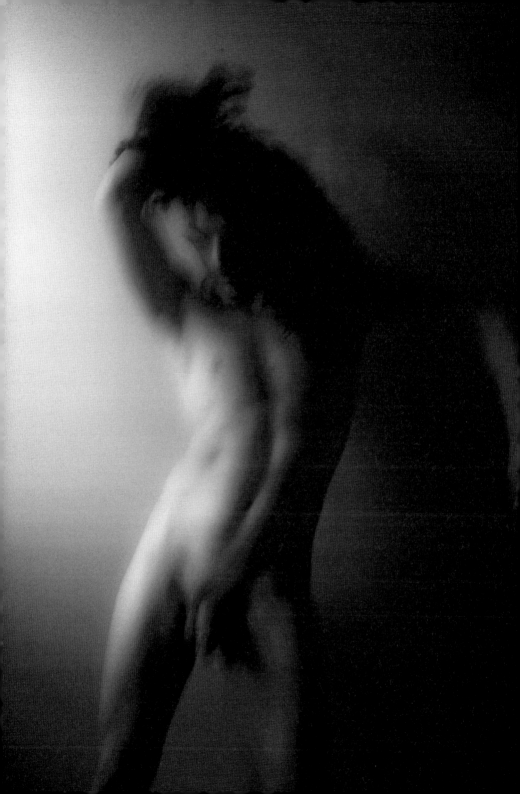

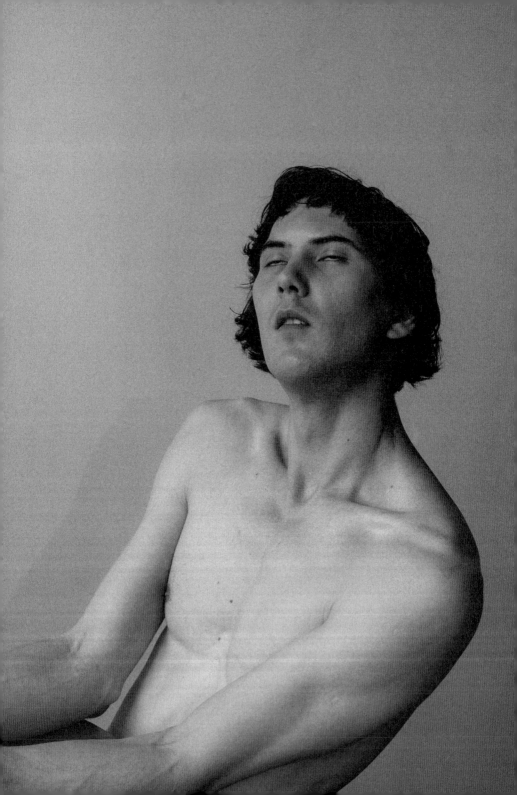

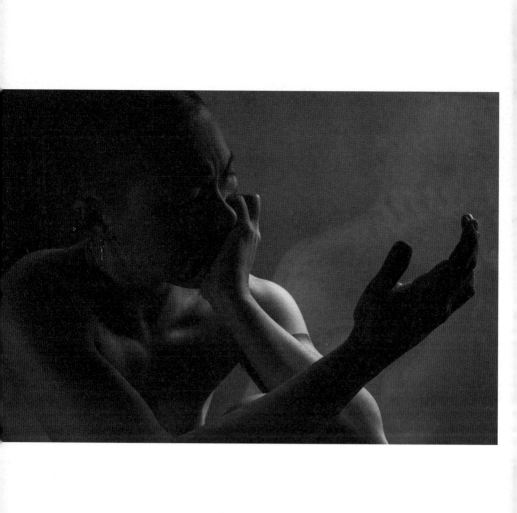

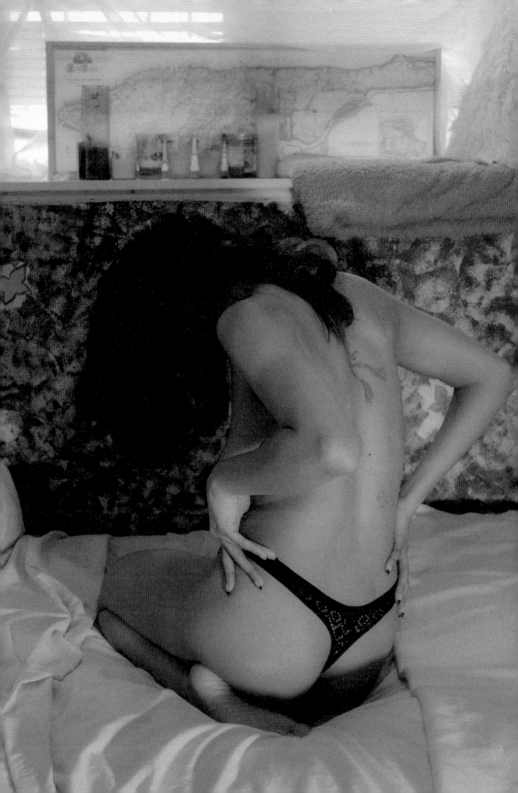

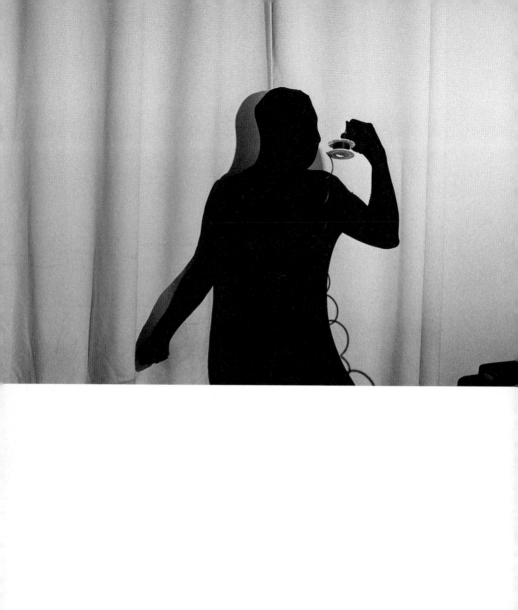

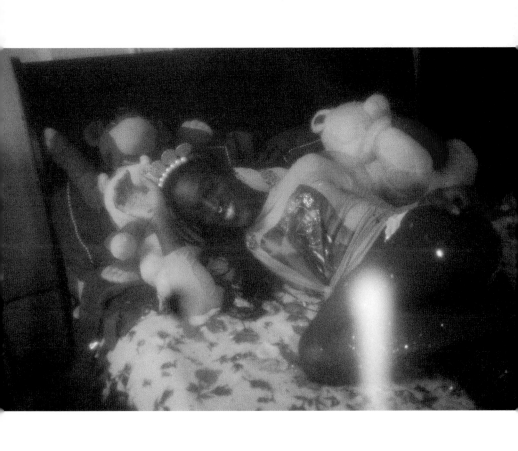

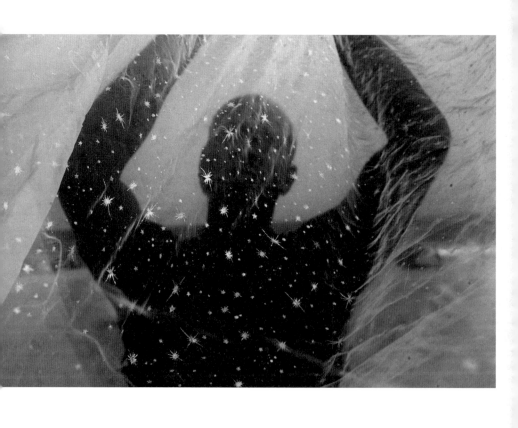

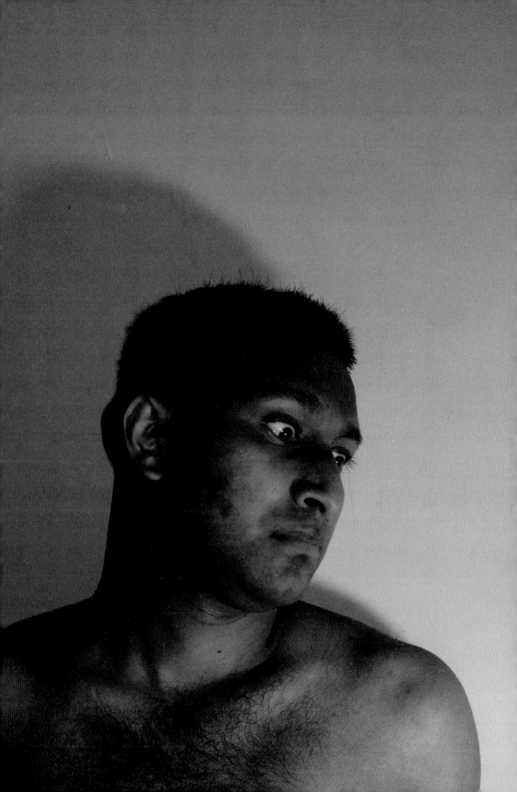

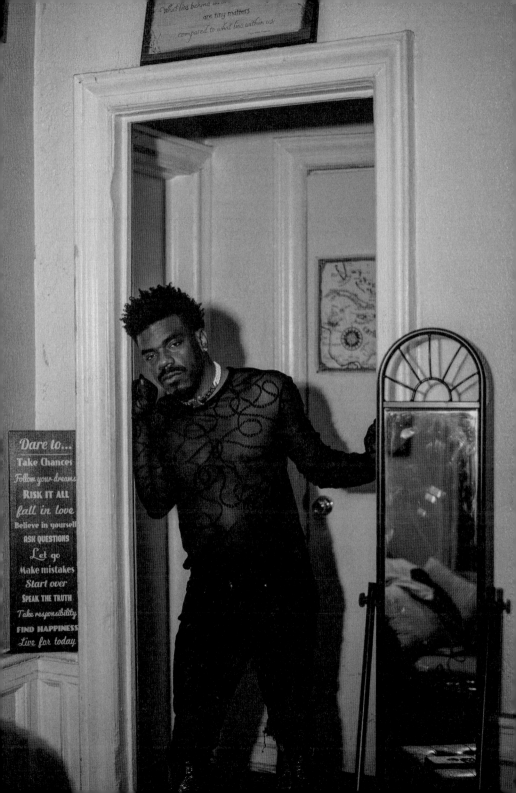

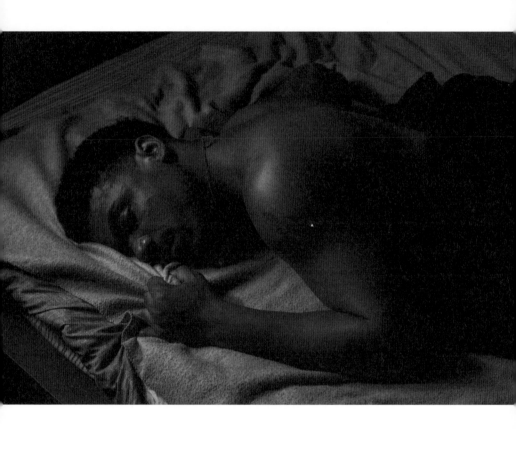

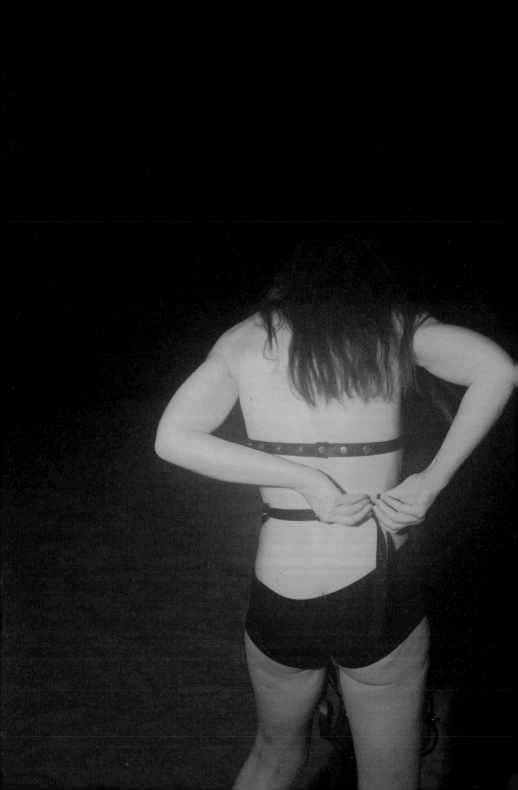

ACADEMY
at National Centre for Writing

MASTER YOUR CRAFT

Courses, workshops, mentoring & resources

nationalcentreforwriting.org.uk/academy

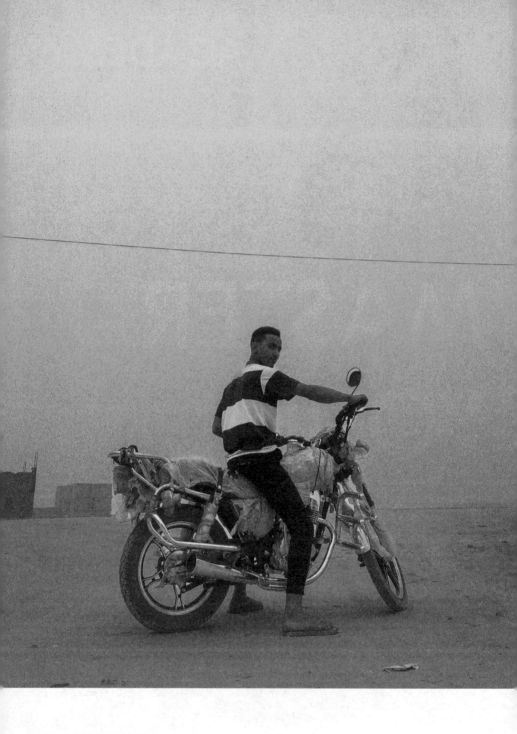

ALL PHOTOGRAPHY DAOUDA CORERA

GOLD FEVER IN THE COUP BELT: THE MINES OF MAURITANIA

James Pogue

The name of the camel was Zajarek. I was told he was moody, but he and I got along fine. By the second day of the mission, the men of the *Groupement Nomade de la Garde Nationale* let me loose to ride him without a chaperone, and after some initial difficulty I learned to keep him in a jogging gait, which the unit maintained for hours, bouncing lightly on wooden saddles, smoking loose tobacco out of short pipes, tying and retying their black service turbans, and posing with their rifles whenever I went to take a picture.

I rode for a long time with a *méhariste* named M'Bérik, a jocular, martial man in his fifties. He knew a great deal about the desert and the work of herding animals. We had a moment of confusion when I asked whether he sensed that the climate of the Sahel was 'hotter now'.

'The Sahel is very hot now,' he said. 'Drones, terrorists, war in every direction,' he said. 'Oooh it is too hot!'

His uncle had been killed the month before in a drone strike after he crossed with his herds into Mali, looking for forage that had grown increasingly scarce in recent decades. 'Look from Sudan, Libya, Mali, Niger, it is hot hot hot.'

We left the vicinity of Néma, Mauritania, and rode south through dunes and acacias toward the border with Mali. It was long into

the winter dry season, and we moved between isolated watering points, where nomads came with their herds of camels, goats, and sheep. The war that raged on the other side of the border had begun in Mauritania, before spreading south and coming to color every part of life in the region known as the Sahel – a name that, in common parlance, denotes a cluster of former French colonies in the northern interior of Africa: Mauritania and Chad at the edges, and Mali, Burkina Faso, and Niger in what is often referred to as the 'central Sahel'. In a decade of fighting focused in this central Sahel, transnational Islamist groups built shadow systems of power – drawing recruits and funds by controlling gold mines and villages inhabited above all by the cattle-herding Peul people, fighting by ambush and dispersing when confronted by government or international troops. In January this year, the UN Secretary General António Guterres gave a speech warning that the region had become the world's 'epicenter of terrorism', and that it was facing an 'an all-out assault on civilization itself'.

The war was fought mostly between central authorities and the sons of nomads. But few people in Mauritania are more than a generation or two away from having been nomads themselves. The *méharistes* – the camel cavalry – carried small arms and barely enough ammunition for a firefight. But they have developed their own way of fighting the insurgency that has outlasted four international deployments and the military power of half a dozen African governments. It is a soft-touch approach, and goes some way in explaining the mystery of how Mauritania, nearly alone in the region, has managed to achieve a tenuous peace. They cultivate spies. They control the watering points and watch who uses the passes in the high country. They move on the ground, and speak with the women whose sisters have married jihadists and the old men who can point them to the arms caches and smuggling routes.

A short ride to the east of us, thousands of refugees a day were crossing over from Mali toward camps and watering-places near

M'bera. The city of Kidal, the 'historic fief' of the Tuareg, who in 2012 rose up to take control of northern Mali, was recovered last November by the Malian army and their Russian allies. For at least a few hours, the death's-head flag of the mercenary Wagner Group flew over the city's colonial-era fort. The soldiers with us had all seen the photo. At night around the campfire, they talked earnestly about what it portended.

Mauritania has become an uneasy haven from the upheaval that has been 'shredding the social fabric' of the Sahel, as Guterres put it. The once-sleepy capital of Nouakchott is booming, a refuge for agents of armed groups, and the locus of geopolitical competition. WHY EVERYONE IS COURTING MAURITANIA ran a September headline in *Foreign Policy*. 'NATO, China, Russia, and regional powers all want closer ties.' Migrants from war-torn countries like Mali and Sudan have come by the tens of thousands to prospect for gold in Mauritania's deserts, much of which would be smuggled to refineries in Dubai.

'There,' M'bérik pointed northeast, toward the trackless frontier inhabited only by gold prospectors, smugglers, and nomads. 'It is plein désert,' – the *full desert*. 'We go nine days to places no 4×4 can go. No one has a compass. No one has a GPS.' Many Mauritanians consider it vaguely shameful to rely on maps or devices to navigate the desert. 'And there are many mean people there.'

I asked him how they didn't get lost. 'Monsieur James,' he chided me. 'Nous sommes les gens du terrain.'

I was back in Mauritania for the first time in fifteen years. In 2008, when I was twenty-one, I moved to Mauritania to work as the logistics chief for a crew of pilots and geophysicists exploring for resources in the far northeastern region of the country, near the borders with Mali and Algeria. At the time, the global economy was several years into a boom in resource prices known as the commodity 'super-cycle', which many economists and development gurus expected would bring prosperity to African resource-exporting

nations. The country's first major gold mine, near the Atlantic coast at a site called Tasiast, would soon be developed by the Canadian mining firm Kinross. The few bars of the capital Nouakchott were full every night with South Africans, Australians, Britons, and Canadians – all involved in developing mines or offshore oil and gas fields. The first night I drank a few beers with the American Ambassador, who predicted great things for the region. 'It's finally time,' he said. 'With everything they have here, someday it'll look like Dubai.'

I lived for most of this time in a town called Zouérat in the far northeast of the country, built around a set of iron mines developed by a French consortium in the 1960s. Until recently they represented the country's only major source of export income, and by far its largest source of government revenue. If the American-led order really is an empire, then Zouérat was by definition a frontier town – a heavily guarded mining outpost at the outer edge of where the order held sway.

There was no paved road to the city. The only land route was a train line that served as an almost too-perfect synecdoche for the way that our system transfers resources from the periphery to the center – a thin capillary stretching deep into the desert, carrying back the substance used to build Western infrastructure. The train line has never been extended to the capital of Nouakchott, where a full half of the population lives. The iron leaves as ore, sometimes worth as much as $130 a ton. When some of the iron comes back, its worth is multiplied thousands of times, in the form of cars and building materials, and as the mining equipment and train engines used to haul it out in the first place.

Every empire has its ways of keeping order at its fringes. The Americans living those days in Mauritania arrived in the spring. They were taciturn pilots who landed in Beechcraft King Airs, planes that the Canadian pilots I worked with noted were the same kind that US law enforcement agencies use to monitor smugglers in the lake-strewn borderlands where Ontario, New York State, and the Iroquois reservations come together. It was a safe bet that the men were there

to make surveillance flights, helping the Mauritanian military search for smugglers and fighters in what was then a force of about one thousand or so members of a newly formed franchise known as al-Qaeda in the Islamic Maghreb (AQIM).

The leadership of AQIM came from an elite of ethnic Arabs, most of them veterans of the civil war that began in Algeria in the early 1990s. They grew powerful and rich by smuggling drugs, guns, and cigarettes along the traditional trans-Saharan routes linking sub-Saharan Africa to the Mediterranean. The commander of the group's operations in Mauritania, an Algerian named Mokhtar Belmokhtar, became internationally famous under the *nom-de-trafic* Mister Marlboro.

Shortly before I got to Mauritania, a young ex-gangster named Sidi Ould Sidna orchestrated the kidnapping and beheading of four French tourists in the southern town of Aleg. A few weeks into my time in Zouérat, I traveled overland to the capital. When I got to the hotel I'd reserved I found shrapnel and burning thatch in the courtyard. A small Volkswagen parked outside had been positively aerated by gunfire. I had missed the assault by a few hours.

This attack was claimed by AQIM, which was earning tens of millions of dollars a year by kidnaping and ransoming Westerners. Sometimes smugglers in caravans would fire small arms at our planes, which flew at low altitudes making large survey maps showing what are known as anomalies – areas where magnetic or gravimetric readings indicate propitious areas to drill and sample. It was the first step in the long and expensive path toward mining development.

This development did not much benefit the people of Mauritania or its Sahelian neighbors. Mining creates little wealth for regular people – per dollar of revenue earned, it creates fewer jobs than almost any other industry. The wealth it creates comes in the form of resource rents paid directly to state coffers, and for it to benefit populations or create lasting development, a government needs to save and spend carefully to avoid falling into a vicious cycle of dependency. Mining exports raise the value of the local currency,

making food and goods produced locally more expensive, which can leave a country even more dependent on resource exports to sustain itself. It's a cycle that arose in many African countries in the years after they gained independence.

In 1974, Mauritania nationalized the company working the iron mines in Zouérat and redubbed it the Société Nationale Industrielle et Minière (SNIM). It also withdrew from the CFA Franc, the regional currency pegged to the franc and then to the euro that has made it impossible for France's former African colonies to devalue their currencies to spend on infrastructure, security, or social programs. But it did not escape the resource trap. A large majority of people living in 'extreme poverty' on earth today live in African countries defined by the IMF as 'resource-rich'.

I was elected to be our project's 'crew chief', which meant that I oversaw demobilization of our project. My last duty was to deliver a CD containing the data from our $7.5 million project to the local offices of Rio Tinto, the Anglo–Australian mining behemoth. I was conflicted about this final act, which seemed to implicate me more directly than I was ready to accept in the process of binding this country of nomads to the rich world. But I was twenty-one, and a small cog in a process that then seemed inexorable. I handed the disk off to a South African geophysicist with a salt-and-pepper beard and an old-hippie vibe, who offered me tea as he unwrapped the disc and carefully wrote out a label for it. 'Where should I put this?' he muttered as he looked around the messy office. 'You know, I have quite a few of these lying around.'

The country I arrived in last December was not the Mauritania I remembered. It was in the midst of an upheaval that had transfigured the whole society. The change was part of a chain reaction that had been set off when France, in 2011, had pushed for the NATO bombing campaign that drove Muammar Gaddafi from power in Libya. Gaddafi had offered training and refuge to Tuareg rebels from the north of Mali. After he fell, the Tuareg retrieved

thousands of small arms and heavy weaponry such as SA-7 mobile rocket launchers from Libyan weapons caches, and joined in a brief but consequential alliance with al-Qaeda, which had always wanted a regional war. 'Back then I was on the dark web all the time,' Rudy Attalah, who had been George W. Bush's head of counterterrorism in Africa and now runs a think tank, told me. 'And there was this map they shared, with black arrows all pointing directly to Bamako. They said, *if Mali falls, all of West Africa will fall.*' The alliance swept toward Bamako, and French troops intervened, in what became a deployment that would span three countries and last eight years.

The jihadist campaign in Mauritania had by this point become a part of life in the country. In the summer of 2009, AQIM murdered an American aid worker and carried out a suicide attack on the French Embassy in Nouakchott. A year earlier they targeted the vital iron mines and ambushed and killed twelve soldiers near Zouérat. They attacked the military barracks at Néma, and in 2011 they tried to assassinate President Mohamed Ould Abdel Aziz, who took power in a coup shortly after I left the country. And then everything went quiet.

'Various explanations were proffered,' an intelligence brief by an American security consultant explained, about the mysterious and sudden peace that emerged. 'Mauritania was good at counterterrorism; the government had made a deal with the devil; jihadi groups respected Mauritania's neutrality.'

The truth may be a combination of all three. In 2016, American officials declassified a letter from 2010, found with Osama Bin Laden when US Navy Seals killed him at his secret compound in Pakistan. It discussed a possible truce with Mauritanian authorities, provided they pay 'between ten to twenty million euros' a year and agree to 'not intercept the Mujahidin and cause any evil in the country'.

Even if there wasn't an official deal, Mauritania found some arrangement that led the jihadists to turn their attention elsewhere. 'It wasn't that there were these attacks and our military did this great fighting,' Yahya Loud, an Islamist opposition parliamentarian told me

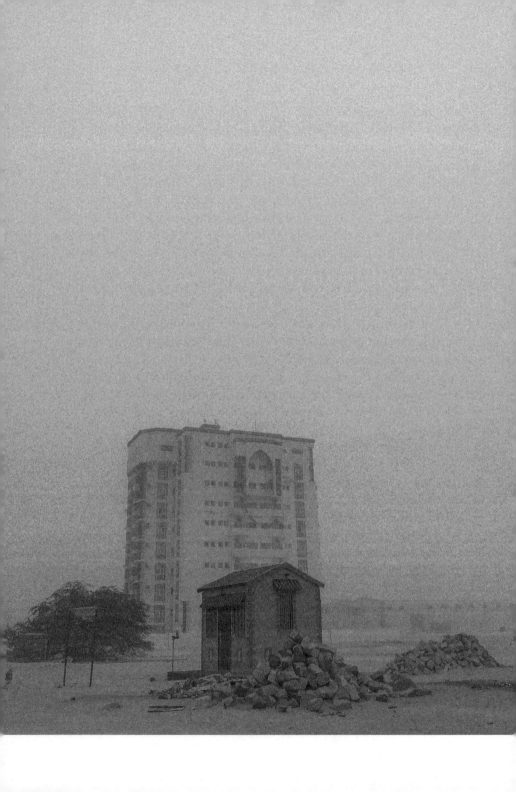

when I got to Nouakchott. 'They just stopped.' The country turned toward the Arab world, and Abdel Aziz oversaw an Islamicization of public life. 'The average Mauritanian is already an extremist in their interpretation of Islam,' Loud laughed. 'They don't see us as the enemy.'

Under the leadership of Mohamed Ould Ghazouani, who would go on to become president in 2019, the country developed a security apparatus that was far more supple than that of its neighbors, investing its new gold revenue in units specializing in mobile desert warfare, in the camel corps of the *Groupement Nomade,* and in intelligence. They monitored social media, and imprisoned and 'corrected' suspected enemies.

The war spread south, and a so-called 'jihad noir', formed in Burkina Faso and Niger. When a wave of coups brought populist and anti-Western leaders to power in the three countries of the central Sahel, Mauritania became the region's strategic free agent. The government struck a military agreement with Saudi Arabia in 2017. The United Arab Emirates pledged a $2 billion investment package in 2020, amid rumors it planned to build a drone base in the northeast. As the country looked to become a gas exporter by the end of 2023, interest and investment flooded in from powers across the world.

Villas the like of which I never imagined seeing when I first lived in Mauritania began to appear behind high walls on the outskirts of Nouakchott. In July 2023, Ghazouani met with Chinese leader Xi Jinping for the second time in the space of eight months. 'These meetings underscore Mauritania's status as the sole bastion of relative political stability in the Sahel region,' *Foreign Policy* reported. It was a sign of the 'the often-overlooked intensification of geostrategic competition in Mauritania'.

'You're surprised?' the driver who picked me up at Nouakchott's modern new airport asked. 'There's a lot of money in Nouakchott now. A lot a lot of money. It's the gold.' He was proud of

the new growth, and that the country was at peace. 'What we have is a military government,' he said. 'We have elections but we go from one strong man in the military to the next. Not many people know Mauritania, but we're developing, we have peace, *we* are the example for all of West Africa. For all the Sahel. We are the only peaceful country.'

In Nouakchott, I hired a fixer named Ely Cheikh Mohamed to help me see the gold rush that was at the center of the region's upheaval.

Ely was a thirty-two-year-old who spoke excellent English, French, and international Arabic. He was from a family of Sufi leaders, and grew up in the central city of Atar as a religious child, expecting to become an Islamic scholar. Islamic education in Mauritania had long been popular among foreign students and jihadists, 'both because of the authenticity of the curriculum and the austerity of the locale,' as a security report I'd read put it.

Ely lived this austere life in childhood, but in his late teens he'd discovered Nietzsche, and it all went sideways from there. He had studied philosophy and math, and he was part of the small and intimate circuit of intellectuals and writers that make up Nouakchott's bohemians. He was conflicted and in some obvious ways bitter about the opportunities available to a kid who wasn't in the country's elite and had been denied when he'd tried to apply for a visa to get to America. He had worked for a Chinese mining company in Zouérat. 'The Chinese, they treat people like animals,' he said. 'They look down on everyone African. I'm educated so I felt like I can say to them you can't talk to people like this. It made me unpopular. Now I can't find a steady job, so I am a fixer.'

I went to the city of Zouérat, where I'd lived in 2008. We sat around drinking tea for hours, and a local guide named Ahmed Jidou helped me arrange interviews with miners. Breaking for a lunch of fish with rice, we sat on the floor and shared and ate with our hands. The fish was new, one mechanic explained. President Abdel Aziz had made it a personal mission to convince a desert people to look to the

resources of the ocean. 'He told us it was bizarre that a country with the fishiest coast in the world' – *la côte la plus poissoneuse du monde* – 'lets the Chinese and the Europeans take it all, and we only eat goats.'

Ahmed introduced me to an administrator at the SNIM. Abselaam Beyrouk had worked his whole life for the company. We spent a couple afternoons talking at his house, which was part of a tract of new houses constructed for workers. He told me about the days before independence, when Zouérat had been almost entirely purpose-built as a company town. At the time, the salaries for the SNIM's 3,000 expat workers made up two thirds of the wages paid out in the entire country. 'The French came and built pools, housing, cinemas. It was very . . . clean.' The company now operates four mines around Zouérat, and alone contributes 10 percent of the country's GDP and 22 percent of the country's export revenue. But it only employs 6,500 people, in a country of five million.

'At the beginning it was all for the French, it was so the French could exploit and take everything,' he said. 'There were movements, there were strikes, in 1968.' I had never heard this story. 'Oh yes,' he said. 'People died – there are plenty of people in town who have family who died in the strikes.'

A clandestine Marxist and nationalist movement grew up among the mining workforce, and the singular importance of the Zouérat mines to the national economy gave them leverage. The dictator Moktar Ould Daddah nationalized the mines and pulled out of the CFA to calm the agitation, and the SNIM began a process of 'Mauritanization'.

'I was there when the Mauritanization started,' Ibrahima Aw told me. He was a slim and serious man in his fifties who joined us one day and sat apart from everyone, because he didn't speak Hassaniya. He was Peul, and had left his ancestral home in the southern town of Kaidyi to look for work in the mines. He'd ended up as a mechanic working on the SNIM's train engines. 'It was bunches of French people just leaving. They started doing anything they could to Mauritanize.'

'That can work, okay,' he said. 'But they're still just an exploitation company. It's not refining anything. You break rocks, you sell, that's it.' He snapped his fingers. 'Do you see what I mean? If you want to make a factory or something here – you have to ask the World Bank, the International Bank of Development, something like that to give the money. All the deals they make are with foreign companies,' he said. 'And one day, when everything is mined, voilà, that'll be it.'

Ibrahima had the air of frustration particular to highly intelligent people stuck in a life they feel has dead-ended. He wanted to explain to me the life of a Peul, the people who now make up the vast majority of both jihadist fighters and civilian victims in the central Sahel, as the drought pushed herders and the far larger populations of settled farmers into conflict over productive land. 'Look, I've basically lived my whole life here,' he said. 'And when you leave your home at sixteen, and live here where you're never around many Peuls?' He paused 'But a Peul is a Peul, everywhere.'

He said that for the Peul, the problems came with the borders drawn by Europeans. 'The French found this people, who are intellectuals in Arabic and in Islam, who have wisdom, a way of life, laws and judges. And this people refused to be integrated. So the French, because they're politicians, they're savvy, they cut the community up, into many parts. So now some are Mauritanians, some are Senegalese, some are Malians. The Peul don't have a land of their own. Like the Kurds, like the Palestinians, like the Tuaregs.'

He had been speaking in the third-person plural, but suddenly he switched. 'But it's only us, only in our case, that we never rose up to demand a land of our own. We let it be. We're resigned.'

He expressed a feeling I heard during the months I spent in Africa. The Western vision of democracy and development had failed, and whatever came to replace it wouldn't necessarily be any better. 'I don't care if we have a democracy or not a democracy,' he said. 'If it's a good dictatorship? That's better than democracy, do you understand?'

He had watched as the Peul tried to escape the massacres and drone strikes across the border. 'They're fleeing here,' he said. 'But you know that soon Mauritania will be too full of refugees.'

'It's a world crisis,' he said. 'You are the best, the Americans, with your democracy, integration.' He did not think this would be coming to Africa. 'At some moments I look and say we should have stayed colonized. Maybe it's better. I'm distressed. That's why I talk this way.'

I drove out with Beyrouk to see the newly-constructed camel corrals on the edge of town. I asked him, given that he was management at the SNIM, about a rumor I had heard from Ely. He'd said he'd heard talk of a Russian-operated gold mine, far out into the desert near the Algerian border. I had thought this was implausible, but Beyrouk knew what I was talking about.

'Oh yeah, that's at the border,' he said. 'It's *top*,' he said, pronouncing the word in English. I didn't understand what he meant. 'It's top-secret,' he said. 'We say *top* here, like James Bond.'

I asked what he thought the Russians were doing out there.

'I think it's an exchange, they offer guns and arms,' he said. 'There's an exchange like that. We never know,' he said. 'You can't get near it. I went there and they said you can't come near. But there are Russians.'

Five months before, in July 2023, a coup in Niger – France's last ally in the central Sahel and home to a key American surveillance base – set off a panic among Western officials and their African allies. A 'domino effect' was thought to be turning the Sahel into what Western think-tank types began to call the 'coup belt'. The deposed Nigerien president had come to power in an election that was almost certainly fraudulent, but the US and France went to increasingly desperate measures to try to restore their 'democratic' ally. A Western-backed regional grouping, led by Nigeria, threatened to invade.

The threat fizzled into nothing but embarrassment, and the entire central Sahel slipped out of the Western sphere of influence.

Niger joined Mali and Burkina Faso in a new bloc, all led by coup governments that had come to power accusing democratic and Western-backed governments of their weakness in the fight against jihadist insurgents. They threw out French troops and turned to Russian mercenaries as their business partners.

All three states – Niger, Mali, Burkina Faso – were highly dependent on gold. Their leaders fanned local resentment of France and the West, and launched mass popular mobilizations as part of 'a process of recovering our total sovereignty', as the leader of Niger's new junta put it.

Western analysts began taking bets about what country would be next to fall.

I had little idea when I first came to work in Mauritania that I was playing a bit part in setting off one of the biggest gold rushes in history. At the time, I hadn't known exactly what we were looking for – geophysical surveys don't necessarily target a particular resource. But there was gold in the block of territory we surveyed, and lots of it. When the area was opened to miners in 2016, the '*maudit fièvre de l'or*' burned so hot that tens of thousands raced to pay the 100,000 ougiya (€250) the government was charging for permits. *Jeune Afrique* reported that Nouakchott had been choked by traffic jams, as would-be miners lined up on Avenue Charles de Gaulle, trying to buy equipment and set out. Scammers sold fake metal detectors for around €200. A good one cost €4,000, a fortune in Mauritania. By 2019, a full 10 percent of the population of the central Sahel was working in the small-time mining sector. Rebel groups and Islamists took over mines. Gold replaced kidnapping as the biggest source of revenue for the jihadist groups.

The whole arc of the failed promise of development became legible in the traces of the gold rush. 'Gold mining was initially sidelined by the impetus of "modernisation",' a report by the Italian scholar Luca Ranieri, whom Ely had helped to research gold smuggling, put it. 'However, the environmental crises of the 1970s and 1980s propelled

artisanal gold mining as an alternative source of livelihood for local labourers.'

Gold made the Sahel countries into some of the most mining-dependent economies on earth. In Burkina Faso, Russia won new gold-mining concessions, and the country's young president Ibrahim Traoré announced highly symbolic plans to build its own gold refinery. 'For a while now gold has been our biggest export,' he said. 'But we don't have control over the gold. We asked ourselves many questions, and now we've decided to put a whole chain in place.' He said the new facility would welcome the country's small-time gold miners. 'So much of the gold in our country is exported fraudulently,' he said, 'and goes to support terrorism. So we will ask our local miners to bring their gold to the center.'

Mauritania created a governmental organization called MAADEN – Arabic for 'mine' – to regulate small-time gold mining. In Zouérat, MAADEN had built a centralized processing for miners to come and process their ore.

I talked to the site manager, a man named Hamed Salam, who had a bad limp and wore a hi-vis jacket and a black turban. He used the French term for local mining – 'minerie traditionelle'. This was a funny way of phrasing it, since before the huge mine at Tasiast opened in 2007 there had never been much gold mining in Mauritania. He said that it was what they called it everywhere, and then pointed at the clutches of squalid tents staked all around, where men who'd brought in their ore from far out in the desert were camping. It was, quite literally, a nomadic existence. 'It's mining, but it's also a traditional way of life.' In English, journalists use the delicate euphemism 'artisanal mining' to describe the same industry, which makes no more sense.

The site was infernally loud, with dozens of screeching crushers pulverizing the bags of ore into sand. Diesel engines powered scores of generators and big trucks roared constantly. The wind was ripping hard enough that it blew away one miner's tent. Mercury-laden

dust from Sahelian mines has been traced as far away as the Canary Islands.

Never with success, Salam had tried his own hand at mining. I asked how the successful miners found their sites. 'They just hope,' he said. 'Some of them have metal detectors.' There was so much gold that often people just looked for quartz veins and dug. Miners spoke of it wistfully as a lottery.

Salam took me to look at a row of amalgamators, where mercury was added to the ore sand to process it out. Mercury binds to gold like a magnet, and makes an extremely dense alloy, which lets you easily separate it out by machine or by swirling in a pan. Artisanal miners do this without the machines, filtering out the likely gold by mixing pulverized ore with water, then pouring the liquid cup-by-cup over an inclined trough lined with fabric, so that the densest sand gets caught in the fibers. You collect this and then massage a pea-sized bit of mercury into the sand with your palm, over and over, until the alloy forms. Then you swirl out the remaining sand. If all goes well you have a few grams of gold, reduced down from perhaps a hundred kilos of rock.

Here there were machines that did it, and we looked down into the open vats where sand was being mixed by huge steel wheels. 'That is the mercury,' he said, pointing down into the churning sludge. The miners paid an extortionate price to the processors who owned the machines, almost $25 a gram – 40 percent of its worth.

'Every break I get,' Salam told me, 'I go and look for gold.'

We went to the government office nearby, where permits were handed out and there were four 4×4 ambulances parked, waiting to be dispatched to cave-ins and other accidents out in the mining camps. I asked the official in charge how many gold prospectors there were in Mauritania now. 'Hundreds of thousands,' he said. Ahmed cut in. 'Before we had so many people leaving to become migrants,' he said. 'Now they stay for the work.'

Back in Nouakchott, Ely and I began hanging out at a modern spot called Arena Café, where members of Nouakchott's small intellectual scene often met up. He talked about books and politics for hours on end. Ely warned me not to underestimate the country's internal surveillance apparatus. Social media in the country was heavily monitored, and journalists were sometimes arrested and charged under the country's broad 'blasphemy' laws. 'It's sophisticated, with foreign help. They are bringing some kind of surveillance software here.' He was reading the conservative American economist Thomas Sowell, and said he thought 'post-colonialism' in the West doomed Africa to rule by the Chinese and the Russians. 'You pull back,' he said. 'And for someone like me, if they arrest me – the only help I can hope for is if France or America says something about human rights. If the West leaves Africa, people like me have no hope.'

He asked me if I had read Ibn Khaldun's *Muqaddimah*, the fourteenth-century study of empire that describes history as a continuous cycling of power: groups hardened and given common purpose by life on the frontier move to overthrow ruling classes that have grown soft and decadent in centers of power, only to become effete, sedentary rulers themselves. 'It is a good explanation of what is going on in Africa now,' Ely said. 'The power change happens in all civilizations. Savage people that live on the fringes gather and become dominant, and they take the power. The story here is not new.'

We arranged a meeting with a deputy to the mayor of Nouakchott, an engineer by training named Salek Najem. He had lived in Algeria and Germany before coming back and marrying a Frenchwoman. He was refined and erudite and had been shadowed all his life by jihadist violence. At the Hamburg University of Technology he studied with the lead 9/11 hijacker, Mohammed Atta.

'The old Nouakchott was multicultural,' he said. 'There were lots of ethnicities – Wolof, Soniké, Maur, Haratin. Everyone lived side by side. You'd have a Peul next to a Haratin. All the kids played together.'

'I think it was in 1992 that Mitterrand said to all the African countries that it was time for a democratic system. And this system broke Mauritanian society. Before, we didn't know what tribe or ethnicity anyone came from. But democracy reignited all that. Every clan and tribe started to try to win things for itself.'

'Everything started to change in 1978,' Najem said. 'There was *la sécheresse*, two years without rain, when people lost their herds – their way of living – and fled to the city. That is how the slums started. For us who grew up here, we were in the center, but bit by bit they made camps and corrals all around the city, and they brought the nomad culture here.'

'Now you have no more trees, no more animals,' he said. 'But there's some positive in that. It wasn't the State, it wasn't the French, that liberated the slaves here. It was *la sécheressse*, because people didn't need slaves anymore to watch their herds, and they couldn't feed the slaves they had. So they said, *go, go away*.' He'd lived in Algeria during the civil war that broke out after the military government refused to allow Islamists who'd won democratic elections to take power. 'When I went to Algeria in 1996, during the war, I saw the checkpoints and gunfire. I was in a bombing once. *Ça va*,' he said. 'At the time it wasn't a big deal.'

'It's that war that influences all the Sahel now,' Najem said. 'If in 1992 the French had let the Islamists take a bit of power – if they had just let them run some of the communes, we wouldn't be where we are now. You have to look at it and see that the Islamists were in the right. They won the elections. But I was there, and I remember some real atrocities. They would arrive in a village and burn the houses of people who hadn't voted for them, or whoever was informing for the army against them. And then of course the army would come and burn all the other houses, because they knew those were the people who supported the jihadists. So you see how it was during *les années noires* in Algeria.'

The same thing was happening now in the Sahel. 'The groups that left to go to Mali all grew out of the Algerian groups,' Najem said.

'All the first jihadists there were involved in drug trafficking, cigarette trafficking, and they were the ones who recruited the Mauritanians. It was all the big chiefs who have been killed today, Abou Zeid, there was Abou Yahia El-Hammam, Droukel . . . Mister Marlboro.'

I asked whether he thought the country had done a deal with the Islamists. 'Mauritania invested a lot of money in the army in the past few years,' he said. 'But it's only calm because all these people don't have any time for us. The jihadists don't want to open a second front with Mauritania. And anyway, all this is a facade. It's a security that's not secure.'

He said the new Islamism was a facade too. 'They have to pretend,' he said. 'It's become this social thing for the elites. They look to the Gulf. But behind the walls . . . who knows.'

Ely and I arranged to go north to Chamy, sometimes described by foreign reporters as the gold capital of the Sahara, in a new white Hilux. It was only a few hours north along the coast, and from the road you could see where the land faded into the Atlantic. The city had quadrupled in size in the past four years to 48,000. The rent for one of the little cinderblock houses in town was now 15,000 ougiya a month, almost $400. Our driver, Vaissal, was in his forties. He had a deeply pockmarked face and a trim moustache. He had worked in gold, and he knew a lot about how things actually worked.

He took us to a mine site far into the desert, through a classically Saharan set of dunes and wandering camels. He was worried that the Gendarmerie Nationale might find us and make trouble, so we drove fast, fishtailing and sinking through low washes of soft sand. We ended up at a tent city on a low ridge. 'There are probably a thousand people here,' Vaissal said. 'You never know. They come, they go. The conditions are terrible.'

We stopped by a mining pit, where four or five shafts had been dug with pneumatic picks. A young Haratin miner told us they were about forty meters deep. He looked bemused when I asked if there was any ventilation. He'd been living in the camp since 2016. I went

to look around. 'Be careful,' Ely said. 'I had a friend who died, walking around talking on his phone. He was on the phone with his girlfriend and just fell in.'

Vaissal said we had to move; he had spotted a national guard Land Cruiser moving toward us. We pulled down the main track, which was lined with tents – small shops selling bags of rice and bottles of cooking oil. Women sat in the entryway to many of the tents, holding babies and watching us silently. One clutch of three women hailed us. 'There's a lot of prostitution here,' Vaissal said. 'I heard the HIV rate is twelve percent.' I said it seemed unlikely that sex-workers would solicit in daylight in Mauritania. He said that the morals were bad in Chamy.

'Every mining town in the world is the same.'

We drove toward the Tasiast mine site, which we could see in the distance. Vaissal took out an old water bottle full of mercury, wrapped in a plastic grocery bag, and handed it to me. He laughed when he saw the look on my face. It was a lot of mercury, and heavy. He told us he'd had to quit working for nine months after getting mercury poisoning.

Tasiast looked like a mountain being slowly denuded. Vaissal told me I had it backwards – the mountain we saw in the distance was overburden from a pit mine. They were piling it hundreds of feet high as they dug. A huge billboard reading DANGER: CYANIDE had been erected on the road leading to the mine.

Cyanide leaching is a more efficient, and more expensive and mechanically involved, way of processing gold than using mercury. Pulverized rock is sprayed with a cyanide solution that dissolves the gold. Artisanal miners bring the sand they've already sorted once with the mercury process to cyanide leachers who take another cut, trying to squeeze every bit of value out of the rock. Huge amounts of cyanide escape into the environment during this process.

The cyanide processors are often owned by entrepreneurs from Sudan. 'They're gangsters,' Vaissal said. 'They have contact with the Sudanese government. They went to Turkey before they came here,

but they're too corrupt. They had legal problems. So they came here and now they're fine.'

'Most of the gold is actually trafficked,' Vaissal said. 'You can see why – because they buy the illegal gold for more than the real price. So people want to sell it to them, and they can launder the money.'

This was almost point-for-point what I'd just read in a UN report on how gold trafficking funds armed groups in the Sahel. Traffickers typically pay a 5 to 10 percent premium to launder money, and in return get an asset that is easily transported and tradeable on international markets.

'It goes to terrorism,' he said. 'To drugs. Who really knows? It's all international.'

In the past decade, Nouakchott has become a haven for rebels, refugees, and journalists. At the Arena Café I encountered a *France 24* correspondent named Anne-Fleur Lespiaut. She had contacts among the separatist Tuaregs, who had been scattered by the Russian advance. She put me in touch with the young leader of a splinter faction fighting around Menaka, in Mali, who had been accused of cutting a mercenary deal with the Nigerien government to fight against the Peul and Arabs in the north. He said he'd been there trying to broker dialogue with other herding groups. 'It's the land issue all pastoralists face,' he said. 'Our states give priority to farmers and for us there is nothing left.'

Lespiaut had been expelled from Niger by the new anti-French government. She'd spent a long time reporting on the gold trade in Bamako, the waystation where much of the region's smuggled gold was brought to be refined into rough bars before being shipped, usually in hand luggage, to Dubai. The city has hundreds of small refineries built to process trafficked gold. 'You look out and you see smoke rising from building after building after building,' she told me. She'd been to the mining sites in northern Mali. 'Là c'est le *business-is-business*,' she said. 'Everyone tried to keep it peaceful.' But in February Wagner troops began seizing mines directly.

I talked about this with Yahya Loud, the opposition parliamentarian, who had been elected to a seat representing Mauritanians abroad. He had lived much of his life in the Bronx, and seemed amazed by what had happened since the gold rush began. 'Our national budget doubled in three years,' he said. 'Our GDP doubled in five years – doubled. But mostly Mauritanians don't see the effect of that.'

'Most of the gold now goes out through trafficking,' he said. 'They send it to Mali and it finds its way on an Emirates flight to Dubai. That's called a "gold flight".' Dubai's officials deny this, but the emirate, long an entrepôt for African traders who come to buy car parts or electronics, has been accused by rival refining centers like Switzerland of accepting forged documents that obscure the provenance of trafficked gold. Refiners there are fond of the impure blocks of gold that come from Bamako. 'Buyers in Dubai prize low-grade bars of African gold,' one report put it, because 'precious metals such as silver, palladium and platinum can compose ten percent of a bar's original mass.'

'How come there's a daily flight from Bamako to Dubai now?' Loud asked me. 'That's something that would have never happened before.'

A single ton of gold is worth around $67 million at today's prices. So the suitcase traffic represents a huge amount of money, especially in this part of the world. Mali produces around 60 tons of artisanal gold a year, though no one knows how much of this is trafficked. In Burkina Faso, it is estimated that 30 tons of artisanal gold are smuggled illegally every year, to say nothing of the legal production. That comes out to more than $2 billion, equal to the entire GDP of the Central African Republic, where I reported for the last issue of *Granta*. A UN report suggested at least 1.8 million people were working as gold miners in the three central Sahel nations, and the true number is assuredly much higher.

'We let the central bank buy gold,' Loud told me, 'as a way of controlling the traffic. We said we would use this gold to build our reserves and make our currency stronger. But the World Bank said,

no, we can't do that.' There was concern that the Mauritanian central bank was acting as a state-backed money-laundering operation. He shrugged. 'So instead it disappears.'

Loud told me that the Mauritanian government began giving out artisanal permits right around the time that Mauritanians began migrating en masse to Europe and the United States. It has become the only option for many of the people pushed by drought out of farming or herding.

'Wear a turban over your face,' Salek Najem told us before we went to the Malian border. 'Be very discrete.'

Vaissal drove us to Néma, with one bare foot propped on the dashboard. The drive took two days. We stopped for a night at a small roadside guesthouse. Vaissal grew increasingly frustrated by the trouble we had at checkpoints, and with Ely, who made a point of joining him each time he stopped to pray.

'He is from a warrior tribe,' Ely said. 'He's very Islamist. It is like that with all of Mauritania. There is one truth you see in public, but under it there are lots of people who are basically al-Qaeda.' He said Vaissal was making snide insinuations that he was too soft and Westernized.

Néma was in a tightly controlled military zone. An overworked representative of the UN High Commission on Refugees helped me with my papers. She was a French former child actress named Joséphine Lebas-Joly. People were coming by the thousands now, she told me. There had been around 60,000 refugees in the border areas in 2014, during the fighting between the French-led international force and the jihadist groups. Now there were well over a hundred thousand in the region of Hodh el Gharbi, along with more than a million animals in the flocks and herds they'd brought with them. This put a burden on the desert environment, and meant that an impossible number of animals were competing to graze in an area where almost all the local Mauritanians also kept livestock. So many refugees were crossing that even with the entire UNHCR staff registering people, they could not keep up.

'It's a nightmare,' Lebas-Joly told me. 'All the estimates are that it's going to triple, or more.' Most of the new arrivals did not live in the camps, and had spread out instead around a muddy and malarial lakebed. 'It should be,' she paused, struggling with the English phasing. 'It should be at least eighteen-thousand people. In the last two weeks.'

I went out in town with a local schoolteacher, a friend of Ely's. We drove through the marketplace, a crowded and rutted dirt track between cinderblock shops selling sacks of pilfered World Food Program rice and fly-covered goat meat by the kilo. He took me to a spot where Peul refugees from Mali had been squatting in abandoned houses, but said it would be hard to get them to talk. Ely told me that the vendor who sold him cigarettes back in Nouakchott was a Malian refugee too. 'He lied to me for months,' he said. 'He didn't want to say. He was scared of Malian intelligence.'

Only one of the refugees we found spoke any Hassaniya or French, and he came out to talk to us. He said they'd come from Baly, just over the border, three months before. They had left their animals. He said they'd come willingly, looking for work, but now they rarely had any food. 'We are seventeen here,' he said. 'I am the man of the family.' He was no older than fifteen, and blind.

He wouldn't say what had happened to the men in the family. Ely's friend said they had probably been killed or conscripted into a jihadist group. Two young girls in dresses hung onto him as he talked to us, and a naked baby sat with one leg dangling off the doorstep. There were scars around his eye sockets and he didn't answer when we asked what had happened to his eyes.

'I want to tell you a story about how this all works,' said Colonel Moulay, the imposing commander in charge of the intelligence units of the *Groupement Nomade*. He spoke in eloquent French, and sat in a huge leather armchair. 'I was in Niger, where you know they have more and more problems, and I met with a general. While I was there, two herders came to ask for help. There had been five cows

stolen. They asked if the general could help recover them. But I had already seen the cows tied up in the courtyard.' The Nigerien troops had stolen the cows themselves. 'You cannot win a war like this.'

Moulay showed me a picture from a few days before of himself with the American Ambassador. He said that militaries across Africa had been contacting him, hoping to copy the Mauritanian model. 'Everywhere I go, they want to know. You are here wanting to know – *why does it work for you and not for us?*'

He gave me a philosophical lecture, echoing the *Muqaddimah*, and seemed to be suggesting that the conflict in the Sahel could never be won, only managed. 'There was the first war in Chad, the second war in Chad, then war in Mali. Then there was the war in Libya, and then another war in Mali. So you see, war always comes from another war unfolding in the region.'

He described how the jihadist and Tuareg fighters in the north of Mali had melted away as the Russian and Malian troops advanced. Much of the civilian population had dispersed as well, many to Mauritania. 'They let them take it,' he said. 'And when the people come back? It'll start again, bit by bit. Look at modern history – no power has won an asymmetric conflict. In the end they will leave with their tails between their legs.'

He said that Mauritania's approach, combining counterinsurgency warfare with development aid, was unique in the region. I noticed that when he used the word 'development' he meant something different than the promises usually held up by the West, that modern economies would rise to fill the void left by the upset of colonization and a changing climate. His version of development meant things like offering water stations in the desert – for better or worse allowing for nothing more than that nomads might remain nomads.

Moulay said the Mauritanians fought their frontier war by living and thinking like a frontier people. 'Our work is intelligence,' he said. 'And we work by aiding the nomadic populations. The nomads are our school.'

He arranged for me to join a unit of *méharistes*, and after two days of riding through a bare landscape of acacias and dunes we came

to a watering point where several bands had gathered with their herds. Ely took notes for me as an adjutant-chef questioned a man under the shade of a wild plum tree. 'There was one stranger who passed on a motorcycle,' the herder said. 'Six days ago. I reported him immediately.'

The adjutant-chef was concerned above all that the mission reflect well on him and Mauritania's military. He made sure the men were aware that days on a hard saddle and nights on the hard ground might be taxing for a Westerner. It was hard to convey to them that I found the camping and riding through borderlands invigorating. As an American it felt like a chance to live out some of what we had lost on our way to becoming a world-straddling commercial superpower.

'It is true what he says,' an old soldier named Shalek said. 'Life in America used to be very much like it is here. The cowboys were almost nomads. But now they have lost that.'

B ack in Nouakchott, I spent a couple evenings reading at the outdoor restaurant attached to the French Embassy, where I met a young Wolof named Ibrahim Sey. His mother had been in Arizona since he was a boy, and he hadn't heard from her in years. He thought she might be in Tucson.

He was debating trying to get to America via Pedro, a Nicaraguan smuggler all the young men in Nouakchott seemed to have heard of. The route was a series of flights from the capital to Manuaga, followed by a long journey by foot across the Texan border. But Ibrahim didn't have the money. I showed him videos of scenes at the Arizona border, and warned him that this Pedro probably wasn't a real person. He took out his phone, in turn, and showed me texts they'd already exchanged. He had friends who'd made good money mining gold, but he didn't have the startup money for that either. He spoke four languages and had gone to college. He gestured at his waiter's uniform. 'This is the best I can hope for here.'

Ibrahim had lived in both Nouakchott and Dakar. He missed Dakar. 'It's a city with life. C'est une ville cool,' he said. 'But it's so

expensive to live, and there are no jobs. No one can survive there.' He thought the jihadists driven out of havens in Mali would take up their trade again in Mauritania. The only hope a young African had was to get out, he told me. 'Or . . . maybe things will break,' he said. 'People hope China or Russia or somewhere will come to change things. But the Mauritanians, the nomads, they're different,' he said. 'I think they would be happy to just go back to the desert.' ■

This piece was supported by the Pulitzer Center on Crisis Reporting.

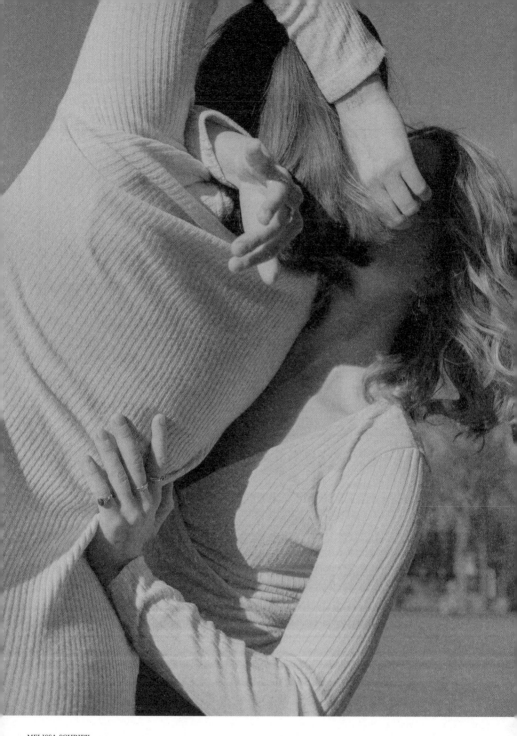

MELISSA SCHRIEK
Sway, 2021

THE PNEUMA ILLUSION

Mary Gaitskill

> When there is too much going on, more than you
> can bear, you may choose to assume that nothing in
> particular is happening, that your life is going round
> and round like a turntable. Then one day you are
> aware that what you took to be a turntable, smooth,
> flat, and even, was in fact a whirlpool, a vortex.
> – Saul Bellow, *Something to Remember Me By*

Seventeen years ago, there was too much going on. If I lay out
what was going on, it will sound absurd to call it 'too much'. It
seemed absurd to me even at the time. The turntable: at age fifty-two
I was happily married, I had a tenure-track teaching position, I had
just published the most critically acclaimed book of my career to that
point, and I was healthy and strong, really at a peak of mental and
physical strength. I also felt like I was beginning to feel connected
to two communities, one literary and the other more local and
neighborly; this was a first for me. I had never before experienced
such stability and connectedness in my entire life. The vortex: I was
boiling with a kind of visceral confidence that was completely new to
me and which at times felt mildly unhinged.

The confidence that came with being healthy, strong and stable
had the effect of opening me up to a deeper, more emotionally

complex experience of life that was often wonderful, but that occasionally took the form of irrational terror or pain so great that it caused me to wake at night, holding my hands over my heart in an attempt to comfort myself. As the turntable steadily droned by day, at night I felt the disconcerting, maddening pull of the vortex – and then the night feelings began to show up during the day too.

All of this was accentuated, I am sure, by the hormonal firestorm called *perimenopause*; it had just begun its raucous burn, sometimes making me feel like I was being playfully tossed back and forth by a pair of fiery fists, then repeatedly bounced off the nearest wall. The volatility was an intensity I could use creatively but sometimes . . . it was just a little more than I could bear. I increasingly felt I'd spent decades locked and loaded in a baroquely guarded survival mode and now I could lower my defenses and bust out – except that I didn't know how to make it happen.

In the middle of this I adopted a cat, a feral kitten that I brought home after a months-long trip to Italy. He was a wonderful little creature, one of those animals that wakens in you something new and tender, and makes you appreciate the noun 'familiar': *a spirit often embodied in an animal and held to attend and serve or guard a person.* Then I lost him. It happened three months after we got back. For nearly a year I was grief-stricken to the point of dysfunction; I couldn't do anything but cry and look for my cat. (I wrote thousands of words trying to make sense of my extreme reaction in an essay, 'Lost Cat', published in these pages.) The loss coincided with and amplified other forms of grief, for my family and for what I feared was the impending loss of two children my husband and I had been fostering for years. It was as if my grief for the kitten was a chink in my standard protections, a gateway to so many other emotions that I had been keeping myself from and which now began to trickle, and then to pour across the threshold. These were the night feelings; this was the vortex.

There was a lot more to this terrible period but, in the context of this story, all you need to know is that my life had begun to

seem wrong to me. Not broken exactly or meaningless. More like misguided or undeveloped. My heart hurt. It hurt so much that I had become desperate. This did not feel like 'depression' to me. I didn't feel numb or hopeless. I felt strongly alive and was actively searching for what I still believed in: love and my version of goodness. I'm sure that sometimes my demeanor or behavior did not appear that of a person looking for love and goodness, that outwardly I might've seemed angry or just weird. Truthfully, I sometimes was those things. This would give me a great deal in common with thousands if not millions of bewildered and unraveled people who are not entirely sure why they hurt quite so much and whose hurt reads to others as anger or weirdness.

It was in this state that I came across a type of physical therapy I am going to call Pneuma. I had at this point experienced many such therapies, most of which (chiropractic, Alexander Technique, massage) don't purport to offer anything more than greater physical ease, pain relief and structural alignment – which, in the right hands, can actually be quite significant. I had also experienced 'body work', specifically reiki and craniosacral, that (sometimes, depending on the practitioner) claim to offer something more mysterious: spiritual attunement, psychic integration, and emotional release beyond the scope of traditional talk therapies. Having experienced talk therapy, I felt that in terms of emotional well-being I'd gotten more out of body work, particularly craniosacral. It is hard to explain the efficacy of these techniques, but at their best, meaning with a gifted practitioner, they are remarkable in their direct effect on the emotions via the nervous system, and in conveying compassion through touch. They are also a lot less expensive (at the time, craniosacral ran typically $150 for ninety minutes versus talk therapy at $250–$300 for forty-five minutes), and don't require a weekly commitment. So I was receptive to Pneuma.

The first Pneuma practitioner I met – I'll call her Linda – came highly recommended by a friend, a woman named Donna who had recently lost both her daughters to a rare and terrible disease that they

were born with, and had lived through with a kind of wild courage until finally succumbing, slowly and painfully. Donna said that Pneuma was one of the few things that had helped and strengthened her during her anguish. Linda, who was based in northern California, was visiting upstate New York, and doing Pneuma sessions out of Donna's home in a town very near me.

During this time, I was in residence at an artist colony about an hour away from my home. I made a special trip back for three sessions over a period of five days. I was having a stressful time at the colony which, though it was a great opportunity, was a bit of a hothouse environment. I generally love spending time at such retreats but, perhaps because of my instability going in, this time was different. The group dynamic was neurotic, gossipy and, to me, seductive; I'm sorry to say that I was party to all of it. It was very cliquish, very much about people being rejected and humiliated – and yet there was a kind of rough-play quality that made it absurdly funny. I got drawn into the playfulness, especially in relation to a guy I nicknamed Old Blabber Mouth; together we could be so goofy about all of it that I could make light of the real bitchiness involved, even when it was directed at me.

My first session with Linda was not extraordinary. As with many such therapies it was deeply calming and grounding, that is, it made me very aware of my body. Linda herself was an intense bodily presence. She was in her early sixties, physically strong, stolid and adamant, like a human root vegetable with a dominant personality. Her voice was vaguely scolding and warm at the same time. Her hands were muscular and intelligent, her touch powerfully communicative and directional.

She had me lie on a table, but in a kind of odd contraption of cloth and wood – something like a cradle or hammock – that raised me slightly off the table, allowing her to place her formidable hands on my front and back simultaneously, say, on my chest and the corresponding place on my upper back. She didn't rub or massage me; her hands were firm and still, holding various parts of my body

between them for long, taffy-stretched moments. She might hold my chest and back for several minutes and then move to my belly and mid-back, and then my hips. I don't know if there was any set time or order to these choices. I only know that as she worked, I felt as if I were unwinding until I went into a kind of trance state from which, on that first day, I emerged feeling refreshed.

The second time it became something more. That *something* is hard to describe, especially after the passage of so much time. It involved a very subtle awareness that my body was holding a complex pattern that lived in my tissues and musculature, something woven into me, something deeply a part of me and yet alive and independent of me, at least as I usually consider myself. ('You're a hard one,' Linda remarked, 'like a Chinese knot.') I didn't have this awareness the whole time I was being worked on – most of the time I was just zoning out. It was something I felt in flashes that were not in any way thought-based. If I could compare these flashes to anything, it would be the apprehension one sometimes has in dreams, where an incomprehensible puzzle is suddenly exposed and you are suffused with miraculous understanding – which you forget the next instant. This might sound unpleasant but it wasn't. It was strangely enlivening. It was like discovering that your house has another floor, without being sure you knew what was in it.

The sessions were intriguing, and stronger than reiki or craniosacral therapies, both of which use a far lighter touch (reiki practitioners often don't really touch you at all). Still I did not immediately perceive it as very different from these other types of body work. When I returned to the colony, however, a small but striking incident made me realize how much the treatment had affected me: I walked into the common area and Old Blabber Mouth regaled me with the latest dirt. I don't remember exactly what it was, something someone had said, how someone else, perhaps a person he expected me to dislike, had been put down. A week earlier, this gossip infusion would've worked on me like an injection of allergen, causing layers of internal reaction, the psychic equivalent of scratching and

rubbing that only makes things worse. This time it didn't affect me that way. It hardly affected me at all. I was friendly to OBM and even replied to him. But the poison didn't get into my system – and he knew it. I still remember the bewildered look on his face – something like a cat that had pounced at a mouse which suddenly . . . wasn't there. I left the conversation politely but quickly; we were no longer on the same wavelength.

A small thing, but to me, remarkable. Because the change in response had happened on a completely natural, *unwilled* level, a bodily level. It was the kind of change that people spend years of therapy to achieve. It didn't entirely stick; when I got back into the social mode of the colony, I was drawn into the drama once more. But not as deeply. It didn't get inside me the way it had. It did not cause me the same pain.

I saw Linda once more before she returned to the West Coast. When she was in New York later that year, I saw her another few times. I can't remember much about the physical parts of these experiences; it was more of the same, but deeper, as if each session reinforced the previous one. However, I remember the talking aspect. Talking wasn't supposed to be a big part of Pneuma; Linda actively discouraged talking or interpretation. But given all the change I was feeling in my body, Pneuma-induced and otherwise, it was impossible for me to be completely silent, nor did total silence seem desirable to me. I don't remember exactly what I said, just that I spoke frankly about my emotions, especially regarding loss. I also talked about images that popped into my head during the treatment. Linda was sympathetic with the former, but impatient with the latter. She said that I was too much in my mind; she said, 'You need to cut your head off.' She said this emphatically; she said it as if it were a wonderful suggestion. On another occasion she said it was a good thing I'd never had children because I would've been a 'terrible mother'. I opened my eyes and said, 'Wow, that's really hurtful.' And she said, in a tone of apparent surprise, 'Really? That hurts you?' I may've replied, 'I think that would hurt almost anyone.' But I'm not sure.

I have no idea what prompted her statement about my potential terribleness as a mother. I do remember feeling in that moment that something was really off about this woman, that she was either very unaware or actively hostile or both. And yet I did not get off (or out of) the cloth-cradle thing and leave. Instead, I stayed interested in working with her.

This is embarrassing to reveal and hard to explain – though perhaps it shouldn't be. People will tolerate a lot in relationships that they feel are beneficial in some way. And I *did* feel there was a lot of potential benefit in working with Linda. Despite her ugly words, the work had made me feel better, more open, more *alive*. I don't think this was my imagination. Other people noticed that I was different too. I remember asking a friend if she could describe the change, and she said, 'Yes. It seems like there's more of you on board.' It felt that way to me too. And so, when Linda told me that Pneuma could help almost anyone with almost anything, that it had radically changed her life and the lives of others, I believed her. More exactly, my body believed her. I decided that she was only human, that I didn't really know what her strange words had meant to her nor why she'd said them. I also decided that I could guard against her negative traits, put them in brackets, while remaining open to the good she could do. Because I still wanted to bust out of the internal constriction I'd become aware of. Or, as I came to say half jokingly, to turn into someone else.

I don't think I was – am – alone in this desire, not to become someone else literally, but to arrive at some better, less painful version of oneself – or as people say now your 'best self' – quickly, without years of frustrating expensive therapy that rarely (certainly in my case) helps much. In the early nineties certain optimistic psychiatrists promoted the idea that a then-new category of antidepressants could make you 'better than well'. Does anyone remember the handwringing about how Prozac might make us artificially happy all the time, thus depriving us of our soulful humanity? Insert laughing emoji face here! But no matter: now there are psychedelic therapists

and coaches who claim that one strong dose (or three or four) of psilocybin or ketamine or MDMA can physically rewire your brain so that old patterns are broken and you can bust out into best-selfness. People want it and they want it now!

But what does your 'best self' even mean? I was once asked to define that on a questionnaire, and the more I thought of it, the more ridiculous the question seemed. In spite of my joke about turning into someone else, what I really wanted was to be myself in a way that didn't hurt quite so much or so often – I didn't care about an objective 'best self'. I am guessing that most people in pain feel the same way. At some point in my descent down the vortex, I saw a talk therapist who told me that she didn't think I'd ever really become myself, that my 'self' had been formed entirely in reaction to bad things that had happened to me long ago. This irritated me immensely. It seemed unduly ominous; it also seemed like something you could say about almost anyone. Still, if her words did not exactly ring with truth they creepily hummed; they reinforced the suspicion that my life had been marred by unseen reactive patterns, most especially in relation to others.

During this time, I had a dream of a demonic plant on an impossibly long stalk that darted around my workspace like a snake, striking at everything, as if searching for something to attack or eat. It looked severely malformed: instead of blooming outwards, the flower was turned in on itself, forming a knot (perhaps a subliminal echo of what Linda had said about me, that I was 'a Chinese knot'). I was afraid of it, but also I wanted to help it, and I couldn't make it hold still.

And so when Linda suggested I come to her home on the West Coast to do a three-day intensive course with her I decided to use my frequent flyer miles to do so. She seemed pleased to have me and had prepared a guest room right next to her treatment area. She started working on me the first night I arrived, three hours in two ninety-minute increments that made me sleep very soundly. The next day we went for a long walk and had pastries; we spoke to each other quite intimately, almost as old friends would. And she worked on me all day . . .

This was more Pneuma than I had previously experienced, and I wasn't sure I liked it. It was not comfortable to be so passive for so many hours and the emotions coming up in me were less deep than aggravating. Linda again reprimanded me for talking too much and for thinking too much. 'I have a brain that's *just like yours*,' she said sternly, 'so I know what I'm talking about.' Between sessions, we did talk. About my mother. About her mother. About being a mother. About the guy who had molested me when I was five. About the female gym teacher who had sexually harassed Linda, to the point of calling on the phone in an unsuccessfully disguised voice to say that she wanted Linda to piss on her. In between sessions I would go for long walks and have increasingly dazed, angry feelings. I remember calling a friend and saying, 'For this to be worth it, she'd better start pulling some rabbits out of hats pretty damn soon.'

And the next day, she did. During Pneuma my body would sometimes involuntarily shudder or twitch; Linda explained these small movements as 'energy release' – which is what they felt like. But that day was different. The movements were stronger, like intense contractions – particularly in my lower abdomen – and they lasted longer. They came at quicker intervals. They came with vivid feelings, awful feelings that alternated with a strange disassociation. During one of these dissociative moments, I felt a strong hot tingling move over the surface of my entire body. It happened a couple of times. In the first instance, my body seized up and released in spasms. The second time my mouth began to twitch, exposing my teeth in a sort of weird snarl. I felt myself grimace and then I spoke, in a much deeper, slower voice than is my norm. I looked at Linda and I – or the voice – said, 'You fucking cunt. I'd like to tear your face off.' She responded by smiling benevolently and, I would say, even proudly. 'That's right,' she said. 'Let it come.' I said some other stuff along the same lines. And then I felt my face change again into an expression of real sadness. I felt like I was going to cry. Instead I reached out and touched Linda's cheek.

And then it was over. My body relaxed and the terrible feelings

melted away. Linda continued to work on me and, as she did, a feeling of extraordinary bliss spread through me. I also became very hungry. I went to a restaurant nearby and had one of the most enjoyable meals I've ever had. It was a beautiful day and my senses seemed heightened, including my sense of taste. I felt great goodwill toward everyone around me, and I must've been transmitting that feeling because everyone I looked at smiled at me with real warmth. Tentatively, I wondered if everything was going to be different now.

When I returned home the wonderful feeling stayed for quite a while. I have never been the kind of person who smiles at strangers easily; for much of my life I have had a habit of wariness. After the visit with Linda, that changed: I found myself sincerely smiling at people I passed on the street; I found it easier to talk to people in general. I felt great; I also felt an Alice-in-Wonderland sense of disproportion, as if my life were now too small for me, or the world too large. The yearning for openness that had led me to Pneuma was unabated; it translated into a little *too much* openness, in terms of vulnerability and in what most people might call socially inappropriate sharing. I was very quick with my emotions, whether they were angry or affectionate. Some of it was nice – an odd, childlike kind of nice. I remember doing an interview for a college paper in which the person asked what I would do if I had only twenty-four hours to live: 'I would tell everybody I love them,' I said. 'I would have sex with as many people as possible.' I still remember the incredulous expression on the student journalist's face.

During this time two people, one a friend and one a new acquaintance, told me that I seemed like 'a fourteen-year-old girl'. Both of them meant it in a positive or at least neutral way. But it is not a great idea for a woman in her fifties to be walking around like a fourteen-year-old girl. Especially not a woman with a complicated public persona. This all happened during a period when I was professionally very active, doing readings from a new book, talks and teaching engagements. I became acutely aware that, if I was formed by a subtle internal pattern, I was also formed by an external, social

one. This external pattern was more visible but almost as mysterious. Like the inner pattern it was me and not-me; like just about everyone with a social identity, I had created it but half consciously. Unlike everyone, my creation had undergone rather more conscious input from journalists, critics and publicists. And now it had a life of its own. And, when I was out in the world, that is what most people saw. Sometimes it was – and is – convenient; a persona can function as a kind of armor. It can also function as a steel trap. In my post-Pneuma state, the contrast between this complicated public image and what I felt was happening inside me was confusing and even painful. And then there was something else, something deeper that I associated with the weird voice that had come from me during the final session. I didn't know what it was, but it was there too, incongruously mixed with what I'm calling the fourteen-year-old girl.

I tried to talk to Linda about all of this, mostly via email. But she didn't seem to have any vocabulary for it. Sometimes she didn't reply to me at all, and other times she said I should just trust my body to process the feelings. She *did* have something interesting and mysterious to say about the weird voice; she said she thought it was something external that I'd 'allowed in' at some point in my early life because I had thought it would protect me. I don't think she meant anything supernatural. I think she meant a kind of disturbed adult aggression that I'd internalized, or tried to. She said that even before she heard it, she could see it in my eyes. I found this a little scary; I didn't know if she really was seeing something or projecting it.

I also talked to Donna (the woman who had introduced me to Linda) about what I was experiencing, including my mixed feelings about some of the things Linda had said. Donna allowed that Linda was 'a character', but she basically agreed with her that the work of Pneuma couldn't really be discussed at length, that it was innately non-verbal. She didn't seem surprised by the voice that had burst from me; she'd done Pneuma in group settings and said she'd seen all kinds of things happen.

I continued to go about my life which was quite vivid at the time. I was still working and traveling a lot, still experiencing outsized emotions, which were at times a creative boon and other times were painful and chaotic. My experience with Pneuma had confused me but it also roused my curiosity; I still believed it had done something for me. It was the only therapy I'd ever experienced that seemed equal to the intensity of my own feelings; it spoke the intimate language (or at least *a* language) of my body. This combination of intimacy and intensity was irresistibly compelling to me; I wonder in retrospect if my taste for it made me more responsive to Pneuma than most.

And so, about a year later, when I went to the West Coast for a book event, I made a couple of appointments to see Linda. That is when things got . . . vortexian. I wish I could remember it better but vortexes are kind of a blur. I remember that the weird voice reemerged and that it had some nasty things to say. I remember Linda saying, 'We need to break down your defenses.' I remember a particularly dramatic moment when my body was shuddering and I said that I had to go to the bathroom. She said, 'That's okay honey, you can piss all over the table if you need to.' I thought 'gym teacher' and controlled my bladder as I split myself in two, trying to receive the therapy and protect myself from the therapist at the same time.

Something else happened during that trip, an event that got wedged between my appointments with Linda. I ran into someone with whom I'd had an ephemeral emotional entanglement more than ten years earlier. I felt overjoyed to heal the harm that the misunderstanding had caused. When I told Linda about it, she encouraged me to reestablish a relationship, because she intuited, based on how my body felt when I spoke of him, that he was someone who really 'got me' – which, probably needless to say, turned out to be ludicrously untrue.

Months later, I emailed her to ask her why she had said this. I asked what had made her so certain of her opinion. She didn't answer. I emailed her again, and once again got no answer. I am embarrassed to say how terrible I felt about this; the combination of what had felt like

profound care on the one hand and thoughtless, capricious unkindness on the other was devastating and in some primitive way familiar. I was bewildered that someone could be so gifted while at the same time so irresponsible and inconsiderate on such a fundamental level.

On reflection, I realized that it made a very banal kind of sense. It is precisely those who have exceptional gifts that are most likely to fall prey to the kind of egotism that makes them impervious to other people's feelings. This is even more true of those who have naturally dominant personalities, as did Linda. It is most true for those who excel in areas of esoteric, subjective expertise – doctors, artists, writers, healers. This character flaw is really unpleasant when you are on the receiving end of it. But it is also very human. In the end, I could not consider Linda to be a wicked person; I believed that she sincerely wanted to help people, including me. But I did not want to see her again.

It was hard to give up on something that had given me such hope, hope that I still felt. I was still suffused with longing and vulnerability; I had recurring dreams that I was lost in a humongous airport, late for my flight or unable to find the gate or unable to even remember where I was going – and at least once, on the wrong flight. I would wake with a palpitant feeling in my chest, as if *something* there was actively, blindly searching for *something* without knowing what it was. On one such awakening, I felt like there was a malign presence in the room with me. I was alone and felt genuinely disturbed; it was as if the awful voice was now coming at me from the outside.

I decided to give traditional therapy another try. I saw four psychotherapists, each of whom, like Linda, said strange unhelpful things minus her erratic warmth and powerful touch; they were less efficacious and less interesting than Pneuma but every bit as kooky. And of course I was the kookiest of all, desperately flailing around trying to get help for increasing pain that I felt I ought to be able to bear on my own, or at least to understand. I would have been embarrassed by my absurd susceptibility to any and every kind of purported healing had I not been so beyond embarrassment. I would

be embarrassed now – except that the absurdity of my susceptibility seems, in retrospect, not merely matched but sometimes actually surpassed by the absurd nature of what the therapists offered.

The first one I saw came highly recommended, charged $300 for forty-five minutes, and was plainly a bright, urbane guy. During my first or second session with him I told him I had recently considered suicide. I made clear that I didn't want to do it, but that I was starting to involuntarily daydream about it. He asked, 'Are you a vengeful person? Is revenge important to you?' I wondered why he had changed the subject, but I gave the question some thought. I said that I was capable of vengefulness and sometimes experienced schadenfreude, but that those feelings weren't a big driver for me. 'Why?' I asked. 'Because,' he informed me, 'suicide is always about revenge.' He said that he based his opinion on his experience of the sufferings of those left behind – which seemed inappropriate given that, while he didn't know anyone I might have left behind, I was right there in front of him, suffering.

I lost confidence in the second one – also $300 for forty-five minutes – when she told me, without my asking for her opinion on the subject, that she thought my career as a writer was being impaired by my manner of speech, that if only I spoke differently my income and prestige would increase. I asked her why she thought this. Had she gotten this impression from people in my professional world? No, she hadn't – it was just her 'sense'. She also thought I might be low-grade bipolar or just 'spectrum-y' and prescribed gabapentin. She asked me to call and tell her how it had worked, but when I left a message that it hadn't affected me at all, she didn't call me back.

The third one I saw was at least cheaper – $250 for forty-five minutes. But he decided that he couldn't work with me after I told him during a phone call that I'd woken up feeling like there was a malign presence in the room. He first expressed annoyance that I'd called on the weekend and then said he wasn't qualified to help me and that I needed medication. I asked him to recommend someone, and he told me that he didn't know anyone, but there were a lot of clinics I could go to.

A friend to whom I told these stories said, 'What do you expect? They're business people. You'd be better off cutting a picture of some kind-looking human out of a magazine, taping it to your wall and talking to it for an hour.'

I considered this! Instead, I tried yet another therapist (also $250 a shot) who told me that she thought I had PTSD (which was her specialty). She said that she could see a pattern in my body comparable to other people with the condition, and that this pattern could rouse aggression in others. She said that she could see terror in the back of my eyes; she thought others could too, and, as a result, felt uncomfortable around me without knowing why. This was a dismaying thing to hear, but at least it made some sense to me, and she seemed very intelligent. But after maybe ten weeks, I had to move way upstate, to the Finger Lakes area, for a teaching job and was no longer willing (or able) to pay a $1,000 dollars per month to talk on the phone for forty-five minutes one day a week. I asked if the therapist had a sliding scale; she did not.

I was at that point no longer willing to think much about self-improvement at all; I had too much to occupy me. I'd run out of money; I had a huge tax bill; my marriage had (temporarily) split up; most of my stuff was in storage; I was alone in an unfamiliar place and my family was in crisis. The stability that had helped make a place for new and chaotic emotions had been completely upended!

But I was nonetheless okay. The new job was good; I liked the students and faculty, and I got a lot of writing done. The malign presence had stopped visiting me. But I still felt a lot of pain and loneliness. I remember once talking to Donna about these feelings and she had said something that stuck with me, that 'you have to grab on to good bits, even if they're really tiny'. It's the kind of advice that I hate, but, seeing the sense of it, I did my best.

After the job was over (it was a year-long guest chair position) I decided to move to New York City. This meant having a roommate and I was very lucky to find an optimal situation: large apartment, great location, unexpectedly deep new friendship. My debts were

mostly paid off and I was excited to live full-time in the varied, fast-moving dynamic of the city. Perhaps most important, the hormone storm that had raged through me for the previous six years was finally subsiding. I felt a degree of equilibrium and optimism that I hadn't felt for a while, and my work was flexing.

Still, I wondered about my experience of Pneuma; the intensity of it seemed in retrospect something inexplicable, like a sudden opening in the sky with an outpouring of visions. I remembered the dreams about going somewhere and becoming lost. I remembered the weird voice, and Linda's blend of nurture and cruelty that felt so harshly true to the rest of life. I remembered how vital I had felt, how I had smiled at strangers. These memories made me long for something besides 'tiny bits'; I missed the feeling of almost reckless openness, the apprehension of a deep place where innocence – the fourteen-year-old girl – might reconcile with darkness.

I looked and discovered that Pneuma had a website which listed practitioners. They were almost all in California. I had just been offered a job in southern California. There was a practitioner named Sylvia who worked out of her home in a verdant working-class neighborhood (passion flowers, roses, orange orchards, hummingbirds) that was a ten-minute drive from my faculty house.

If Pneuma with Linda might be compared to *The Haunting of Hill House*, with Sylvia it was more like Candy Land. Sylvia, also in her sixties, was a retired first-grade teacher with a strong inclination toward sentimental mysticism. The room in which we worked was filled with religious imagery and knickknacks – Christian, Buddhist, Hindu and New Age – the walls were covered with uplifting sayings and exhortations about love. (Sylvia had briefly attended Divinity School.) Her house, which she shared with her husband of many years, was always fanatically decorated according to the holiday seasons, which were, during my semester there, Valentine's Day, St Patrick's and Easter. Between sessions we would talk about whatever was on our minds; she shared with me the story of her

escape from a fundamentalist family in eastern Pennsylvania and her belief that she was part of an 'intergalactic council'.

Wide-bodied, soft and sweet-natured, Sylvia could not have been more different from Linda as a personality. As a practitioner, I did not consider her to be as strong. But when she worked on me, the same things happened: my body would first deeply relax and I would become dreamily aware of some kind of pattern within it; sometimes I would drift so deep into this awareness that it was a kind of trance; other times my body would involuntarily twitch, shudder and even convulse. Sometimes the weird voice would speak in a generally hideous way. Sylvia had no problem with it; once she surprised me by growling back at it – she had a surprisingly guttural snarl. On another occasion she invited it to leave me and come into her which struck me as a bad idea. I needn't have worried. 'I'm not interested in you,' said the voice. 'I want *it*.' It being me.

Was this frightening? It was. But it was a kind of fright I had gotten used to. As had previously happened, I felt great when I got off the table. And, as had previously happened, there was a rebound effect. Again, I felt the bewildering and sometimes painful contrast between the deep, private experience of Pneuma and my outward relationship with the world. It seems worth mentioning too that during this time I was assailed by violent sexual dreams that were too horrible to relate. Even with no bad dreams, I often woke with the familiar sensation of openness in my heart area combined with the feeling of searching for *something*.

Sylvia encouraged me to keep believing that I would find what I needed; she talked a lot about love (of all varieties), claiming that it was 'the only real thing'. She also talked a lot about outer-space people called Pleiadians, with whom she served on the 'intergalactic council'. This sort of talk was difficult for me to respect; as I had questioned Linda's essential decency, I now questioned Sylvia's thinking to the point that it became hard for me to be receptive to her touch. Eventually, I concluded that she was weird but wise, essentially a very kind woman who happened to have some sort of power in her

hands. Because even as I closed off to her in my mind, my body still responded, sometimes dramatically, to her touch; it was impossible to deny.

But where had this power come from, how had she gotten it? I looked again at the Pneuma website; it relied heavily on the concept of an 'energetic biofield' which it claimed may be manipulated to great effect – but the language was so hackneyed and vague that I found it ridiculous. (The concept is, however, acknowledged and even treated with a degree of respect by the National Library of Medicine which cites several studies that appear to support its efficacy.) The website was created by a guy I'll call Jonathan who claimed to have invented Pneuma after discovering his unusual ability to heal people almost by accident. Linda had already warned me about him; she had said that Jonathan was a sexually abusive, power-hungry guru-type from whom she and several other women had split years earlier. But Sylvia didn't describe him this way. According to her, Jonathan was immensely gifted but very troubled (as opposed to abusive); she hadn't seen him for years but still sent him a Christmas card every year – he in turn sent her his photographs of wild animals.

At this point the Pneuma phenomenon was seeming increasingly discordant. On the one hand, everything about it said *ridiculous-cult-org-preying-upon-the-vulnerable-and-dumb*. I appreciate that the reader might now be saying aloud: 'You just thought of that?' I actually thought of it earlier. But Pneuma seemed too small and too disorganized to be a cult of any kind. There were at the time maybe a dozen practitioners in the US (there were more in Europe, where it seemed more popular), and they weren't doing much to advertise themselves, i.e. to prey upon anyone. You didn't have to become a member or to have any particular beliefs. No one had asked me to contribute money to any cause. No one had tried to have sex with me. There was no discernable bad motive, just standard human fucked-up-ness. What I had experienced with both Linda and Sylvia had been disturbing and powerful and, I still believed, at least potentially beneficial.

Maybe a year after I'd first worked with Sylvia I went to Portland, Oregon, for several weeks in order to do research on a project. My destination just happened to be located where Jonathan lived and worked. He was around eighty and semi-retired, but he seemed delighted that I wanted to see him. I wanted to work with him because I hoped to finally figure out what this therapy was. Even more, I hoped to stop being in pain, to stop waking up in the middle of the night searching for *something*; I hoped to get rid of the weird voice once and for all.

Jonathan lived in a small house in a middle-class neighborhood in a state of old-guy-alone disarray; dirty dishes on the counter, struggling plants, layer of dust. He was visibly sad. I seem to recall that early on, maybe during our first meeting, he told me how lonely he was, that his children didn't visit him often. I remember thinking that he wasn't a good advertisement for his method – also that, plainly, he wasn't interested in advertising anything, at least not in the usual way.

But once I got into the session with him – in a small upstairs room, with windows on every side – he proved himself, just as Linda and Sylvia had done. In fact, he was stronger. He said he was recovering from an operation and wouldn't be able to work longer than an hour at a time – but during that hour, I immediately went into a trance state in which I seemed to be remembering things that had happened between me and my siblings when we were toddlers. My body went nuts: the voice emerged and furiously shouted at Jonathan: 'You're dead! You're dead! You think you're alive but you're dead!'

'I'm Ned?' asked Jonathan.

'Yes! And you're dead!'

After the session, I asked Jonathan how he knew that name. It was the name of the man who had molested me and I had not mentioned it. Jonathan replied that he hadn't said the name, that he had just repeated my words back to me, saying, 'I'm dead?' The moment seemed uncanny to me.

Jonathan was very different from Linda or Sylvia, but session time with him was similar in that it was a matter-of-fact blend of the

uncanny and the mundane, a time where the weird voice wasn't even weird. Over two or three weekends he worked on me for four hours a day, in one-hour increments, with half-hour breaks during which I would go out for a walk or eat something with him. During these breaks Jonathan talked to me about the women in his life who had, it seemed, hurt and disappointed him a great deal, from his mother and kindergarten teacher to his wife. He struck me as one of the most unhappy people I'd met – but he was convinced that this method, which he had somehow come up with (a process he could not explain to me any more than Linda could), was able to cure people of everything from trauma to depression to severe menstrual cramps.

The last time I had a session with Jonathan he told me he thought that I was done, that my problems had been solved. I didn't believe this, but I didn't debate it with him. There had been a fascinating depth to the entire Pneuma experience which I felt – and still feel – had helped me to become less constricted by old ways of being. At the same time, I suspected it had also done me some damage, or perhaps just led me into a few strange places.

Right before I left Oregon, Jonathan emailed to say that he wanted to take me to lunch. Almost as soon as we sat down, he brought up the then-current pedophilia charges against Jared Fogle, a former spokesperson for the Subway sandwich chain. Jonathan expressed sympathy for Fogle, who is now in prison for child pornography and sexual exploitation of a minor. He looked me in the eyes and said, 'What exactly *is* child sex abuse anyway?' I answered pragmatically, with the legal definition. But I was shocked, too shocked to respond appropriately. Even now I'm not sure what 'appropriate' would've been. Get up and leave? Throw a fit? Hit him? All of the above? While I sat there Jonathan carried on, agreeing that sex with children was wrong, but arguing that sometimes young girls could be seductive; he gave me several examples of his own experience with supposedly perverse pre-teens. The conversation was like a more extreme – more stupefying – version of Linda's announcing to me that I would've been a terrible mother, and unlike in her case, I could not 'bracket it'.

I never saw Jonathan again. I saw Sylvia the next time I taught in southern California. (I asked her if she could refrain from talking about outer-space people and she graciously agreed.) I no longer believed that she was going to do anything more than give me emotional support, but she was very good at that. I had never considered her as strong as Linda or Jonathan; it occurred to me then that perhaps I had confused force with strength. Something more occurs to me now: the weird voice, while it had spoken in Sylvia's presence, never spoke aggressively to *her*. But it had called Linda a 'fucking cunt'. It had told Jonathan that he was 'dead'; it had linked him with 'Ned'. Perhaps that voice is something I should get to know better. Perhaps it was the best thing to emerge from Pneuma, even if no one understood it, even if I still don't.

For that alone, even if I can't exactly advocate for Pneuma, I'm glad that I did it. The experience in retrospect seems both real and chimerical, suffused with some kind of sub-personal force that Jonathan and the others had tapped into without really knowing what it was. That ignorance (mine as much as theirs) combined with the mysterious *whatever* they touched on, the sincere will to help combined with real human failings – a seeming disregard for harm – all of that truly did let something loose without definition or judgment. I still think of it with a question mark. And with respect. ■

SOHRAB HURA
Nine, 2023

LÍGIA

Victor Heringer

TRANSLATED FROM THE PORTUGUESE BY JAMES YOUNG

Sr Mendes thinks I'm his wife. He speaks to me like he spoke to her, and even calls me 'petal' and 'my angel'. His wife, Lígia, has been dead for twenty years – he knew this perfectly well until he turned eighty-eight.

There were three guests at his birthday party: me, one of his daughters and one of his grandsons (he has one son, four daughters, and four grandkids, no great-grandkids). We sang, clapped our hands. The birthday song echoed metallically in the almost empty apartment. The extra verse: *It's snippy, it's snappy, now it's time now it's time now it's time. Ba . . . dum . . .* Our three voices and his, crackly, trying to sing along. Sr Mendes no longer had enough strength to clap, his throat couldn't hold a tune, his lungs were weak. His grandson, who's twenty, blew out the candles on his cake. Two candles: 8 and 8. Sad to see, but every birthday party can be mistaken for a funeral. *Hip hip . . .*

Silence. Sr Mendes, his grandson and his daughter smiled, all three for different reasons. I went to fetch a knife to cut his diabetic cake. Sr Mendes asked, with that raspy voice of his, where Lígia was. Did Lígia make the cake? Where's Lígia? I came back from the kitchen saying something or other and the old man's mind

put my voice in his dead wife's mouth, my face on the memory of her dead face. He looked at me and opened his false teeth wide:

SR M: My angel, did you make the cake?

His grandson and daughter raised their eyebrows at me: play along, it's his birthday and nobody wants to repeat morbid news, especially not 'Mum's been dead for twenty years'. I said yes, I'd made the cake, which wasn't a lie. The old man answered with an ah! and asked for a slice.

Ever since, I'm Lígia.

Sr Mendes went blind in his right eye when he was young, but his left can see perfectly. His hearing is fine. He hardly takes any pills: four in the morning, one in the afternoon and four at night. He isn't confined to his wheelchair: sometimes he gets up and walks around the apartment, supported by a mahogany cane. Genuine mahogany, he says. He likes to go out on the balcony and take the sun.

Before he turned eighty-eight, Sr Mendes knew perfectly well that I was a man called Alex, thirty-three years old, thick beard and short hair. I've seen lots of photos of his wife, pictures of when she was old and young: I look nothing like her. I never met the dead woman, never heard her voice, but I'm almost certain it didn't sound like mine. My voice is deep and throaty. I've got a few feminine traits, but the old man would have said something if he thought I was a fruit. He hates fruits. Nothing wrong with being homosexual – or so he often says when we're watching TV – but a fruit, no way! The TV is always on in Sr Mendes's house.

Now I'm Lígia because I'm Lígia. There's no escaping it. I denied it, the old man re-denied it, I tri-denied it, he cross-denied it so many times that all that was left was a tired, defeated, affectionate *yes*: I'm Lígia! I'm Lígia . . .

SR M: I know, petal, I'm not all that old.

I've known Sr Mendes for three years. I have no nursing training. I learnt how to bake a diabetic cake on the internet. I don't get paid to look after him. We both live in the same building, in lower

Copacabana, me in No. 104 and him in No. 404. The other apartments are occupied by semi-high-class prostitutes, impoverished students, transvestites and other old people. There are dozens, thousands of old people in Copacabana. It's a neighbourhood waiting for death. The old people here will be forgotten like the great armies. Who knows the names of all the soldiers who invaded Poland, or who landed on Omaha Beach? By a coincidence that no longer matters, I found myself in Sr Mendes's apartment. (*Pause.*) Soon I was visiting him every day.

The first year was an extremely lengthy vigil: I was certain the old man, who was eighty-five then, could die at any moment. Those were anxious months. I'd often dreamt he'd died and I hadn't been there to see it. A man should witness another man's death, the exact moment, at least once in his life. If he doesn't, he'll die thinking that life amounts to no more than a stage illusion.

I have lots of deaths saved in my memory, but I saw all of them from a distance, through the TV screen. When I was younger, I collected VHS tapes of accidents, street brawls, sudden heart attacks in restaurants, shoot-outs. I bought the tapes from a newspaper kiosk on Rua Sá Ferreira. The owner was a collector of violent scenes and on a tall rack, behind the porn films and magazines, he'd hidden a whole world. There were dozens of tapes, with no covers or labels, which he got from the hands of black marketeers. Amateur recordings, for the most part, but also films made by war correspondents, videos stolen from police files and a few rare gems: the complete works of serial killers who liked to record their crimes, videos filmed by soldiers on the battlefield, every type of visual perversion. Autopsies, torture sessions, botched police operations, rapes, armed robberies, kidnappings, disgraceful orgies, suicides, revenge killings.

If a customer not in the know, rifling through the porn magazines, came across the tapes and asked what they were, the kiosk owner would say they were blanks, and not for sale. We, the initiates, knew

the code. There was a ritual to be followed: we'd enter the kiosk in silence and, after a few motionless moments, ask, 'Where can I catch the fourteen-zero-four?', a bus that in those days didn't exist, or if it did, didn't go through Copacabana. Then the kiosk owner would say, 'That one goes to Pavuna, on the north side,' and produce the catalogue (a school exercise book with the number '1404' stamped on the cover), which was divided into three sections: SEX, DEATH and MISCELLANEOUS.

I only bought death tapes. The fatal shooting of a transvestite (gunshots to their made-up face) in Kansas, in 1987. A passed-out drunk, stabbed in the neck, Nilópolis, 1991. A pregnant woman dying in childbirth, the anguished cries of her husband (I think in Russia, 1995). A hostage-taker shot in the head by an elite sharpshooter, blood spurting all over the hostage, Georgia, 1994. A man throwing himself from a building in Montevideo, 1996. Scenes from the Sook Ching massacre in Singapore. Franz Reichelt jumping from the Eiffel Tower with his parachute and smashing himself to a pulp on the ground, 1912. Video suicide note, a teenager from New Jersey blames his parents and pulls the trigger, 1997. Video suicide note, a boy in Santa Catarina puts on lipstick and swallows poison, 2000. Someone getting run over in Viña del Mar, 1989. A beating in São Paulo, 1995. An old man dying peacefully in bed in a home (somewhere in England, 1990) after recording a hello to his grandson, a soldier fighting in Iraq. And then a woman's voice: '*Oh my God! Grandpa! Ooooh, my God!*'

I've still got the tapes, fifteen of them (in total, around 140 episodes), in the false bottom of my wardrobe, but I've no way of watching them. Who has a videocassette player these days?

Today I watch this stuff on the internet. And just like when I was a boy, I try to identify the exact moment a person dies. When their eyes fog over? When their jaw slackens? When their leg muscles become limp? When the monitor beep goes biiiiiiiii and what's left of the heart is a straight green line on a black background? When the people

in the street stop their yelling? When somebody starts to pray, or cry? When is it that someone dies, exactly? Is it when the camera is switched off?

The last video I watched was on YouTube. The title: 'Dies after being clubbed in the head in street brawl. Violent scenes!' – *In media res*: a skinny guy, wearing a football shirt (blue, number 10), fish knife in his right hand, up against two huge fat guys. One carries a club, the other has nothing. The set: the narrow, sunlit streets of a poor neighbourhood. In the background, a house painted pink.

The three study each other, they step forward, and then step back again. The skinny guy lifts his leg like a Thai boxer, like a flamingo. The people watch on. Motorbikes go by. Various cries, sounds of fear and humour.

MEN: Get out of here, boy! Yeh! Yeh . . . Yeeeaaah!

WOMEN: Out, out . . . Aaah!

Leaping backwards, the skinny guy dodges two blows of the club, then launches himself at the unarmed fat man, but the guy with the club protects his companion, forcing the skinny guy to retreat. The unarmed man grabs a loose chunk of kerbstone and chucks it, and when the skinny guy panther-jumps backwards again, the guy with the club seizes his chance: one, two blows at empty space, at the ground, the third striking the skinny guy's arm. Now the skinny guy advances again, fish knife poised, other arm raised in self-defence, until the fat man with the club lands one, two blows on skinny's back.

MEN: Get out of here, man! Get out, man!

The skinny one charges, leaping in an attempt to bury his blade in the neck of the fat guy with the club. That's how Achilles killed Hector.

A motorbike passes in front of the camera. The cameraman gets out of the way and without meaning to points the lens upwards. Satellite dishes and the sky, sky floating on sky, blue, clear, quiet. A few clouds. A couple of seconds of the most conventional beauty there is and here down below the skinny guy is running, he's fleeing. His Achilles lunge has failed.

MEN AND WOMEN: Aaah . . . eh-eh-eh-eh!

He no longer has the fish knife in his hand. Now three men are chasing him, another fat guy has joined the first two. A blow to the ground with the club. The skinny guy runs, another blow to the ground, he gets to a corner and hesitates, a misstep, and the fat guy with the club is upon him. A blow to the neck. Skinny collapses. Face down on the ground. Motionless. Another blow to the back. Shrill screams. Everyone stops watching. In the background, a small yellow house. A sign on the front says: BUILDING MATERIALS FOR SALE. Is he dead?

(*Enter a boy. About eleven. Wearing a backpack, yellow Bermuda shorts, moss-green T-shirt.*) The boy wags his index finger at the three killers, who leave in a hurry, but don't run. The boy looks at the prone body, circles it, crouches to get a look at the skinny guy's face. He

waves his arms like someone telling the referee to hurry up and blow the final whistle.

BOY: He's dead . . . ! He's dead . . . !

End of video.

These are peaceful times, the TV tells us. My generation never went to war, that's why we don't really understand the mature work of poets. That's why we love the brutality of posthumous things: we're not on intimate terms with death. That was my first reason to love Sr Mendes. He saw the Second World War. His wrinkles are concrete like the ruins of Europe, where the boys born in 1934 played. Kids of eleven, twelve years of age, invaded and conquered the bombed-out city blocks, Sr Mendes told me. In 1945 and 1946, the entire continent was ruled by a government of children. Gangs of kids infested the devastated cities. He was already almost twenty, but his younger brothers loved finding abandoned machine guns and cannons in the woods neighbouring the small farm where they lived. It was a party.

When he came to Brazil, in the 1950s, Sr Mendes changed his name. I found this out in the second year of our friendship. He disembarked in Santa Catarina, but soon moved to Rio. He worked in shops, didn't get involved in the struggle against the dictatorship. He married Lígia, they had kids and, in the end, he dedicated all his energies to getting old. I don't know what his name was before he emigrated, I never asked.

Today, three years after I befriended him to see him die, the idea of losing Sr Mendes has left me all mixed up. Sometimes I dream about his funeral and wake up half dead myself.

Sr Mendes plays the lottery twice a week, because that way he's always on the brink of something big. He says the lottery forces us to think about the future. Normally I'm the one who goes to buy the tickets. He always plays the same numbers: 03, 04, 14, 27, 40, 41. Last year, he got four numbers right and won six hundred reais. He split the prize with me, because I don't have a job.

It's been four months since I became Lígia. I still call Sr Mendes 'Sr Mendes', but he hears something else, perhaps 'my sweet' or 'Luciano', which is his first name. Lígia, the dead woman, must have called him that.

I've got used to his rheumatic affections, his gnarly fingers suddenly in my hair, on my forearms, my shoulders. Sr Mendes's fingers are like a moose's horns, dark and crooked. The TV always on. He smiles at me and says he's always loved me. On sunny days or when his glucose levels are high, he squeezes my thighs and whispers pornographies in his native tongue. It doesn't bother me.

On days when I have a foreboding he's going to die, I spend the night in his apartment. I make up a bed in the living room, but I don't sleep: I stand beside the old man's bed, keeping an eye on his breathing. Sr Mendes says he hasn't dreamt since he lost his right eye. It was his right eye that knew how to dream. His left hasn't seen as many terrible things, he once told me. I never asked what things his right eye had seen. What his left has seen, I know: Rio de Janeiro, Copacabana Beach, Lígia.

The TV always on. We're sitting in the living room, Sr Mendes in his wheelchair, me on the sofa, watching the telenovela. Outside, Copacabana draws in the night. The city is like the old, it wasn't lucky enough to die young. It's growing, swelling, creating alleys, cancerous lumps, *avenidas*, backstreets, barbecue joints. At some point, even the most long-standing residents get lost in it, like Sr Mendes has lost himself in me. He looks at me and says I'm sweeter than sugar. For years he's only been able to drink diet soft drinks and coffee with sweetener. I don't answer. I scratch my beard and think about sugar. The TV always on. The neighbours complain about the noise. The foreigners have forgotten, but there's so much coagulated blood in our sugar, so many slaves who lost their arms in the mills, so much cold sweat in our sugar-cane juice. I don't know whether Sr Mendes cares.

I don't know what his nickname in the army was. Nor how he lost his eye.

I imagine how they laughed at that prophet who said that one day all the slave quarters would disappear, because the diets of the future would recommend swapping sugar for saccharin.

Panic. Luciano closes his eyes and stops breathing for a few seconds.

SR M (*with a sigh*): Copacabana never ends. Copacabana is the world, petal, it never ends: you can walk – remember how we used to walk? – and walk and walk and reach the end of the beach without even realising you're at the start of the same beach again. Remember? We went right around the world and didn't even realise. What's it called, that snake that bites its own tail?

I sigh too, from relief.

ME: 'Ouroboros', Sr Mendes.

SR M: That's right, uróboro. Copacabana uróboro . . . I don't know what I'd do without you, my angel. I'd be lost. Copacabana is the entire world. Can you hear that jackhammer? The entire world is a building site. When they've finished, no one will be able to leave, my angel. (*Pause.*) My Copacabana.

SIX O'CLOCK TELENOVELA: Get out of here, girl, so I can take a shower! You, you're the devil! Red nail polish? Ha ha.

SR M: Ha ha!

ME: I'm going to the bathroom. I'll be back in a second.

SR M: Do the lottery results come out today, petal?

ME: I'll be back in a second, Sr Mendes. Not till Wednesday.

Before I go to the bathroom, I go into Sr Mendes' bedroom. I look at the double bed: it was his wife's deathbed and will probably be his deathbed too. It's made of mahogany. The wardrobe is mahogany as well. Genuine mahogany. I open the wardrobe. While I'm choosing, I gently bite my lower lip. I know this sensation, a burning planted right in the middle of my chest. I search the drawer, I know what I'm looking for. The old man has kept all of Lígia's clothes.

FIGURE IN THE MIRROR: Remember the first time you put on your mother's bra? You were home alone, the only child of working parents. Ten, eleven years old. Natural curiosity, but you'd better be quick, they might be home at any moment.

You opened your mother's drawer – the most terrible of crimes – and hurriedly chose knickers and a bra. White. You ran out of the room and locked yourself in the bathroom. A bathroom like this one, beige and bright.

You, a boy of ten or eleven, looked at yourself in the bathroom mirror and took off your clothes. Natural. You put on the knickers. You fastened the bra by pulling the clasp to the front, below your breast, then tugged it sideways until the cups were in place, like you'd seen your mother do lots of times. The bra was far too big and you giggled nervously.

The mirror looked like this one, with a solid wooden frame. Sr Mendes wouldn't have such good taste: Lígia, the dead woman, chose this, you're certain. The TV always on. In the other room he coughs and calls you.

SR M: Lígia! Lígia, my angel, help me get up . . .

FIGURE IN THE MIRROR: You had to jump up and down to see the

knickers you were wearing because the mirror was at sink height. From the waist up boys and girls look the same. Then the breasts grow. Complete silence outside the room. If Dad comes home and catches me like this, he'll give me a beating. (*Pause.*) You look. You recognise yourself: that's your belly, that's your skin, as pink as a river dolphin, those are your shoulders. But the image in the mirror looks like a doctored photo: your face stuck onto a girl's body. It looks like the blonde girl from school. You're looking at the photograph of a centaur, a satyr, a mermaid, some creature of the devil or other.

When you got a little older, you'd pray to God and the most famous saints that the blonde girl, one of the few blonde girls at your school, would fall in love with you. You'd haggle with the saints: just kissing will do, no need for sex. But God, who's smarter than all the saints, knew very well you needed sex. You dreamt of meeting a blonde girl lost, passed out, in the forest, you'd save her and sex. The school on fire, you'd bravely enter the burning building to save the blonde girl and sex. The female teachers would think it was natural. Later you got older still and started to watch the death tapes. Even now you're terrified of killing someone. If you did, you're certain you'd kill yourself next.

You started to throb down there. Today you know the name for it. It was the same erection that Lígia's mirror reflects now, twenty years later. You're wearing Lígia's bra, Lígia's knickers. Red. Sr Mendes kept all the deceased's clothes. You got older, but you're not dead. Your body got darker and fatter, hairier. Your beard has just a few grey hairs.

After that first time, whenever your parents left you alone you ran straight to your mother's drawer. You wore all her clothes, you tried on blouses, dresses, trousers, hats, shoes, sandals. But you never put on make-up, or changed your hair. Your face was still yours and would always be yours, unblemished, a boy's face. Remember the transvestite who was murdered, shot in the face, in Kansas? The effeminate boy who killed himself in Santa Catarina? He liked to put

on make-up, he wanted to be a woman, referred to himself in the feminine. You watched the video. The boy died with his mouth red with lipstick, it left marks on the poisoned cup. (*Pause.*) You, after all, aren't a –

SR M: Lígia, come quick, I'm not feeling well.

Revertere ad locum tuum.

Luciano was buried in the São João Batista cemetery. Only a few people saw the coffin being lowered, fewer still saw him disappear under the earth and lime. Four of his five children left before the priest had finished talking. His daughter, the only one who went to her father's last birthday party, stayed behind to take care of some paperwork in the cemetery's office building. She barely looked at the coffin. She didn't look at me either. The grandchildren didn't come. A few liver-spotted friends, as old as L and with resigned looks on their faces (they'd be next), their legs soon getting tired. They pretended I wasn't there too. But they went no further than sidelong glances and disgusted mutterings, nor could they: I was the one who'd given my years to the dead man. They'd all abandoned him, I'd stayed. When the grave was completely filled, only me, the gravedigger and a young woman I didn't know, and who didn't know the deceased, remained. She had thick thighs, was wearing sandals and seemed lost. She offered me her condolences and said, 'Excuse me, madam, do you know the way out?'

A dreadful question to ask in a cemetery.

I pointed to the gravedigger, and she went over to him. I lit a cigarette and thought about the funeral. No one had made a speech, no one had spoken about the life of the dead man. I'd have liked to say

that Luciano made every decision in his life like someone planning to move to Uruguay or Paramaribo or change their sex. Who chose their brand of margarine as though the decision would fundamentally alter their fate. But who lives like that? L died of old age, it wasn't the fault of the margarine with omega 3 and 6, free of trans fats. I'd stopped smoking four years earlier, but I picked up the habit again because it's pleasurable, because it's better to be dying pleasurably.

I saw him die. I saw the exact instant. Luciano had a convulsion, fell from his wheelchair, and landed on the living-room floor, the TV on: 'It was God who sent you here,' four characters shouted with relief on the seven o'clock telenovela. I ran out of the bathroom, in bra and knickers, knelt beside him and watched on, wide-eyed, vigilant. I didn't cry, I didn't say a word. I wanted to see the exact moment when Sr Mendes would die. He looked at me, at my man's face, free of make-up, at my centaur's body. This hairy mermaid, this satyr, this creature of the devil. I think he recognised his wife's underwear, the bra and knickers of Lígia, the dead woman. He tried to smile, but instead he shuddered and then died.

Before he did, he told me his nickname in the army was Ludwig. And he called me Lígia, and called me Alex, and asked for a kiss. I didn't give him one.

The eyes of a man who's suddenly become a corpse go foggy from an epiphany, that's a fact. And anyone who witnesses another's death feels a jolt of relief, like someone who finally remembers where they left the car keys or their voter registration card. My first thought was 'People really do die.' I want to think the same thing when I witness my own death.

On the day of the funeral, as I left the cemetery, I saw a sweaty old man eating popcorn. He looked like he was lost too, like he wasn't from this city or even this day and age. He fixed his eyes on my made-up face, my hair combed in the fashion of little old ladies from Copacabana, and smiled as though he would melt, as though he was made out of refined sugar. I didn't like that smile, it seemed offensive. I responded with a yell.

LÍGIA: What do you want?

I was wearing a very pretty black dress, high heels, also black, Lígia's clothes. The widow. I hadn't shaved off my beard (nor am I going to), despite the heat. The sweaty old man stared at my calves (unshaven, no tights) and gave a perverted smile and my anger boiled up and I advanced in his direction, my high heels sinking into the cobblestones. He kept smiling. He apologised by shrugging his shoulders. He didn't speak Portuguese. I drew my arm back to punch him and the old man said something in desperate French, maybe he hadn't understood me, he hadn't understood me! I bumped my flat breasts against him, almost nose to nose, and below his nose that same smile. I didn't actually hit the old man, but neither did he try to defend himself. He didn't even drop his bag of popcorn. He turned his back and walked away. ■

AUTHOR'S NOTE: The shots of Achilles's lunge are taken from an amateur video on YouTube, its author unknown. The oral diptych is mine, photographed from the TV screen. The TV dialogue is, in fact, lines overheard on TV. The phrase '*revertere ad locum tuum*' was scanned from the R. P. de Carrières edition of the Bible (Outhenin-Chalandre, 1835). I regularly play the lottery, my numbers are 03, 04, 14, 27, 40, 41. I've never won, I've never even got four numbers right.

Bernadette Van-Huy

Moon

Moon is always there
It hides in the wings during the day

It enters at night
Wearing false, borrowed light

Tamara Nassar

Lovers' Quarrel

Certainly we are not too old for that day
as dense as age on your bedroom floor.
My drab white dress, face like a sheet.
Your hands around my throat.

I am not a cynic. I resent your meekness.
It is the year of the rabbit. But I did not think
I could afford one more romance.

Listen,
I am willing to forgive everything
if you will remember me by:

Wednesday morning in Amman,
we walked beneath the cottonwood poplar,
a military of birds sang a chaotic song.
Believe me when I say they called to you.

A journal of what criticism can be.

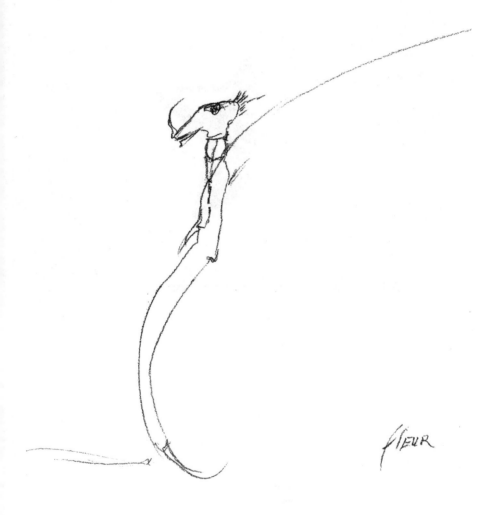

FLEUR JAEGGY

ARMANCE

Fleur Jaeggy

TRANSLATED FROM THE ITALIAN BY GINI ALHADEFF

There are times when I think of cutting my hair, times when I think of cutting my throat, and other times when I think of screwing out my eyes. Forgive me, Doctor, it's just a way to talk about myself, and about Armance.

A sense of perplexity comes over me, I no longer know what to say; that is, in general, when one suddenly falls silent, thought wanders as though in expectation and then there it is – a novelty or a reflection.

I start thinking about all this on the train – since I know the landscape by heart it's not hard to do. I always travel first class, and always sit by the window. I could just about be permanently lost in thought, given the frequency of my displacements.

I also have a habit of sitting on a rock by the river to read Stendhal or look at the river and the stones.

I have absolutely no parents, no friends in particular, my life runs serenely, sweetly.

A young woman has been living in my house for some time and I often meet acquaintances of hers to whom I offer drinks in my beautiful glasses. Miss Armance is very good company, she was born twenty years before me and wears her hair back, always neat. We met on the Milan–Gotthard–Zurich *direttissimo* train of the Swiss Federal Railways.

She was sitting almost directly in front of me and one noticed her right away on account of that strict look she has at all times; now that

I know it, I hardly notice it anymore, except on rare occasions; though there was a time when I couldn't help going to her room at odd hours of the night, to see whether she might have let herself go a little (or not at all), to hear a story, or to be caressed.

And she was so strict, so frightfully fierce. In the train compartment she had looked at me in such a mean way, and kept doing so. And so I took up my newspaper trick, I pretended to read, to look out the window in which her face was reflected, I smoked, blew my nose, picked up a book, looked up, and she was no longer there.

Naturally I thought once again, with a sigh of relief, that I have too much imagination. I don't think much of the very silly, even gullible, person that I am. But one starts to conjecture right away through the entire length of the Gotthard Tunnel – about ten minutes.

She wears a kind of scarf I like very much – reddish, wide and comfortable – with a well-cut suit. Has it ever happened to you while on a train or a streetcar, or while riding a taxi, that you catch sight of someone you'd like to meet right away, just like that, or when you're at a cafe, looking around, *just so*, I'd like to emphasize, for no particular reason?

I remember once, on my way to Lindau, on the Bodensee, a thin tall man with gray eyes came into my compartment, I was a young girl on my way to school and was reading a book in French that I didn't understand. The man started talking to me, asking whether I understood that book, and it struck me – how experienced he was.

Then came the station, and I went back to school, crestfallen. Several years have gone by and I still think about it, like a wolf. I wouldn't hide my desire to see him again (and to devour him).

Often when I look at swallows in flight I wish I could fly: I love the sky, I look at the clouds and have no taste for extravagance. Lately I'd heard a girl ten years younger than me recount her dreams, about hens and metamorphoses. Not that the dreams of others particularly intrigue me, but I can become perplexed at the majesty of certain dreams I've never dreamed. As soon as Armance bid me goodnight, I would wait until she had fallen asleep to find out what might happen to her; I go into her room and watch; every now and then she moves

her lips, or becomes agitated, I start to hum, finding it absurd to see one person asleep and another one standing there.

I can never sleep in her bed, I absolutely detest getting tangled up.

Armance starts telling her tale again. She is slipping into a sea of lizards and experiences a frightful tickling in her feet. I immediately feel pins and needles in my feet and I'm awake. Oh well. Could I ever understand my Armance?

Out of coquetry, or a desire to compare, I look at myself in the mirror and I am decidedly determined to become more graceful, desirable, I spread sea-light pale blue eyeshadow on my lids and brush my hair a hundred times each day.

I remember a dwarf playing in the sand in Camargue with a friend, I would have liked to have been an angel, to run after them, suffocate them, then turn into a mole.

I detest Armance's friends, I can't stand them, I keep looking at my watch and they seem to never go away, and besides I'm not having a good time, and it seems ridiculous that I should have to wait for nightfall to have a conversation with her. I'm sure that in a few minutes she'll smile at me simply because she is a bitch, and in one moment precisely everyone will smile at me; naturally I act as though nothing happened, maybe I've never been perfectly happy, but I know one shouldn't be too patient.

I don't wish to put anyone on guard, but careful. Arousing is not allowed.

Because then I can't fall asleep. And what happens next is that since I am not sleeping I start thinking, scrutinizing my feelings, I go back to Armance, don't say a word to her, adore her, go back to my room, drink a glass of milk and fall asleep again.

I wake up in the morning and ask to be taken to the beach, it's hot, I drink white wine and we're especially cheerful. Everyone's drinking, it's like a picnic, we're all friends, I no longer need to plot anything.

How do I know whether I like the sea, how could I imagine that Armance can't swim? And that all you need is a slip and you fall off a cliff? Let's rejoice.

Go without taking offense, so that I might go back to sleep and watch over Armance as she sleeps.

It's raining, raining hard and I don't think the weather will clear.

... 'The first thing is to understand whether a person's openness might be a positive sign with respect to another person.' This is a problem I have in love.

Everyone has their moment. I don't know what to do with this rainy afternoon. It gets the time it deserves.

The calendar. There are many calendars in my house. Miss Armance has been living in the other room for months. Gazing at the calendars I see a kind of balance sheet, a summary, no way out. On the 3rd of June I could have hit her I was so furious. Categorically. It's a good thing I make a note of everything, otherwise she'd be right all the time. I don't have a comeback all lined up, and don't immediately realize what is going on, I mean that all you'd need is a distraction and I just know that these so-called friends would become – what? Brothers, maybe something more, lovers perhaps, Armance my dear, and all the while I bite my nails.

And today, a Tuesday, is another afternoon like the one before it. If they steal I devour, I'm alive and well, so why does Armance go on torturing me, and if she pretends to be as I want her, why doesn't she take her so-called friends to tea at Babington's or elsewhere, for instance? She'd come back at dusk more beautiful than ever.

The calendar says that from November of last year to today I have spent only one afternoon at home. Brooding.

My solitary afternoons, the movie theaters, the aimless taxi rides, what a nightmare when we won't be allowed to smoke in taxis anymore, Armance, what will I do with my life then? And what of my afternoons?

One afternoon I picked scented roses from a vine, with all their little green leaves, and the petals so pale blue blown in the breeze, which is what happens when I look at the sky, with tears in my eyes I put down my *Rozenkrantz*. ∎

A general-interest magazine in disguise.

Uncover an award-winning publication filled each month with long-form book reviews, original poetry, and surprising essays.

reviewcanada.ca/discover

Literary Review of Canada

A JOURNAL OF IDEAS

CONTRIBUTORS

Kareem James Abu-Zeid translates poetry and novels from writers across the Arab world, including the forthcoming collection *No One Will Know You Tomorrow* by Najwan Darwish.

Gini Alhadeff is the author of *The Sun at Midday: Tales of a Mediterranean Family* and *Diary of a Djinn*. She translated Fleur Jaeggy's *I Am the Brother of XX* and *The Water Statues*, Natalia Ginzburg's *The Road to the City*, and edited an anthology of poems by Patrizia Cavalli, *My Poems Won't Change the World*.

Kevin Brazil is a writer and critic living in London. His essay collection *Whatever Happened to Queer Happiness?* was published in 2022.

Anthony Vahni Capildeo is Writer-in-Residence at the University of York. Capildeo's recent work includes *A Happiness* (2022) and *Polkadot Wounds* (2024).

Debmalya Ray Choudhuri is an artist from India, currently based in New York, whose diverse practice engages with photography, performance and text. Their recent shows appeared at Rotterdam Photo; Les Rencontres d'Arles; En Foco; the LGBT Center; and TILT Institute, among others.

J.M. Coetzee's work includes *Waiting for the Barbarians, Life & Times of Michael K, Boyhood, Youth, Summertime, Disgrace, The Childhood of Jesus* and, most recently, *The Pole and Other Stories*.

Sophie Collins is the author of the essay *small white monkeys* (2017) and the poetry collection *Who Is Mary Sue?* (2018). 'Private View' is an excerpt from a novel-in-progress.

Najwan Darwish is an Arab poet whose work has been translated into more than twenty languages.

Rosalind Fox Solomon is an American artist based in New York. She has had nearly thirty solo exhibitions and her work is held in more than fifty museums worldwide. *A Woman I Once Knew* is her fifth book published by MACK, following *The Forgotten, Liberty Theater, Got to Go* and *THEM*.

Mary Gaitskill is the author of three novels, three books of short stories, and an essay collection. Her most recent works are the novella *This Is Pleasure* (2019) and an omnibus of old and new work, both fiction and non-fiction, *The Devil's Treasure* (2021). She is currently working on a novel based on the Faust story, as well as another novella titled *And This Is Pain*.

Jesse Glazzard is a portrait and documentary photographer from Yorkshire, England. Since graduating from Central Saint Martins in 2019, he has been documenting spaces, friends, lovers and models.

Victor Heringer was born in Rio de Janeiro. He was the author of the poetry collection *Automatógrafo* (2011), the two novels, *Glória* (2012) and *O amor dos homens avulsos* (2016), as well as a collection of non-fiction writing, *Vida desinteressante* (2021). He also wrote a weekly column for the Brazilian literary magazine *Pessoa* and translated from English to Portuguese.

Zoë Hitzig's second collection of poems, *Not Us Now*, will be published in summer 2024. Her first book, *Mezzanine*, was published in 2020.

Fleur Jaeggy was born in Zurich and now lives in Milan. Her work has been translated into twenty-seven languages and includes *Il dito in bocca, L'angelo custode, Le statue d'acqua, I beati anni del castigo, La paura del cielo, Proleterka, Vite congetturali* and *Sono il fratello di XX*.

Christian Lorentzen writes for the *London Review of Books*, *Harper's Magazine* and *Bookforum*.

Tamara Nassar is a Palestinian writer born and raised in Amman, Jordan. She is an associate editor of *The Electronic Intifada*. She lives in Chicago.

John-Baptiste Oduor writes about contemporary art, film and politics.

Susan Pedersen teaches British and international history at Columbia University in New York. Her book about marriage and politics in the Balfour family will be published by John Murray in 2025.

James Pogue is the author of *Chosen Country: A Rebellion in the West*, and is a contributing editor at *Harper's Magazine*. He is writing a book about rural California.

Snigdha Poonam is a journalist based in India and the UK. Her first book, *Dreamers: How Young Indians Are Changing The World*, was published in 2018.

Alexandra Tanner is the author of the novel *Worry* (2024). Her stories, essays and reviews have appeared in the *New York Times Book Review*, *DIRT*, *LARB*, the *Baffler*, *The End* and *Jewish Currents*, among others. She lives in Brooklyn.

Lynne Tillman's most recent book is *Mothercare* (2022). In September 2024 her novel *American Genius, A Comedy* will have its first publication in the UK with Peninsula Press.

Bernadette Van-Huy is one of the co-founders of the artist group Bernadette Corporation. She is currently making a feature film.

James Young is a translator and writer from Northern Ireland. He has translated two books by Victor Heringer, *The Love of Singular Men* (2023) and – co-translated with Sophie Lewis – *Glória* (2024).